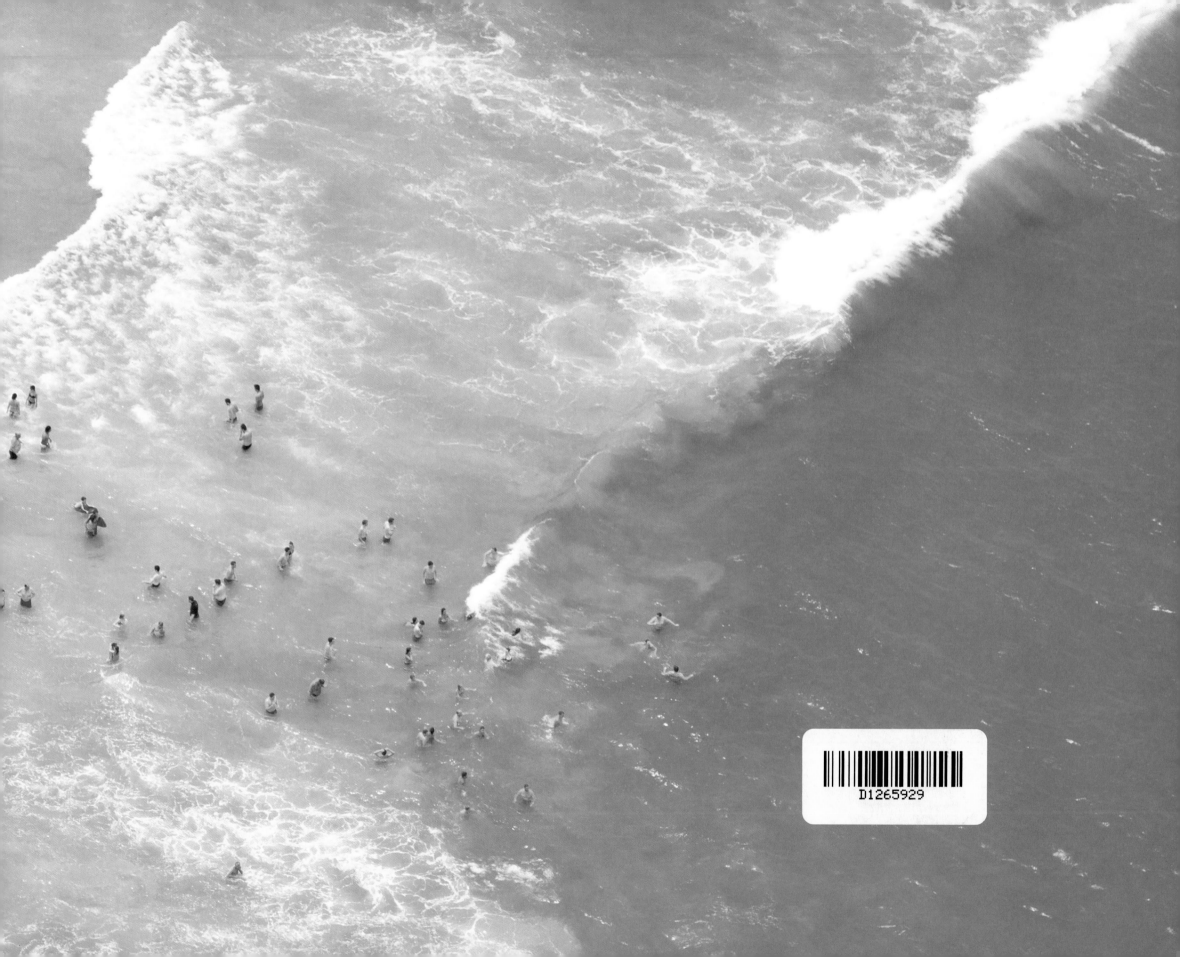

GRAY MALIN

\\\\\\\\\\\\\\\\\\\\\

BEACHES

GRAY MALIN

Abrams, New York

Library of Congress Control Number: 2015946912

ISBN: 978-1-4197-2089-5 (hardcover)
ISBN: 978-1-4197-2271-4 (author edition)

Printed and bound in the United States
10 9 8 7 6 5 4 3 2

Abrams books are available at special discounts when purchased
in quantity for premiums and promotions as well as fundraising or educational use.
Special editions can also be created to specification.
For details, please contact specialsales@abramsbooks.com or the address below.

115 West 18th Street
New York, NY 10011
www.abramsbooks.com

\\\\\\\\\\\\

THIS BOOK IS DEDICATED TO MY PARENTS,

Peter & Amy Malin

AND MY SISTER,

Elizabeth Malin

INTRODUCTION

NO ONE KNOWS exactly when a life-changing idea might come to them, but they certainly will not forget where they were when it happened. In April 2011 I went on a weekend getaway with friends, and our hotel room happened to be twenty stories above a giant swimming pool. As I looked directly down on the crowded scene of sunbathers below, my head began to spin as I observed the bright colors, repetitive shapes, and playful elements of this inviting perspective. I could have never imagined that this one moment would ignite a passion that would take me all over the world.

From above, a simple beach becomes a blank canvas that allows me to start seeing the world as art. People and objects become patterns creating repetition, shape, and form. Each geographic location has revealed that the love of water is a universal experience, an activity that offers people a sense of freedom and joy and unites us all.

My photographic journey began in 2010 at a Sunday flea market in West Hollywood, California. After college, I settled in a corporate job, but deep down I knew I was destined to be a photographer—I just wasn't sure how to make it a viable career. The flea market allowed me to showcase my work once a week and interact with customers to learn first-hand what type of artwork people were compelled to hang inside their homes. Today I have carried this philosophy over to GrayMalin.com, and I conceptualize and execute fine-art series around the world for people to enjoy and live with in their everyday life.

To me, the journey is more than just a photograph, but rather a shared expression of a lifestyle, and you're invited to make every day a joyful getaway.

Gray Malin

À
LA PLAGE

\\\\\\\\\\\\\\\\\\\\\

Shooting from doorless helicopters,
I photographed this series around the world in six
continents. These photographs are a visual celebration
of color, light, shape, and summer bliss.

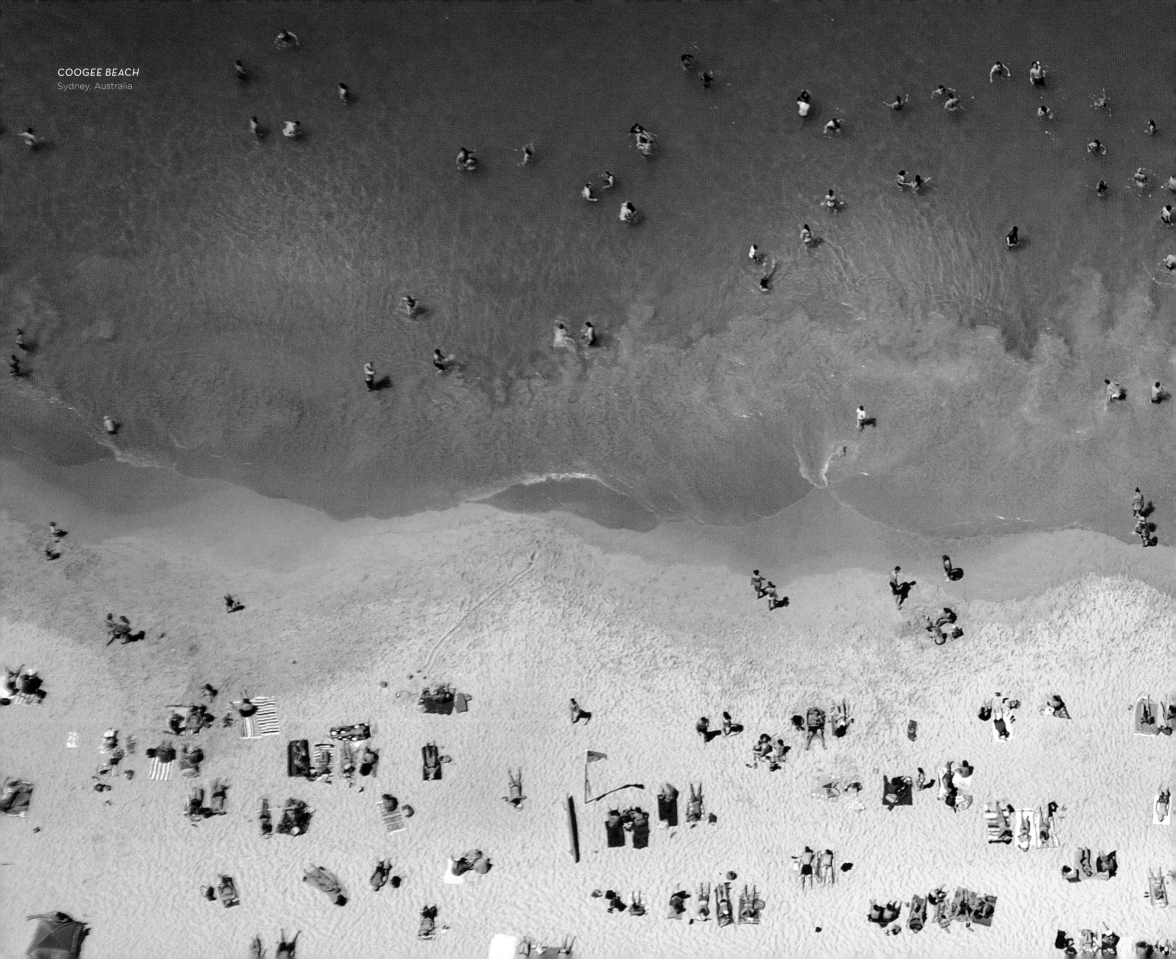

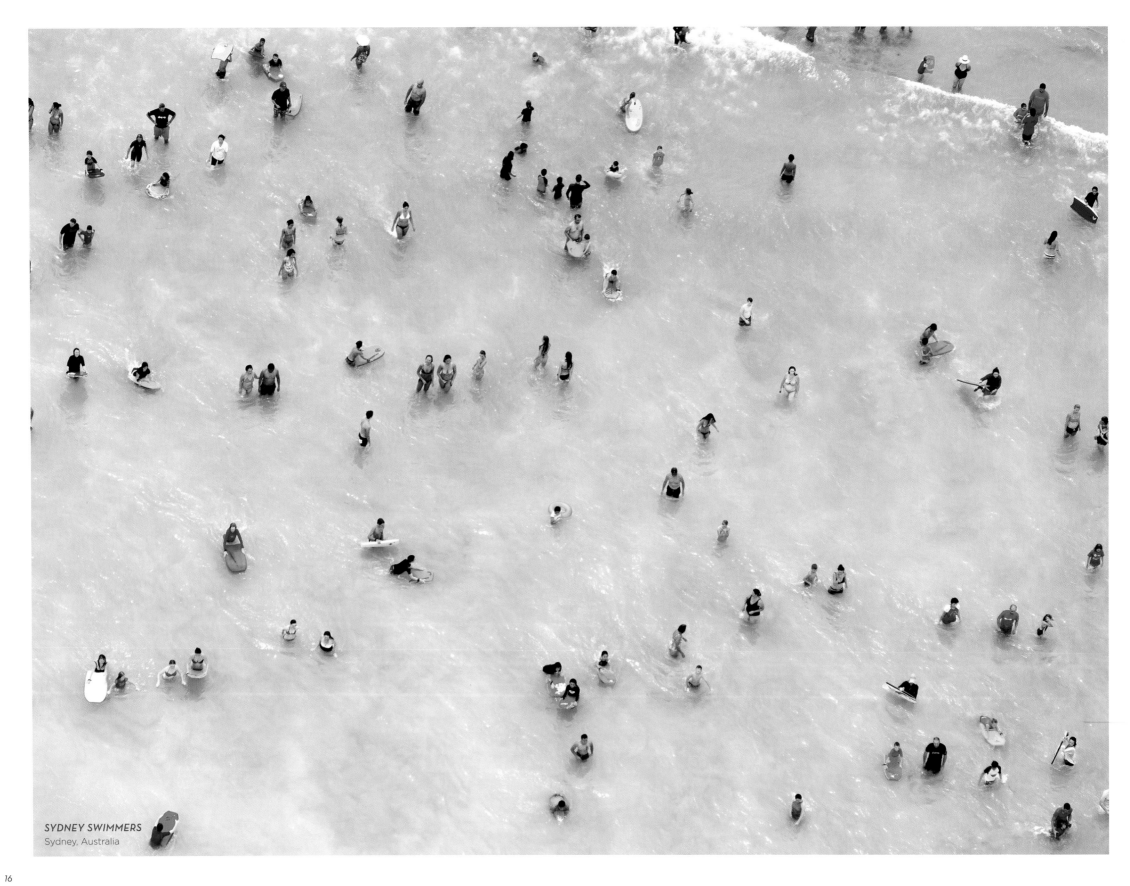

SYDNEY SWIMMERS
Sydney, Australia

IT'S AN EXHILARATING EXPERIENCE DANGLING YOUR FEET FROM THE SIDE OF A SHAKING HELICOPTER WHILE THE WIND IS WHIPPING YOU IN THE FACE, ONLY HAVING SECONDS TO MANUALLY ADJUST THE LIGHT AND COMPOSITION TO CAPTURE THE PERFECT MOMENT.

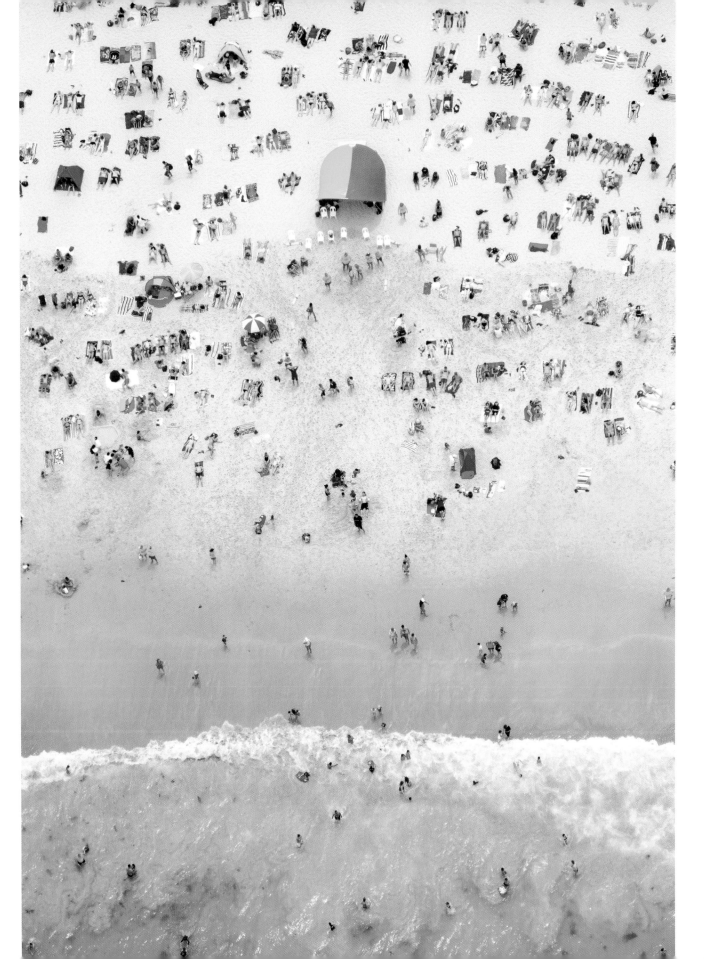
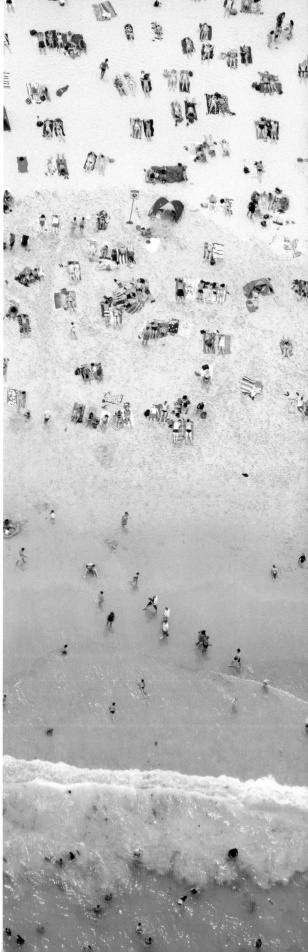

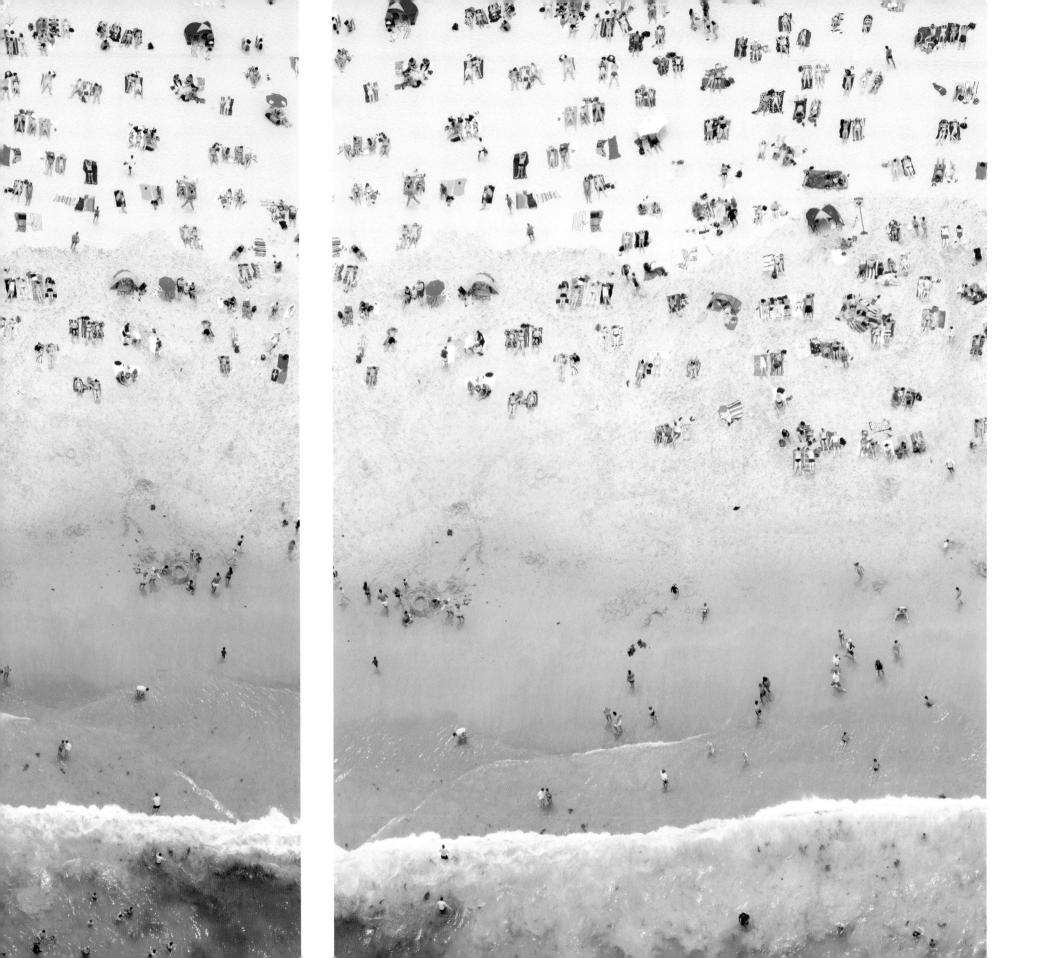

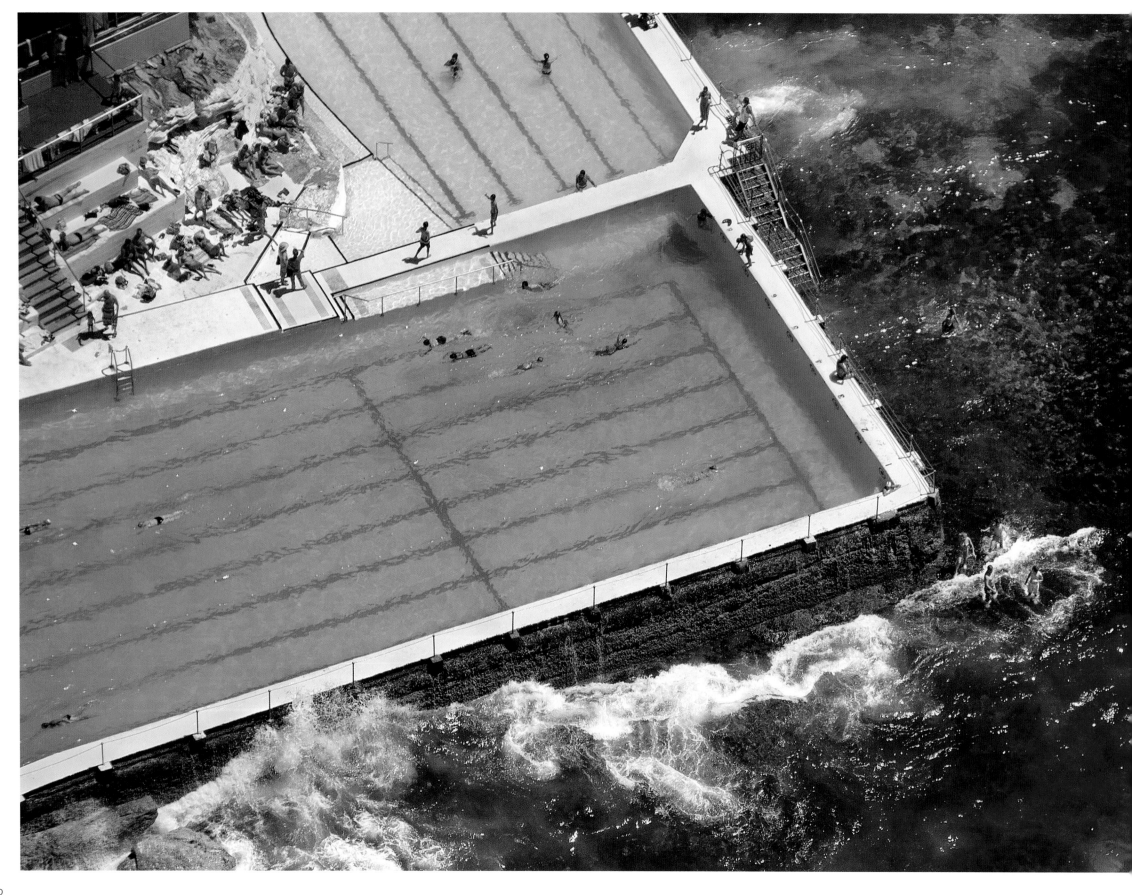

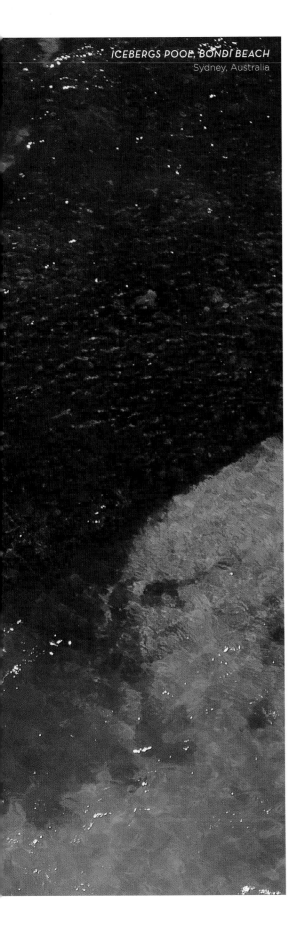

SYDNEY

BONDI

Bondi Bay

BRONTE

Nelson Bay

CLOVELLY

Clovelly Bay

N

COOGEE Coogee Bay

SOUTH
PACIFIC
OCEAN

One of the best things to do in **SYDNEY** is the famous coastal walk from

COOGEE BEACH ----------→ BONDI BEACH

that features stunning views of beaches, bays, cliffs, and—of course—saltwater pools like the iconic

BONDI ICEBERGS POOL.

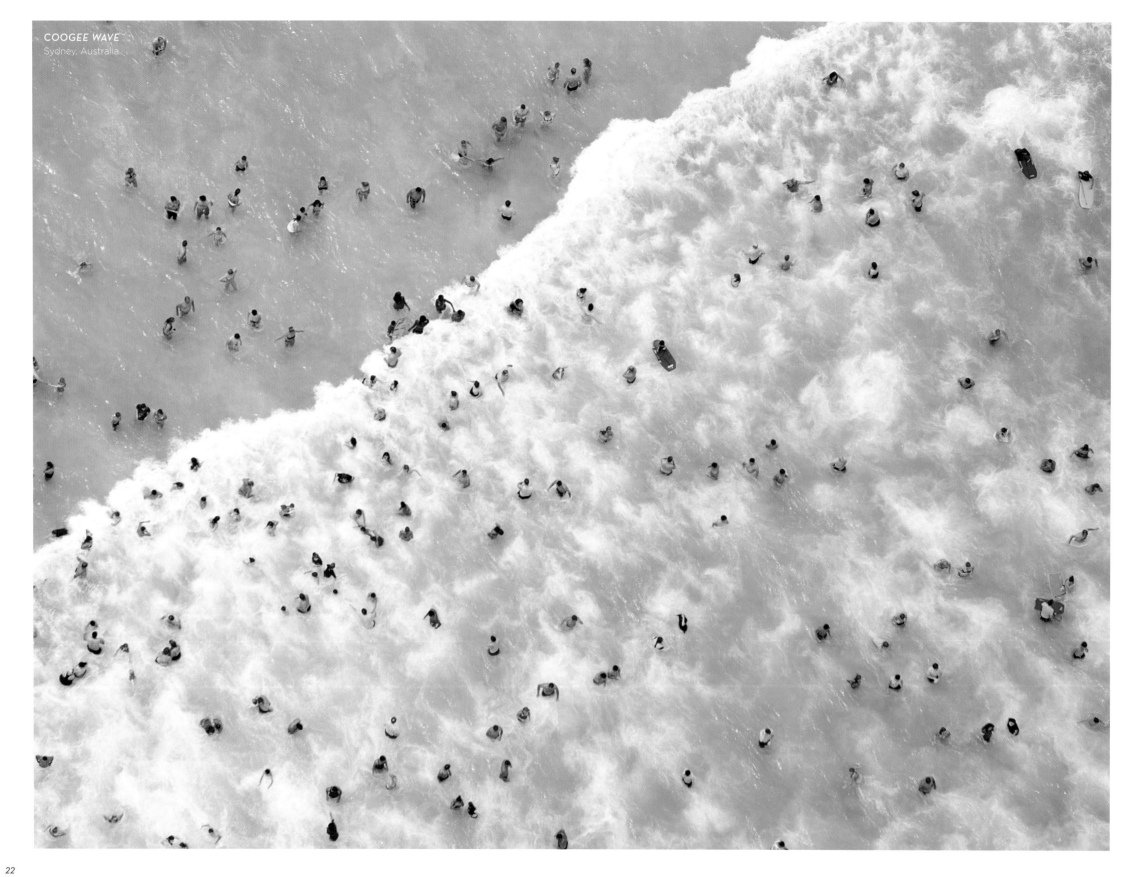

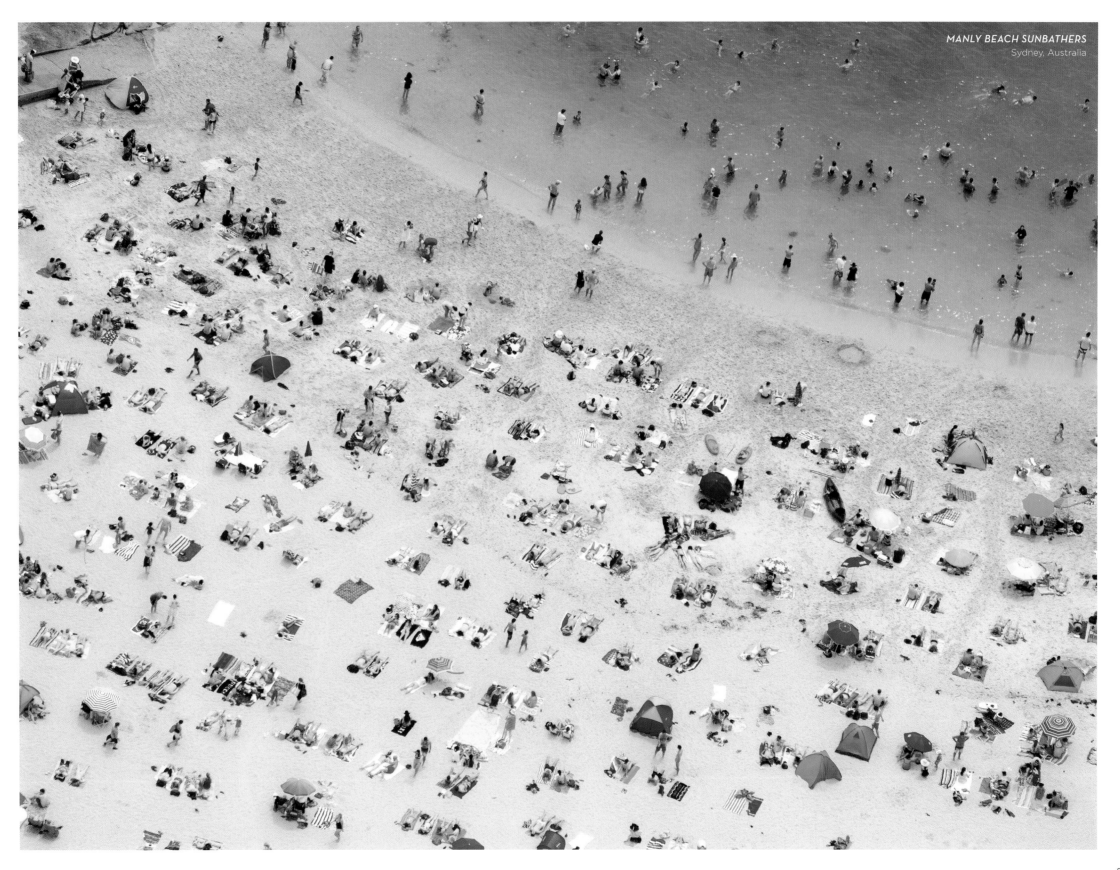

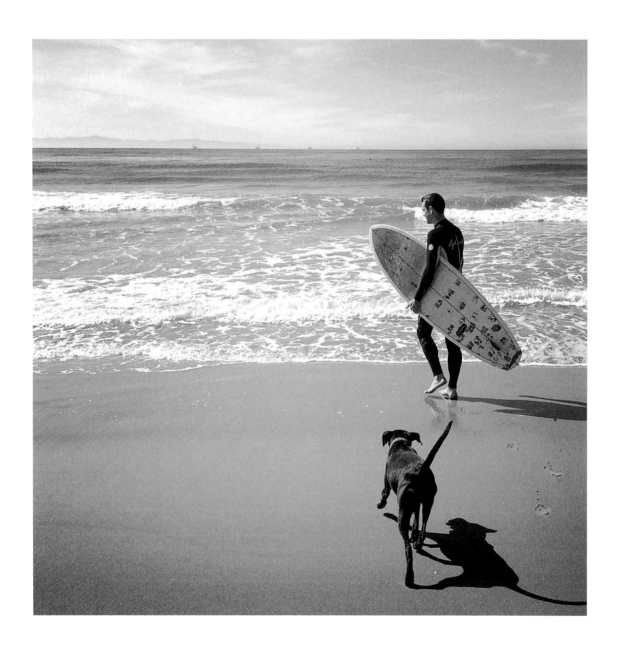

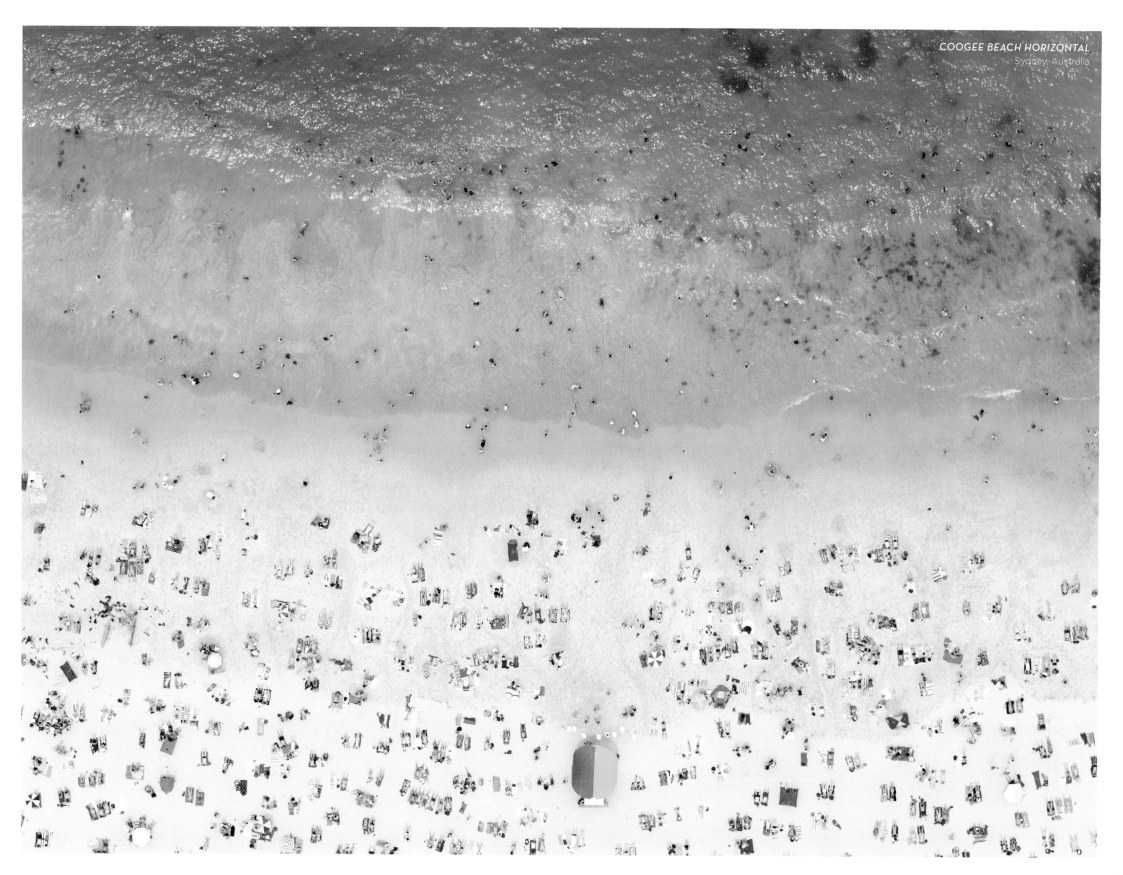

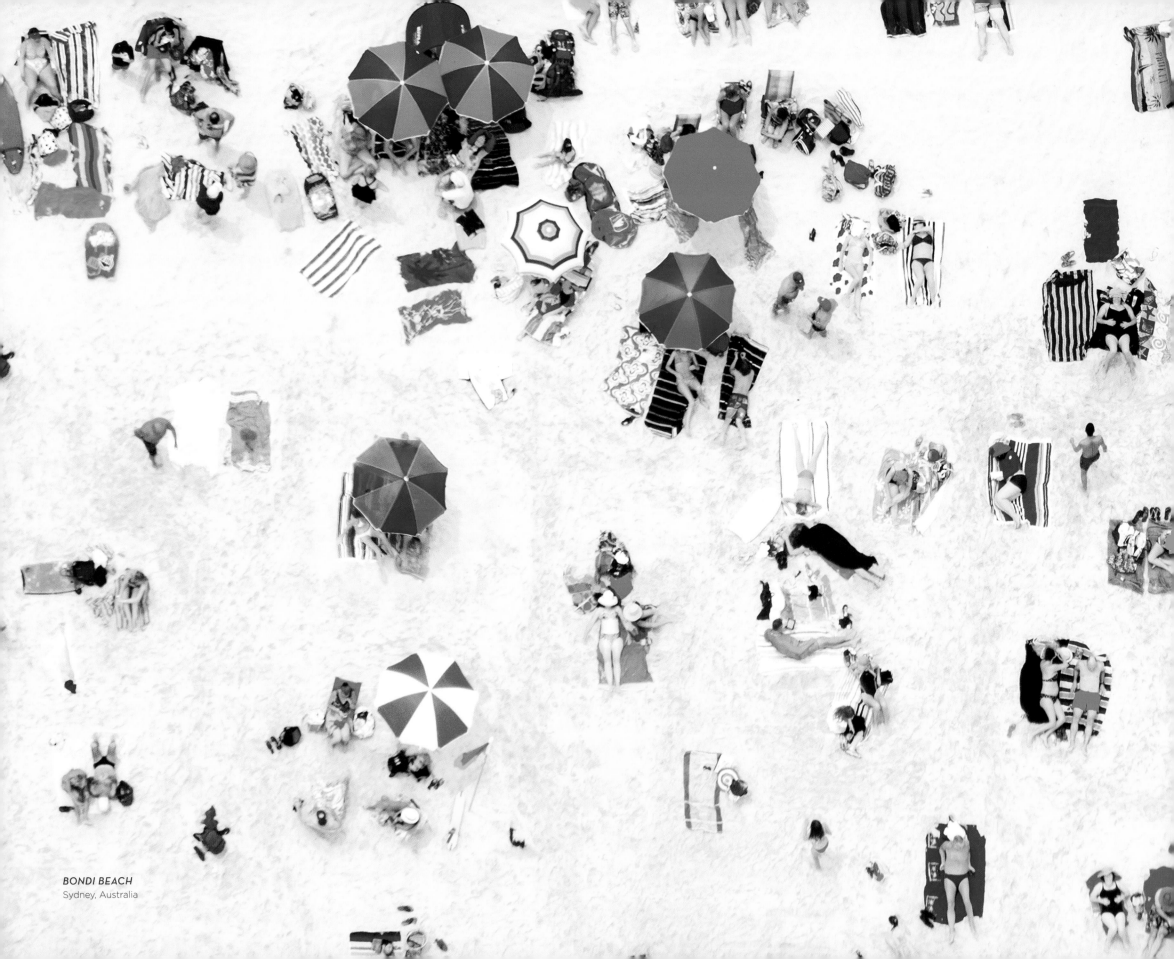

BONDI BEACH
Sydney, Australia

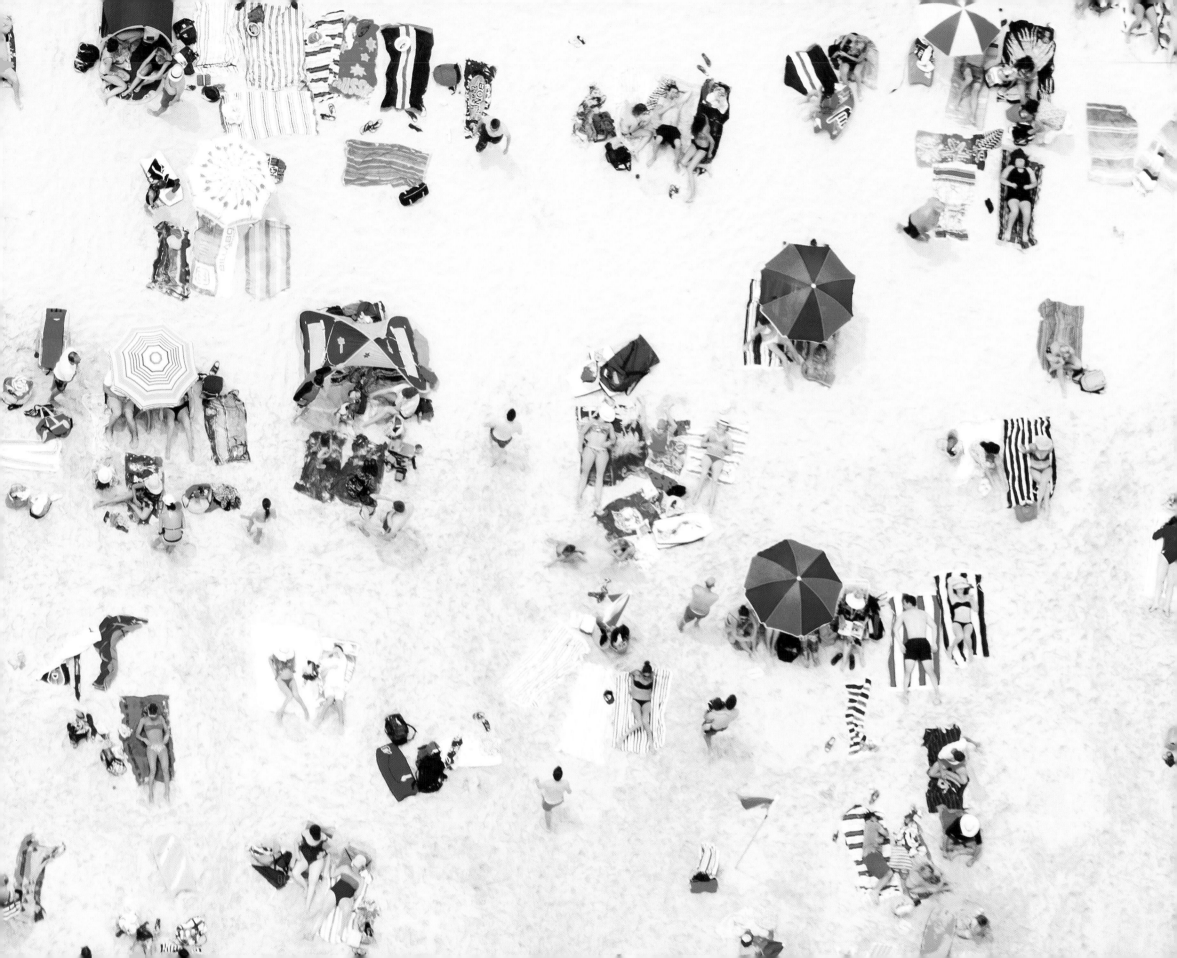

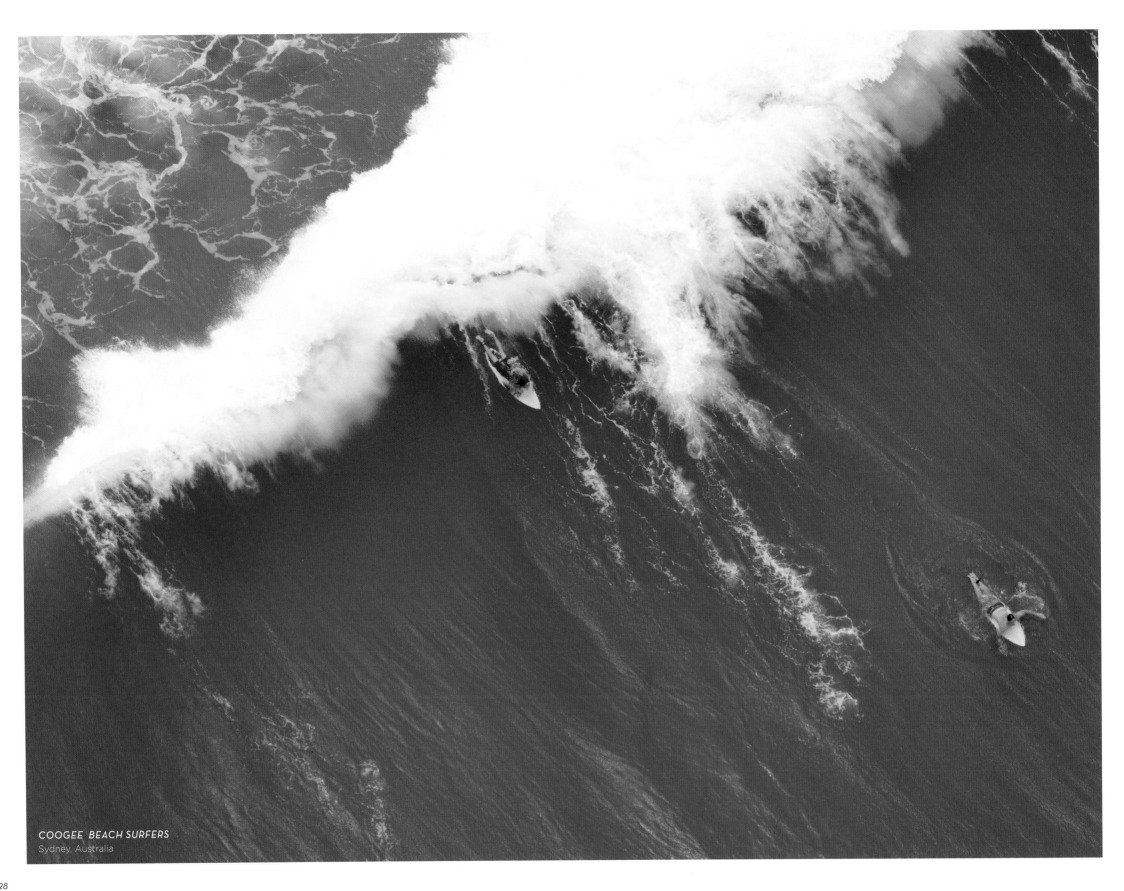

COOGEE BEACH SURFERS
Sydney, Australia

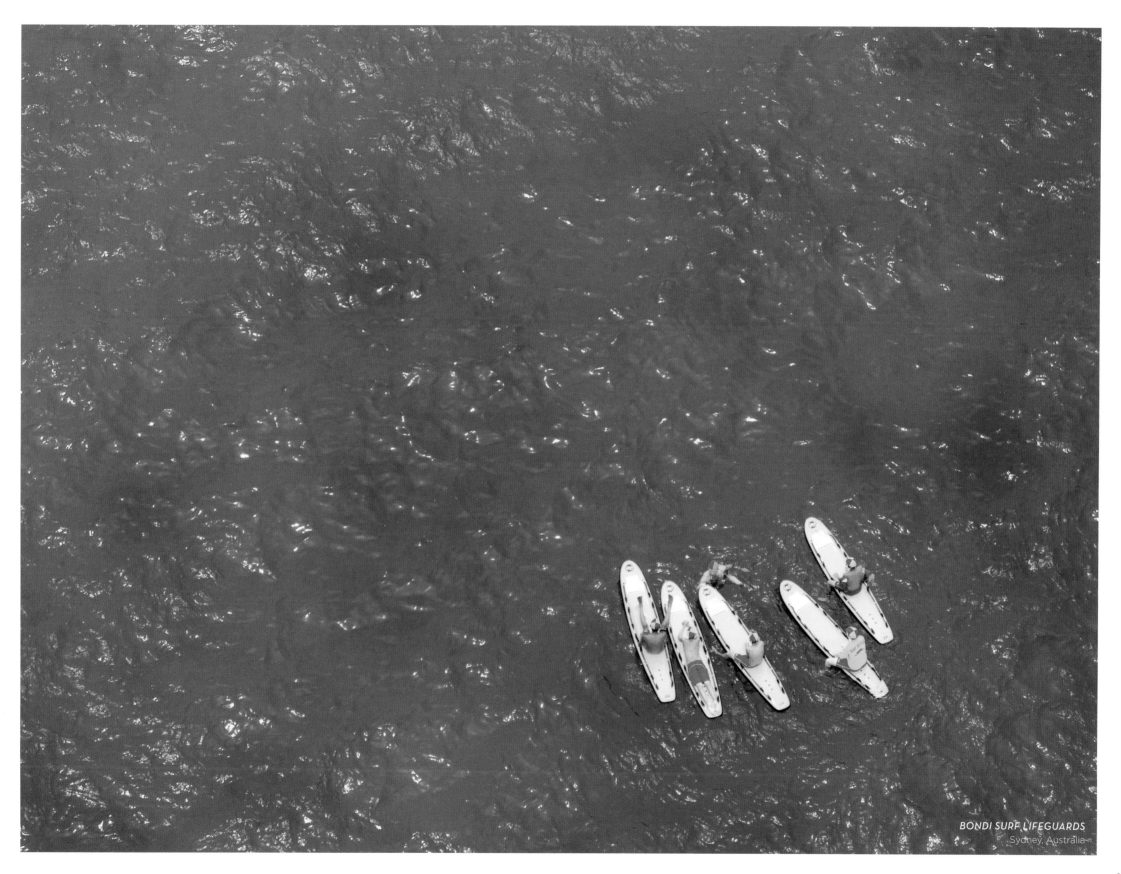

BONDI SURF LIFEGUARDS
Sydney, Australia

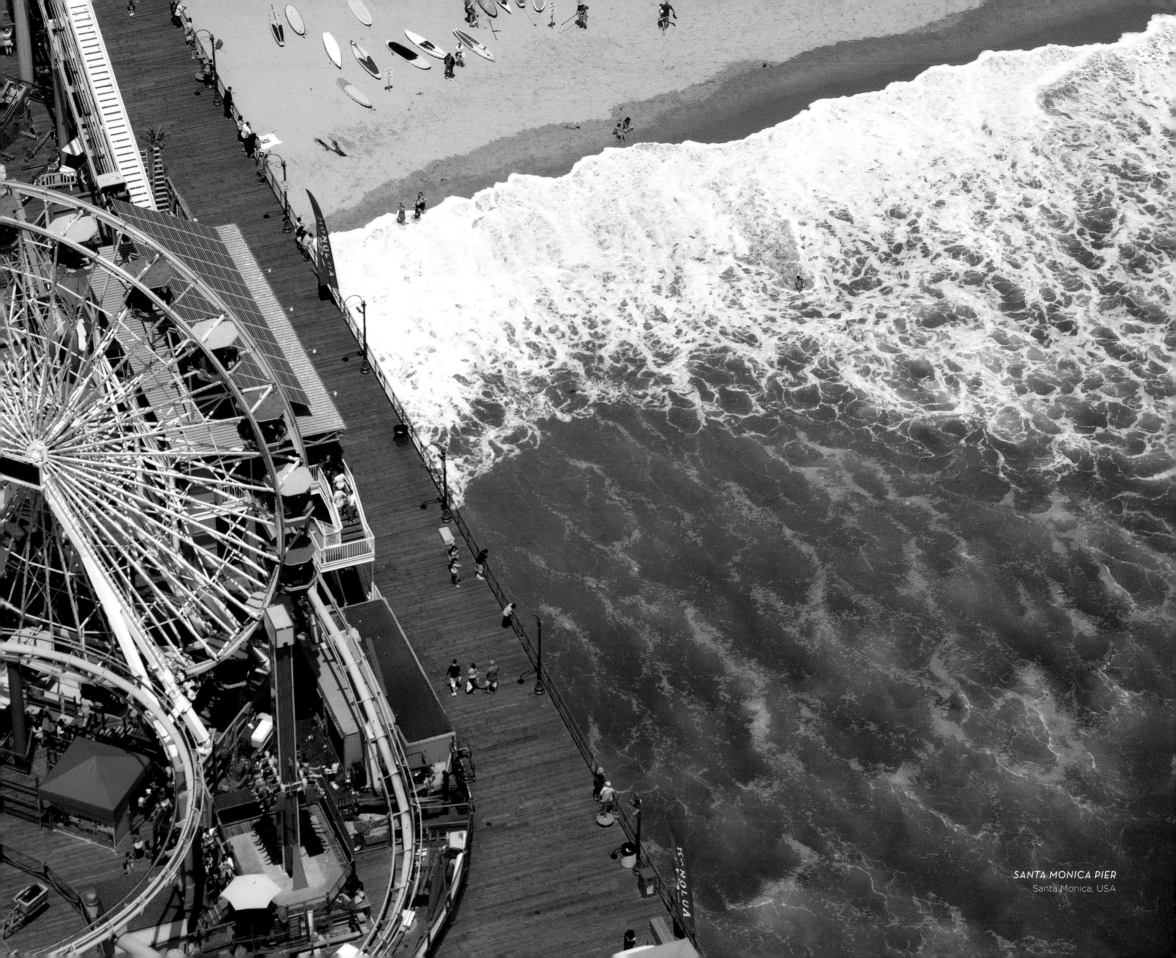

SANTA MONICA PIER
Santa Monica, USA

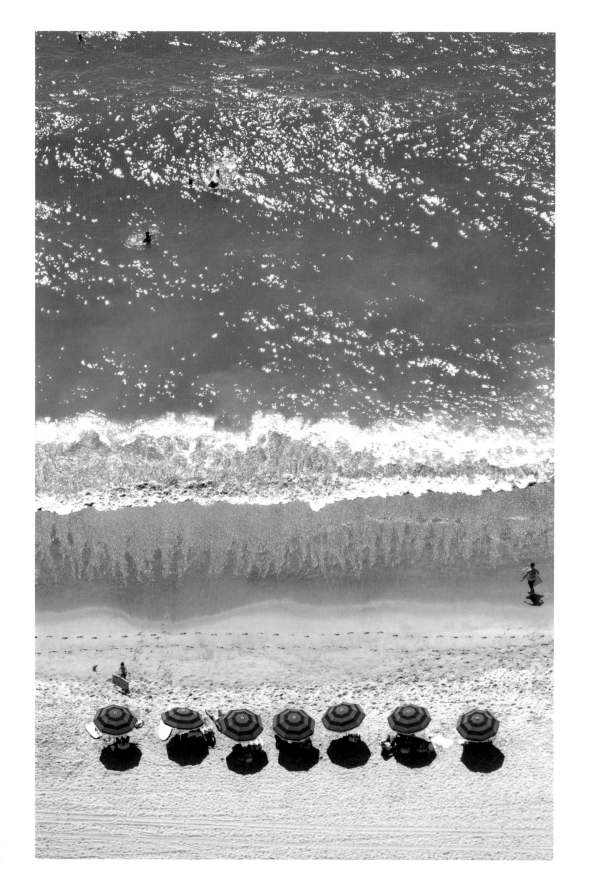

SANTA MONICA VERTICAL
Santa Monica, USA

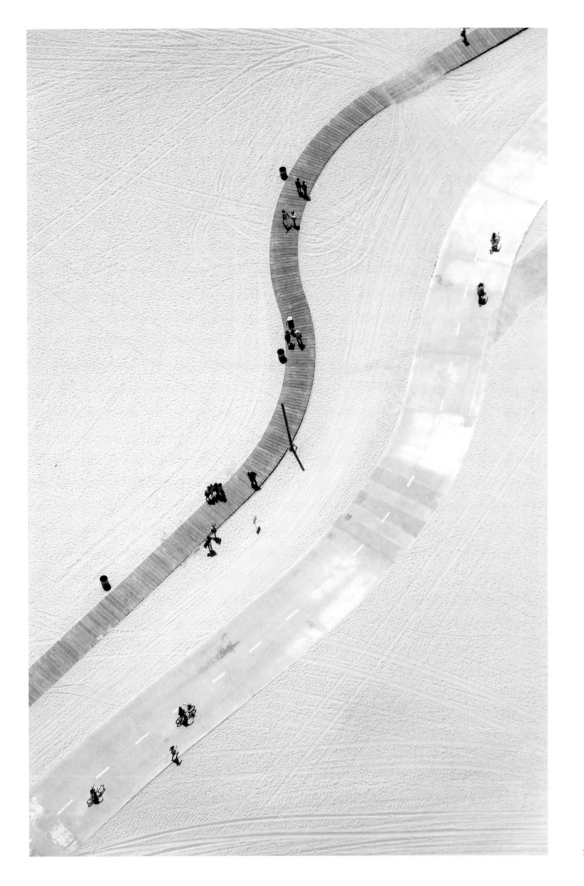

THE STRAND VERTICAL
Santa Monica, USA

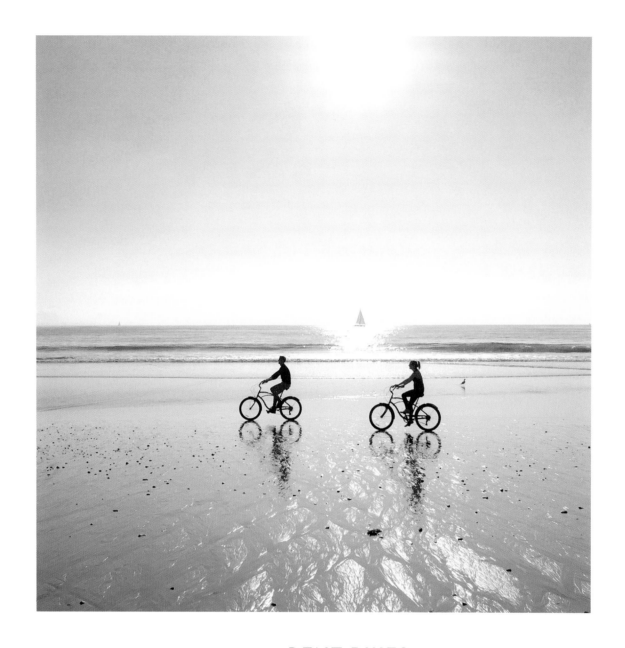

One of my favorite things to do is to **RENT BIKES** and ride them

along the # SANTA MONICA boardwalk

all the way to - - - - - - - → MANHATTAN BEACH.

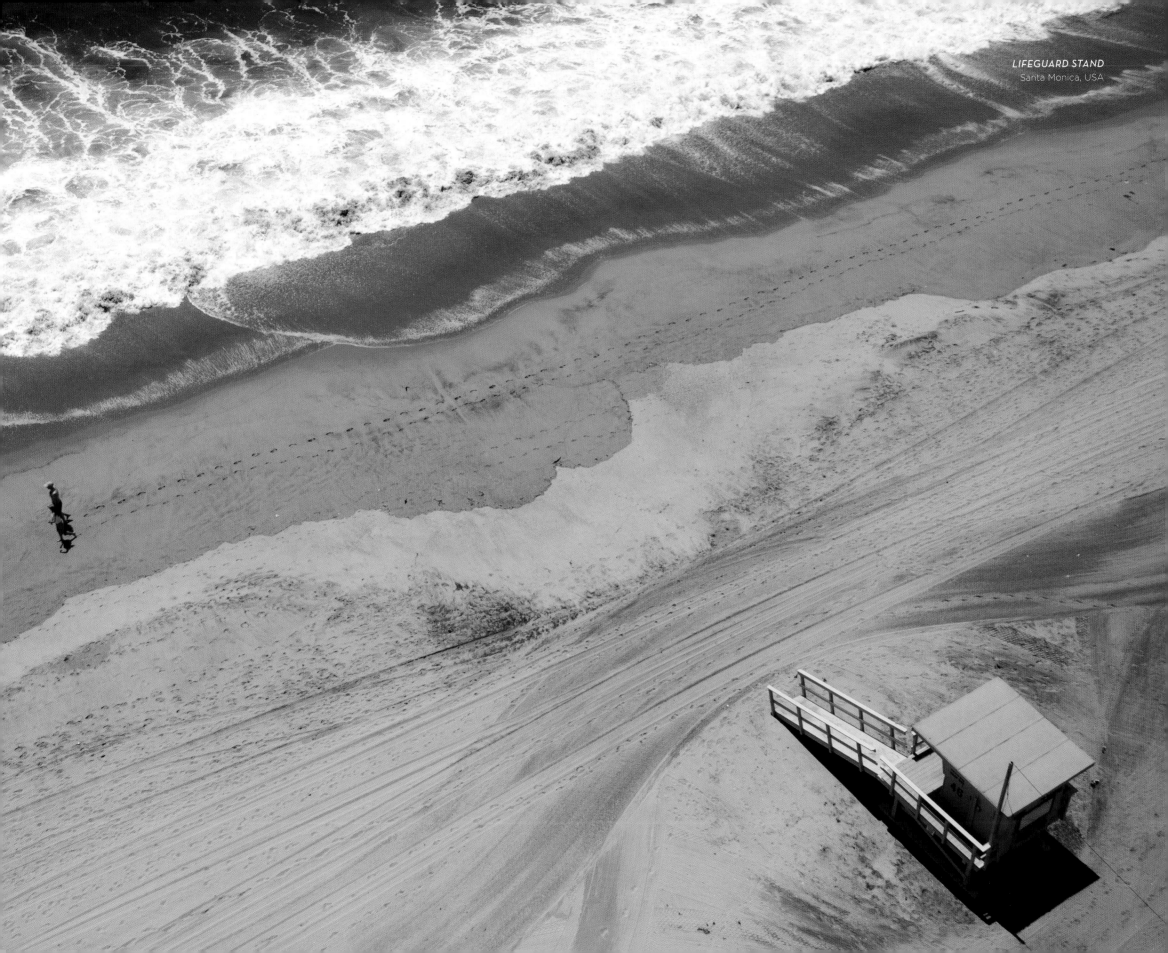

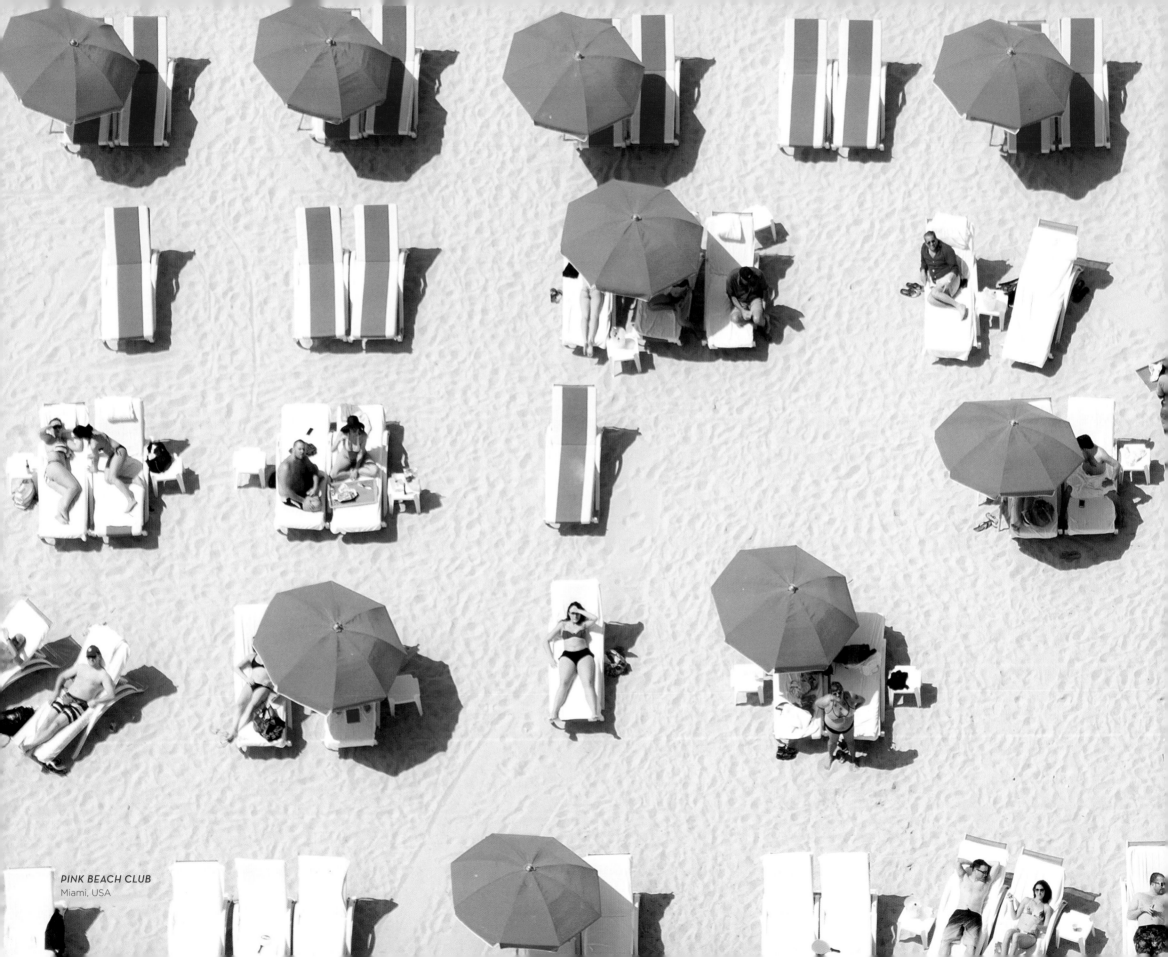

PINK BEACH CLUB
Miami, USA

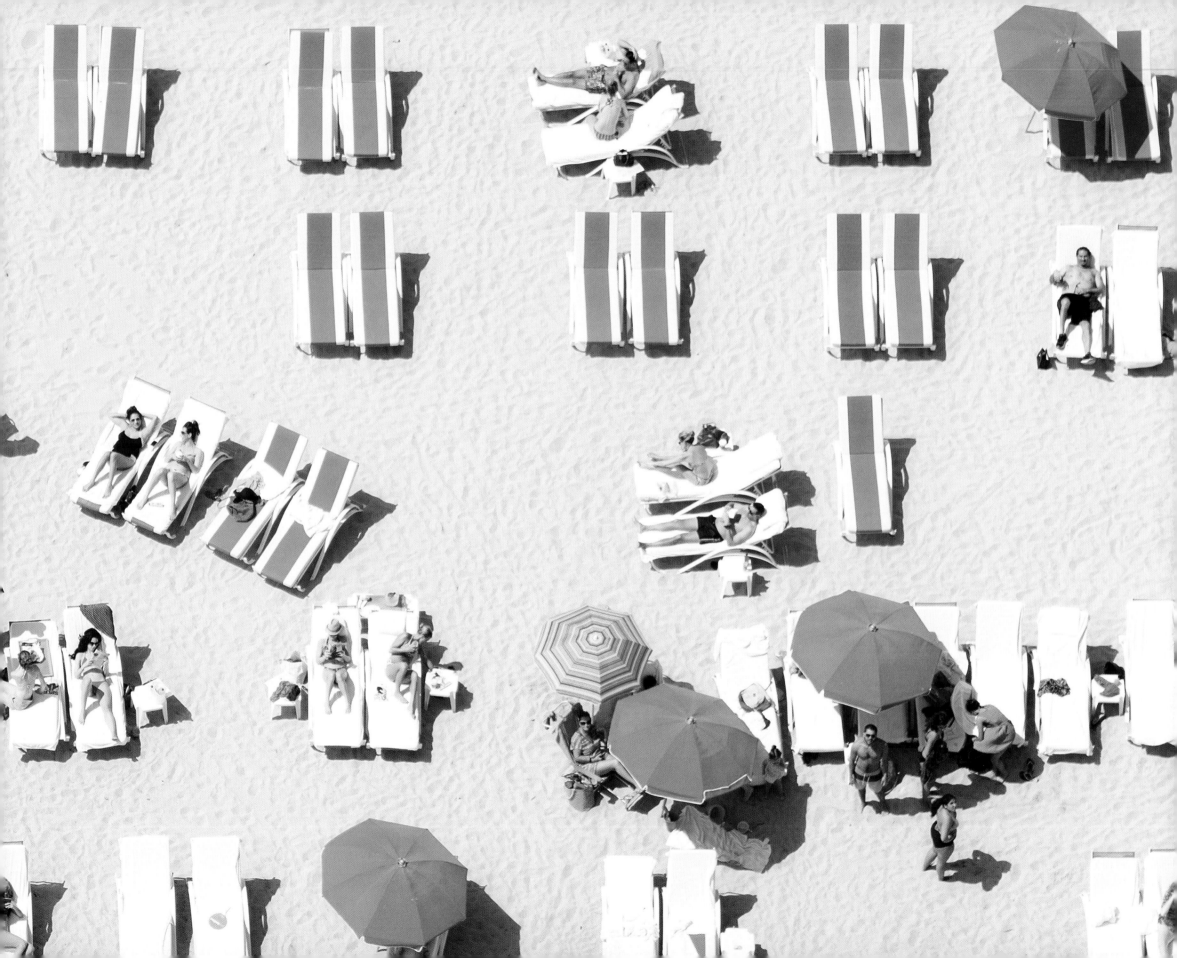

THE IDEA FOR THE AERIAL SERIES CAME TO ME
WHEN I WAS ON A HOTEL BALCONY LOOKING
DOWN ON THE BUSTLING POOL BELOW.
I DECIDED TO GO IN A HELICOPTER ABOVE
MIAMI, AND THAT'S WHERE I FIRST DISCOVERED
THE GEOMETRICAL BEAUTY OF BEACH
UMBRELLAS FROM ABOVE.

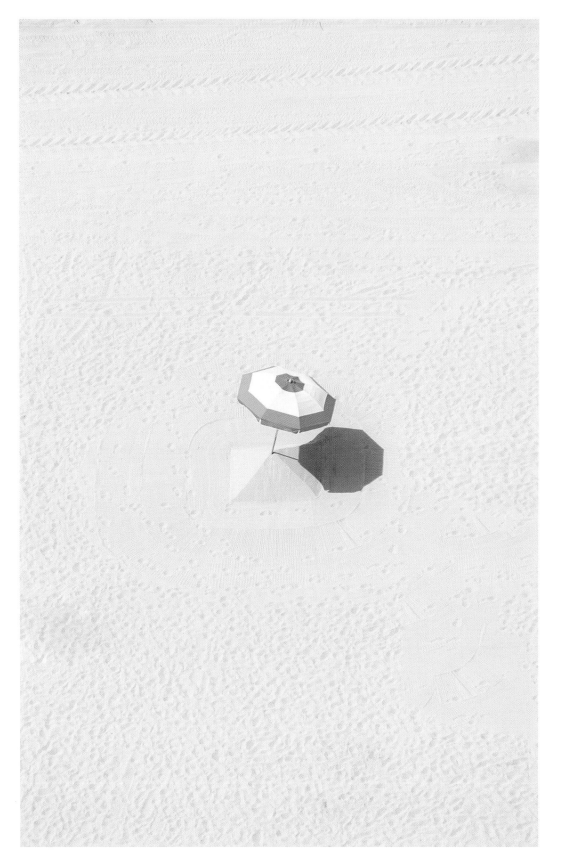

THE ORANGE UMBRELLA
Miami, USA

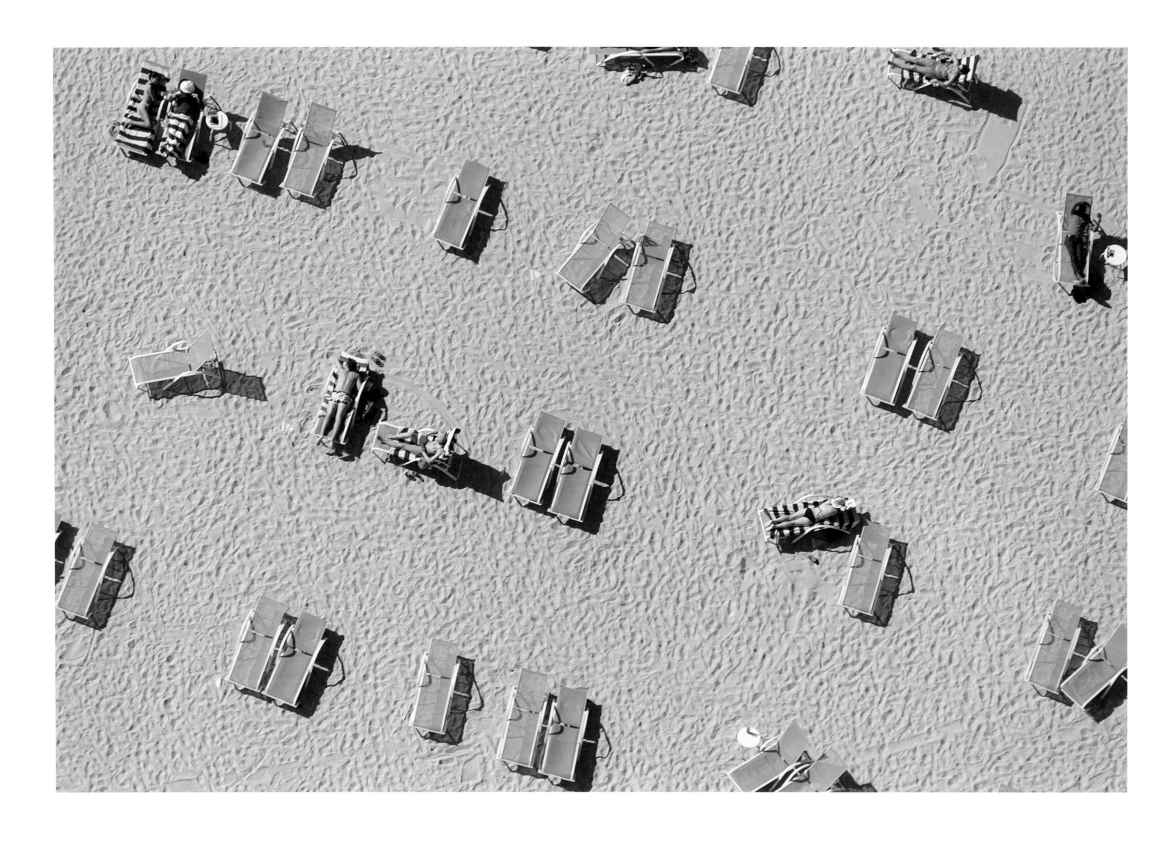

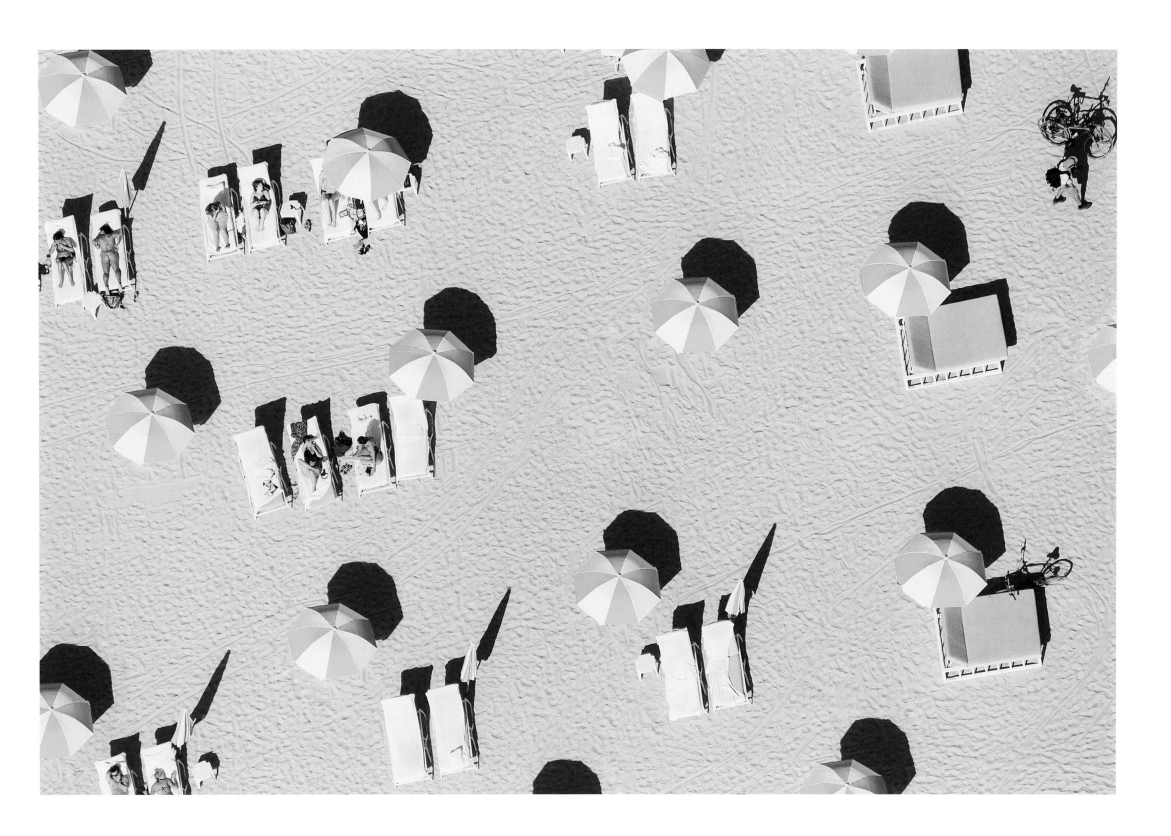

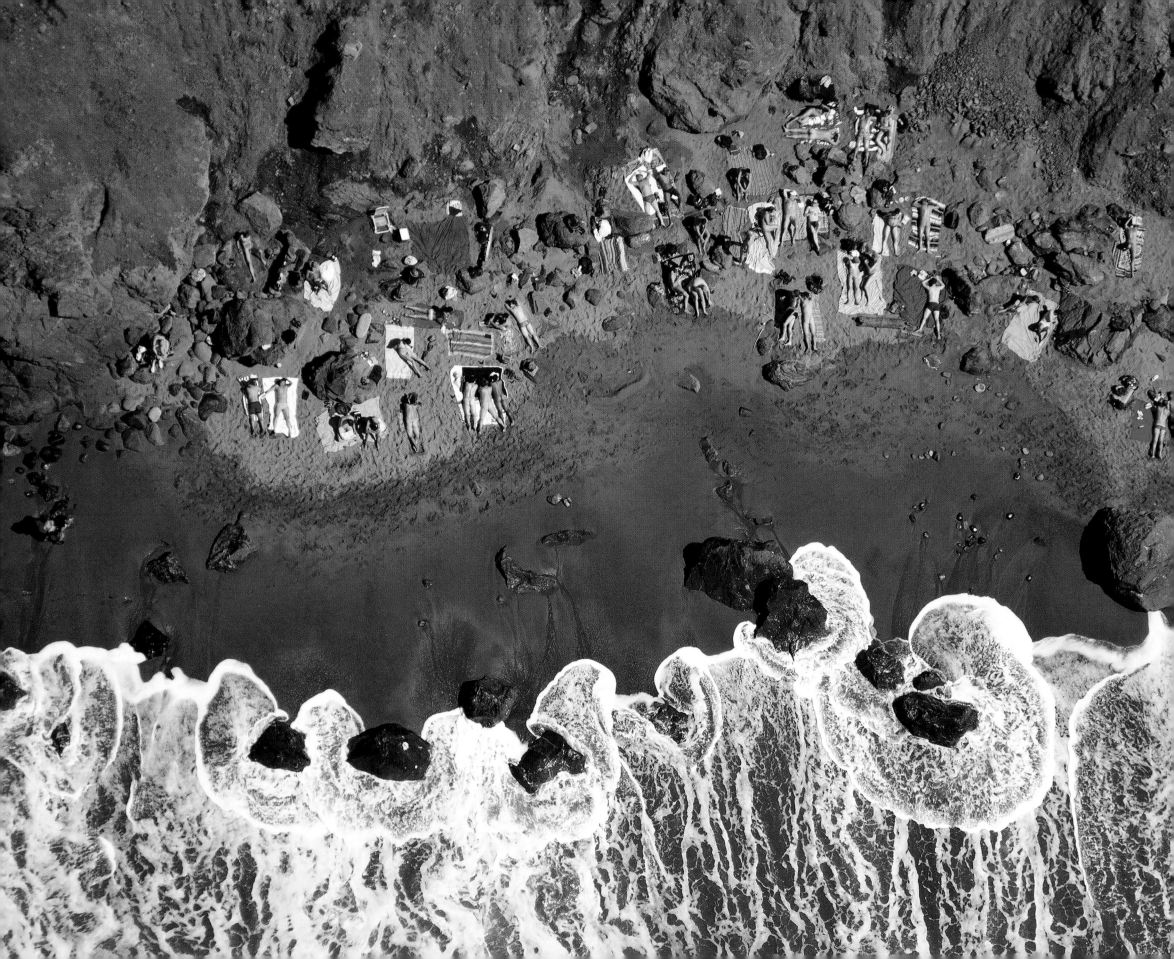

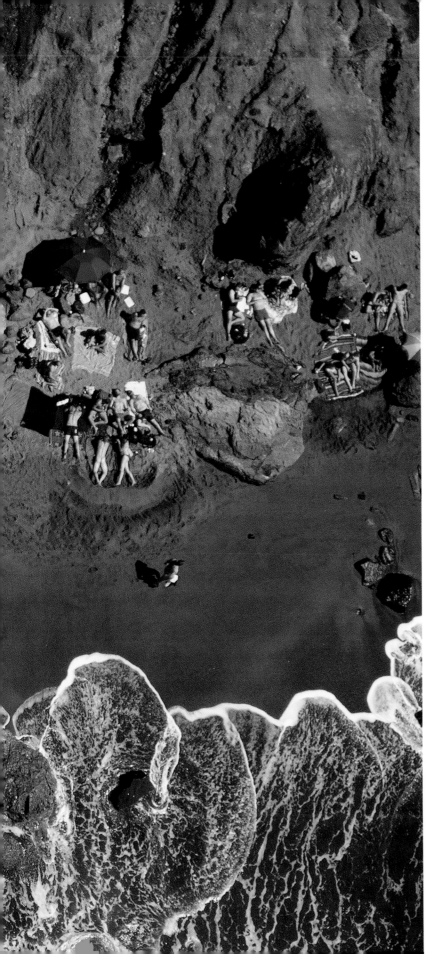

This Spread
NUDE BEACH, SAN FRANCISCO
San Francisco, USA

Previous Spread (left)
TEAL CHAIRS
Miami, USA

Previous Spread (right)
MIAMI PINK UMBRELLAS
Miami, USA

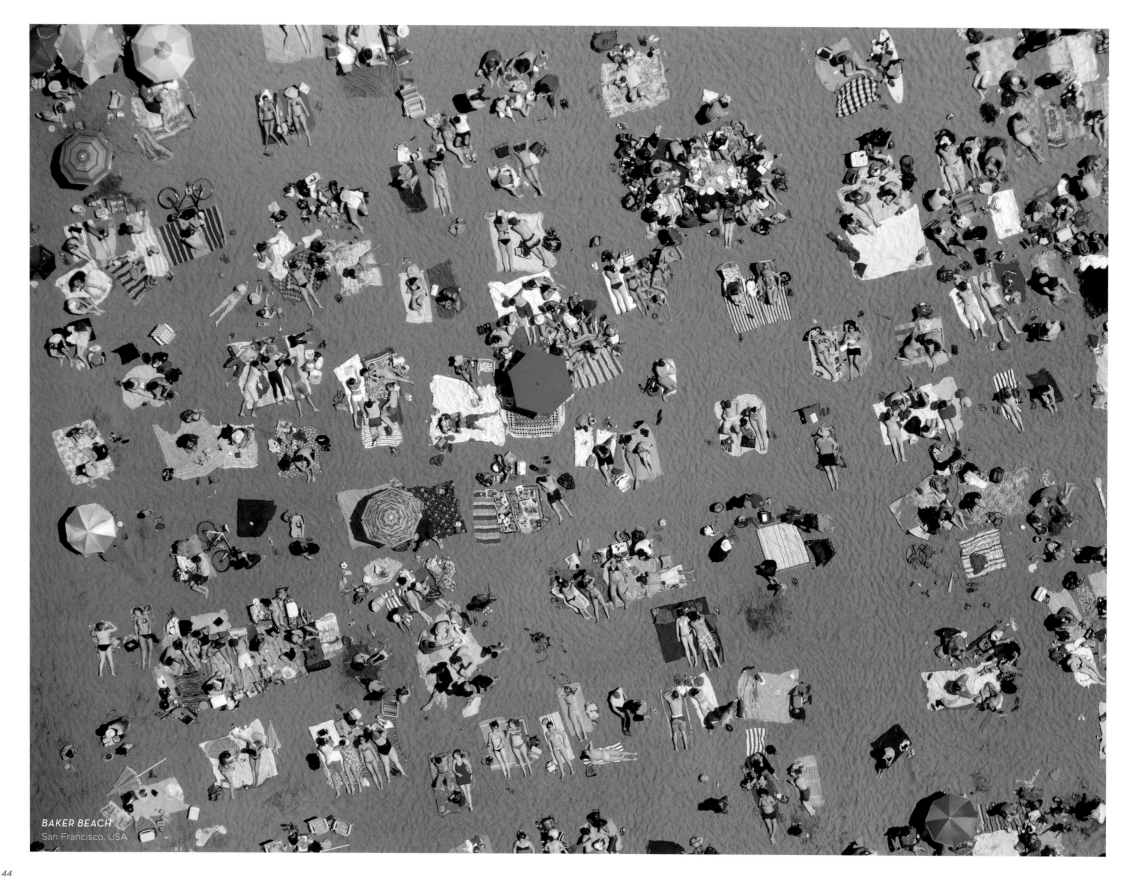

BAKER BEACH
San Francisco, USA

44

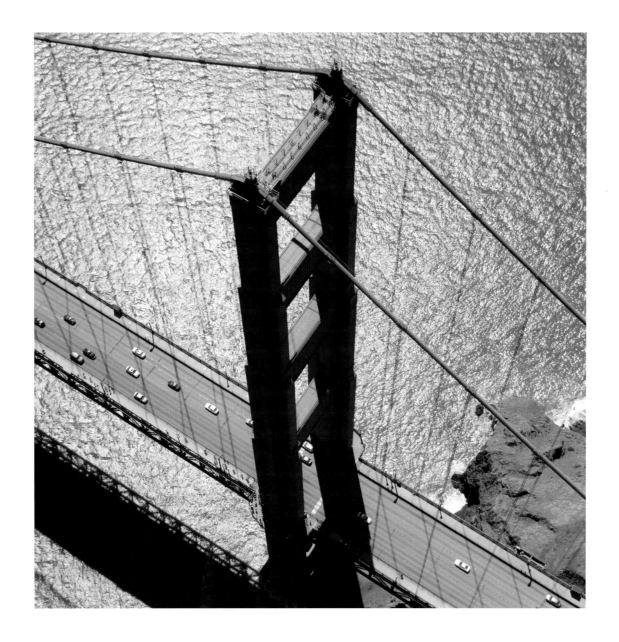

I'll never forget my shoot over SAN FRANCISCO.

The weather was perfect and the beaches were packed.

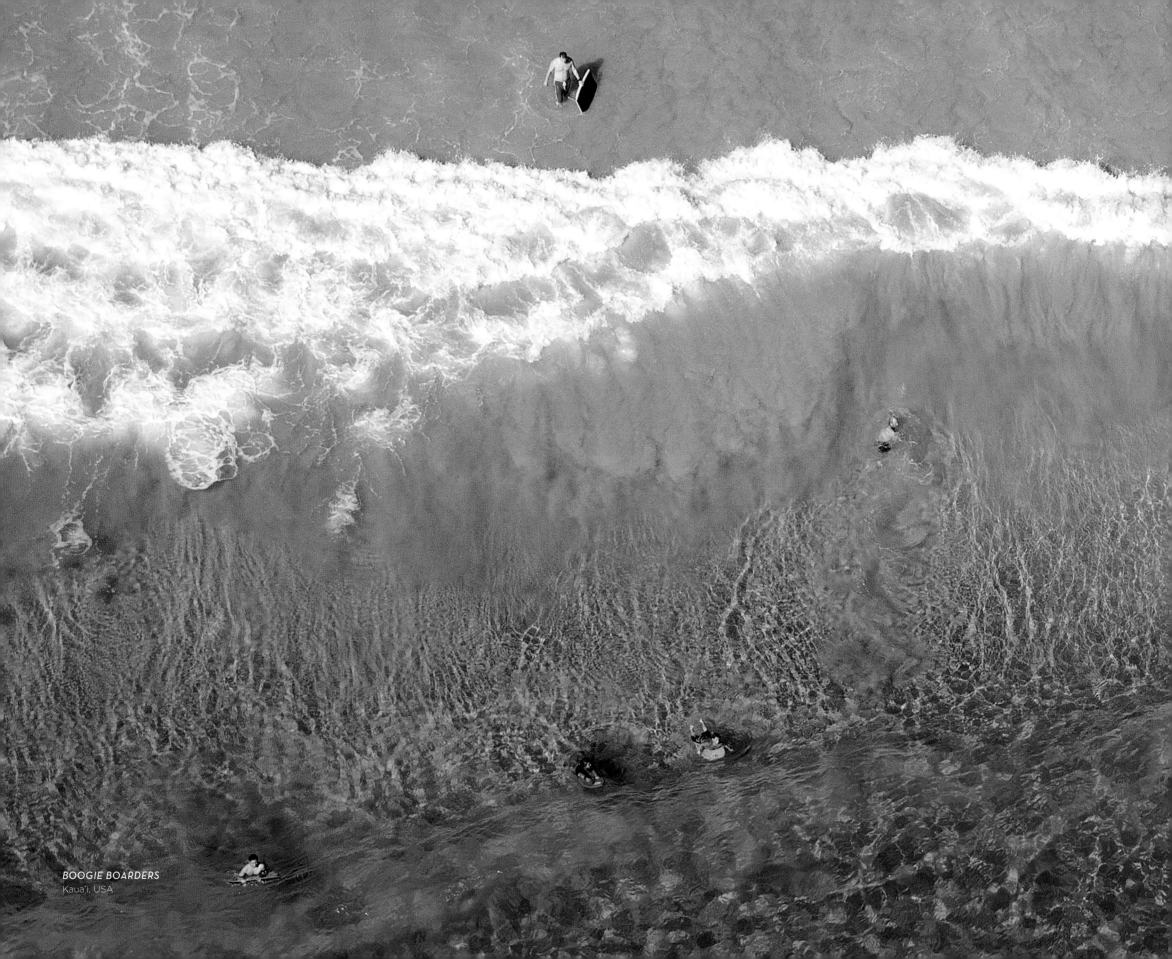

BOOGIE BOARDERS
Kaua'i, USA

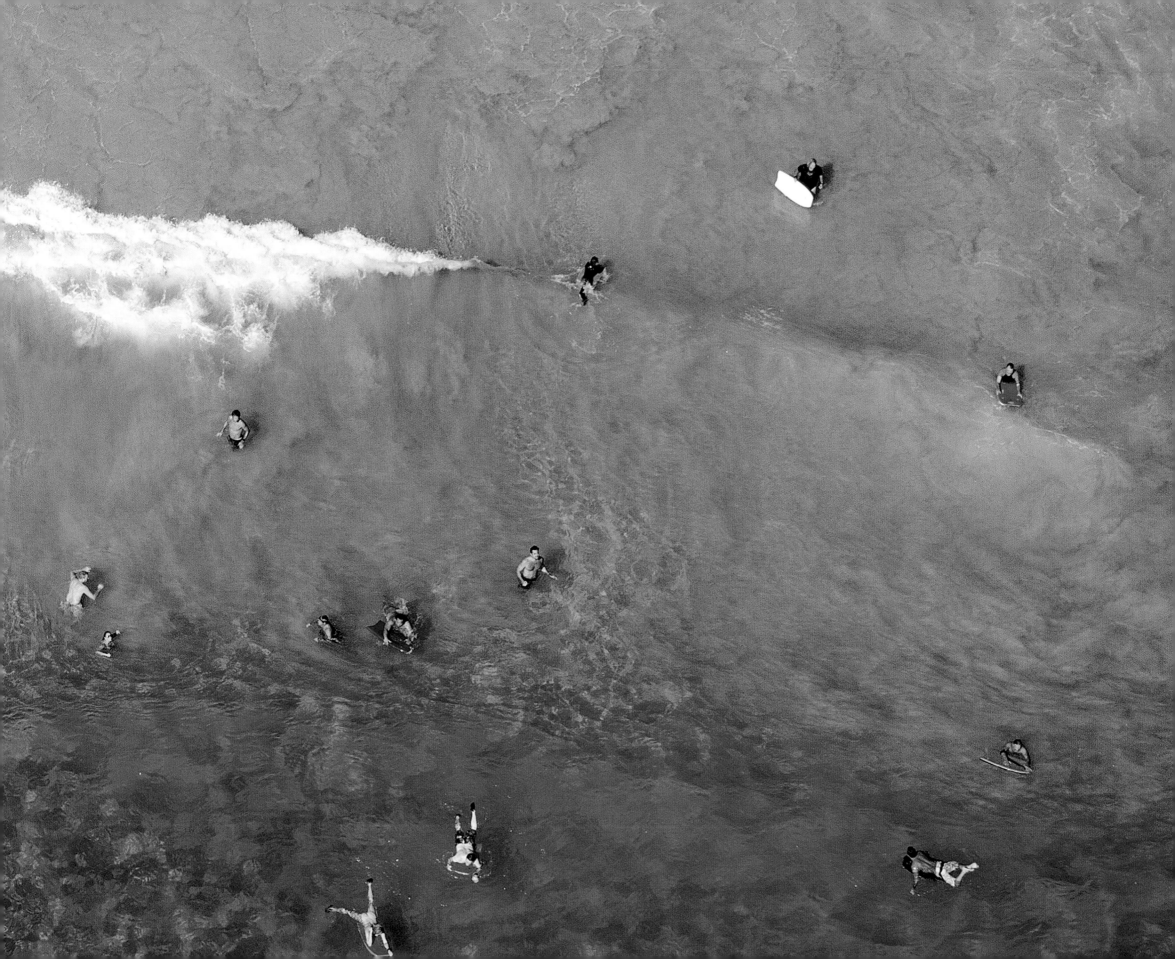

Favorites from

KAUA'I

WHERE TO EAT
SushiGirl Kaua'i

This place has a limited yet interesting menu.
You order at the counter and grab
a spot outside to eat. Then for dessert,
pop into the little general store next door
for an ice cream.

BEST ADVENTURE
Nā Pali Coast

The Nā Pali Coast is truly the picturesque
vision of what you imagined Kaua'i to be.
Take the trip via air or by boat and you'll get
a front-row seat to beautiful private beaches,
high cliffs, and the unbelievable natural
beauty of this island.

BEST PLACE TO WATCH A SUNSET
Po'ipū Beach

Pick up some fresh poke and other
snacks along with a cold bottle of wine, then
set up an evening picnic at Po'ipū Beach.
For the next hour, all you will need to
do is relax and enjoy the show.

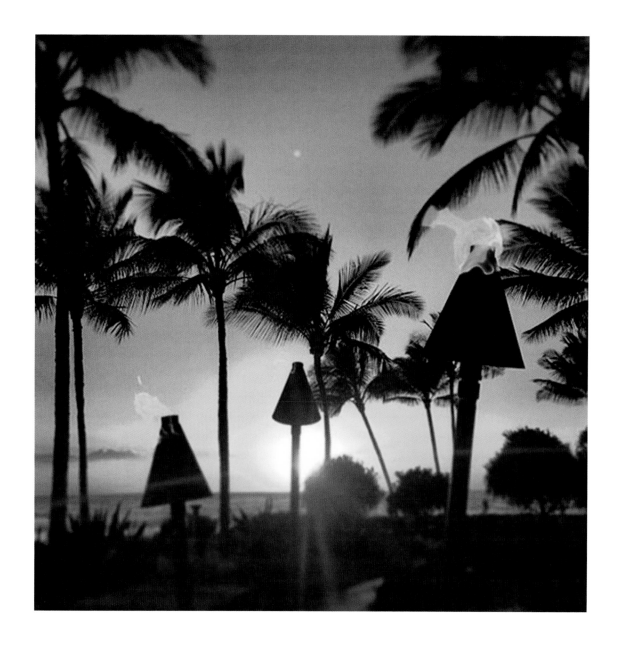

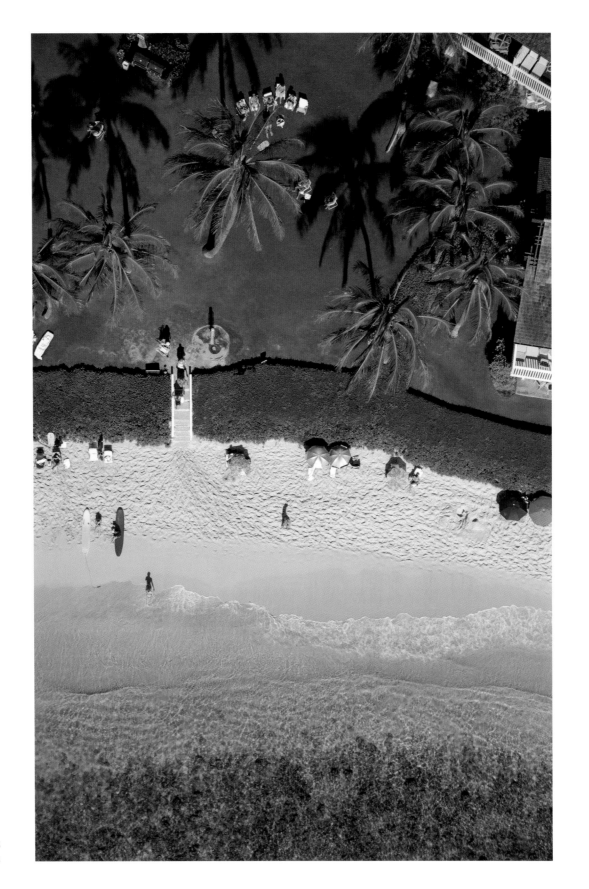

BEACH WITH GRASS
Kaua'i, USA

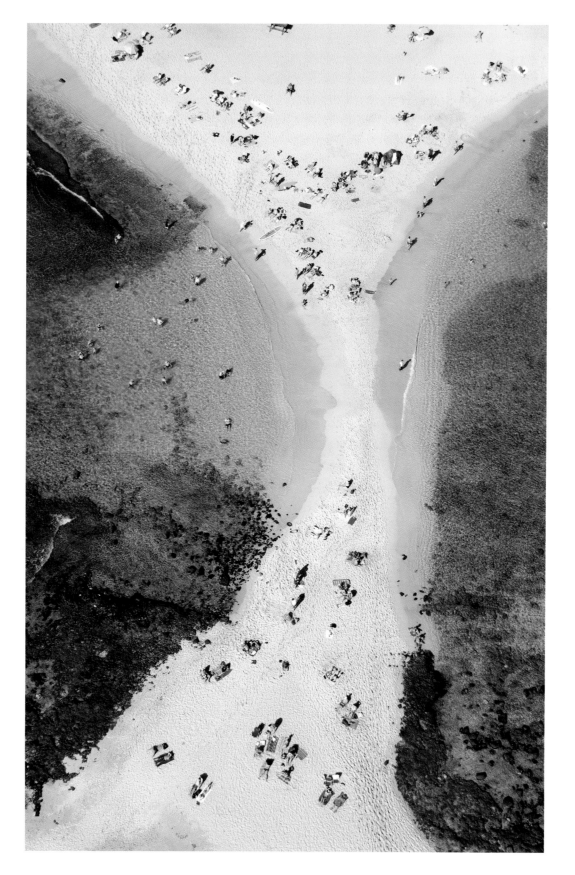

PO'IPŪ BEACH
Kaua'i, USA

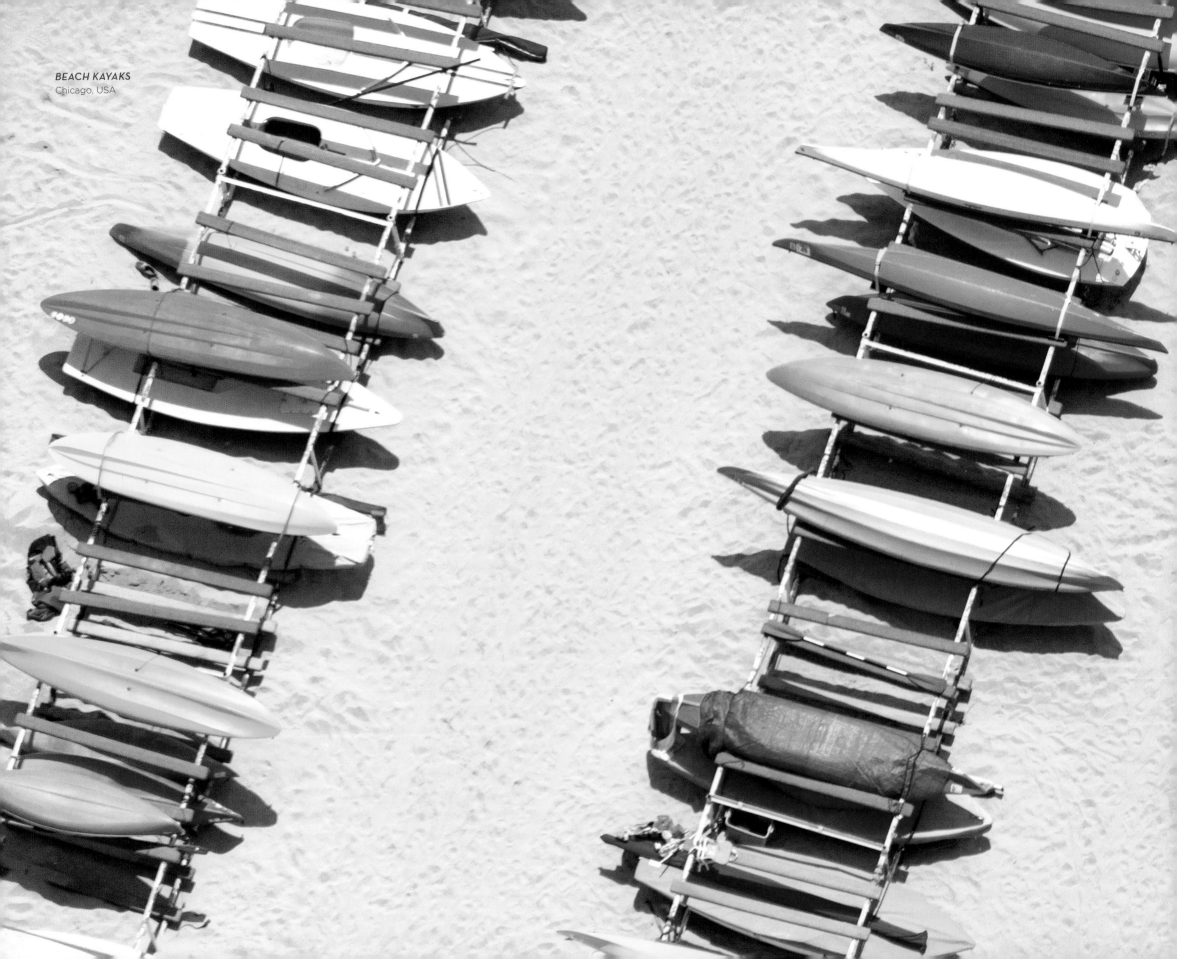

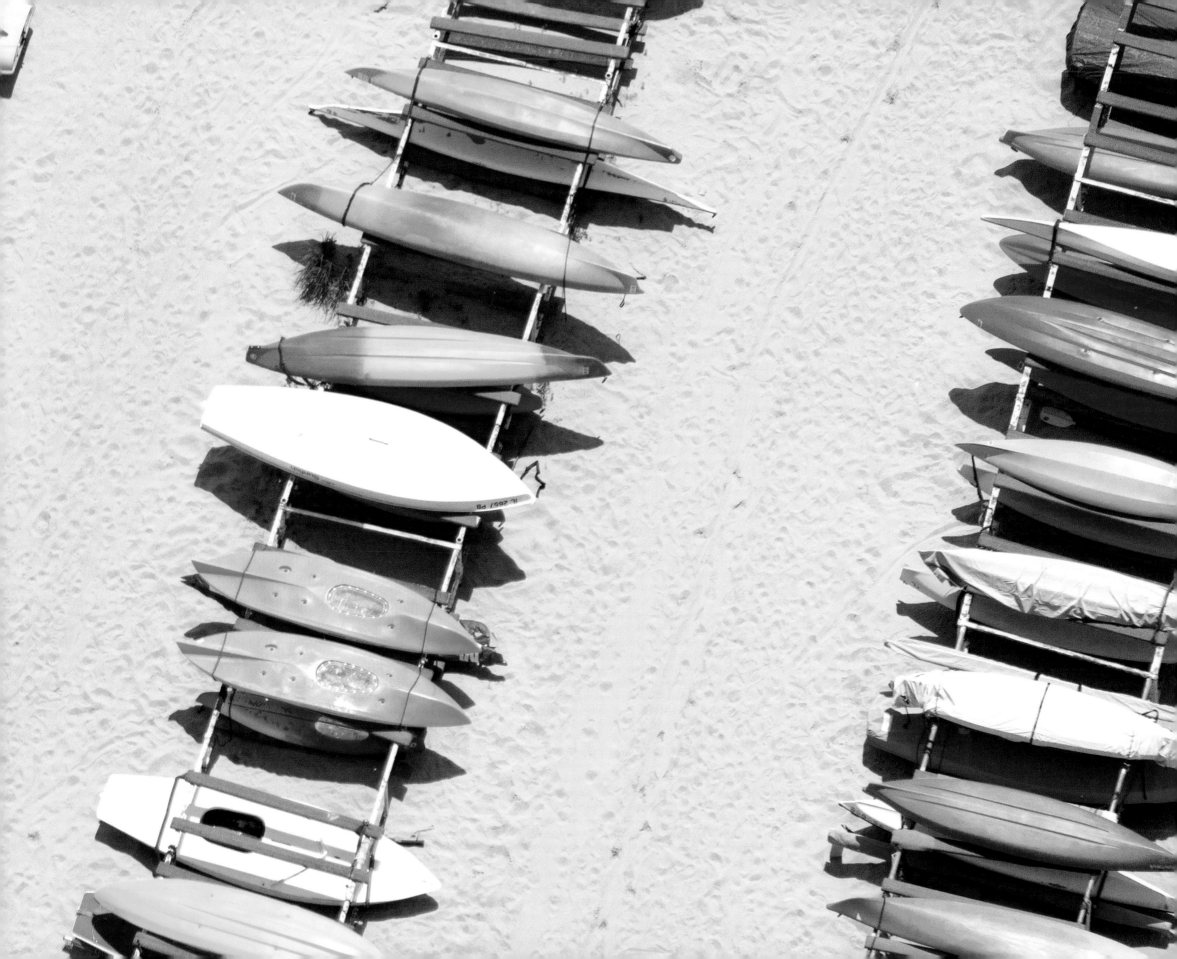

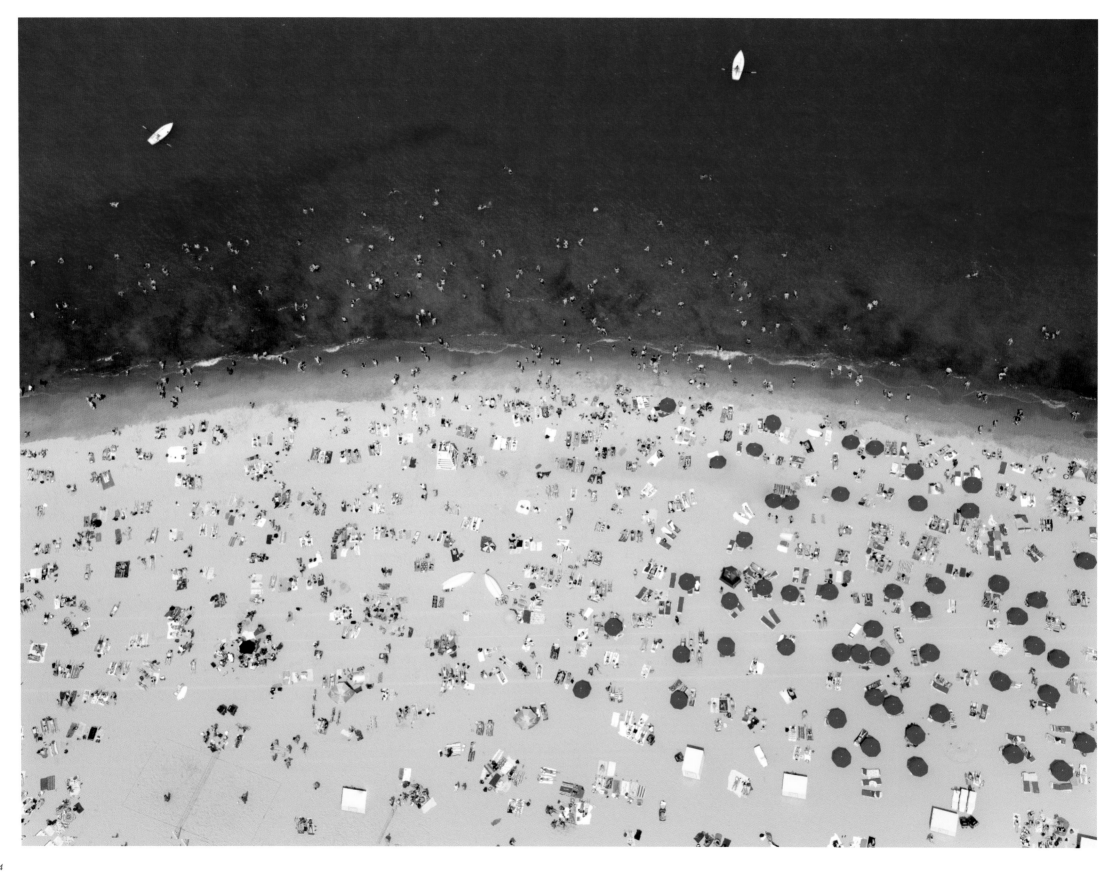

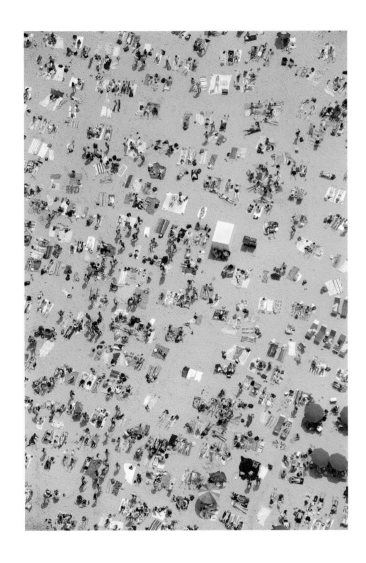

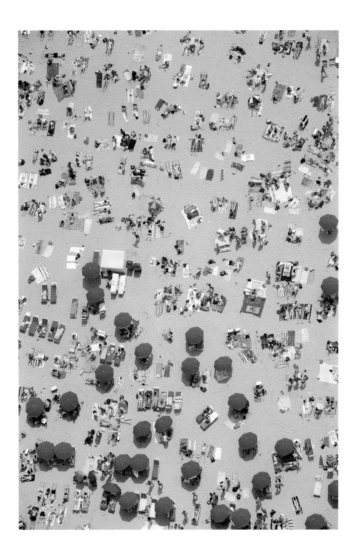

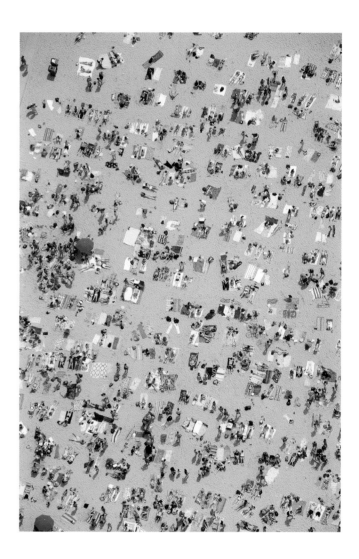

This Page
OAK STREET BEACH TRIPTYCH
Chicago, USA

Opposite Page
OAK STREET BEACH HORIZONTAL
Chicago, USA

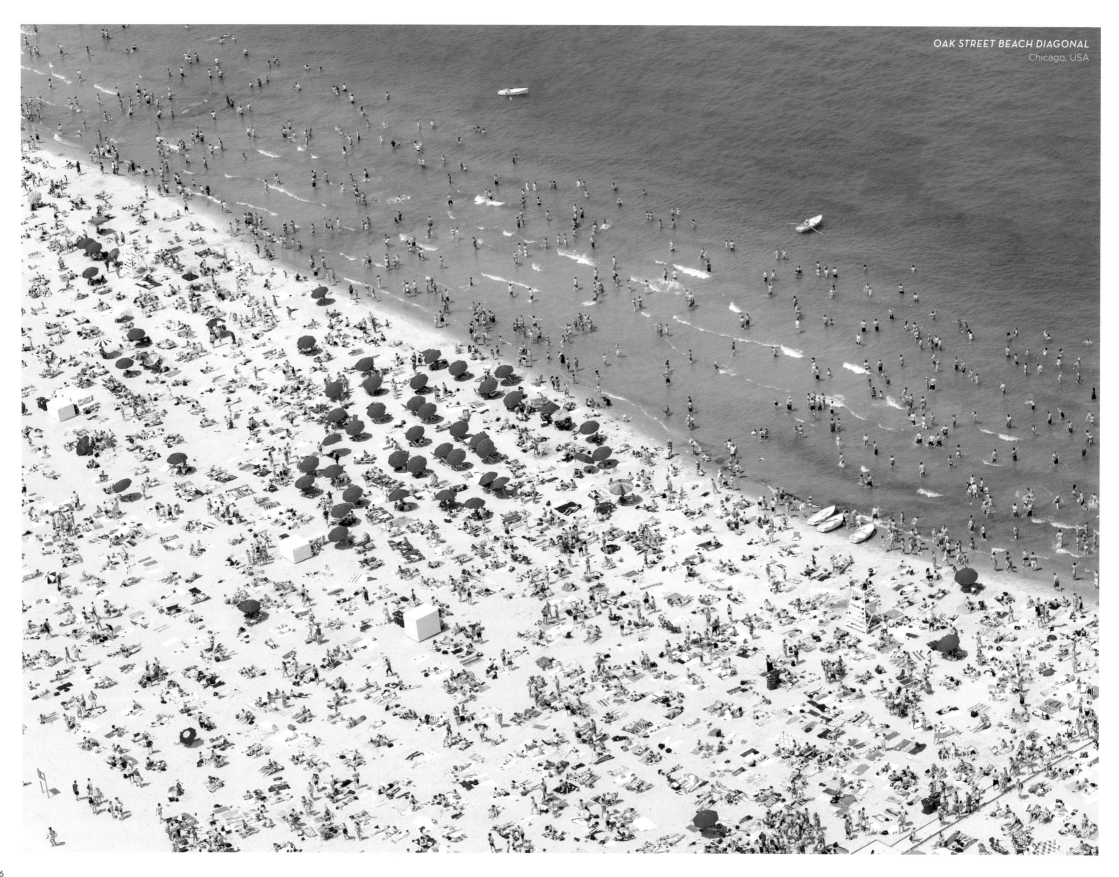

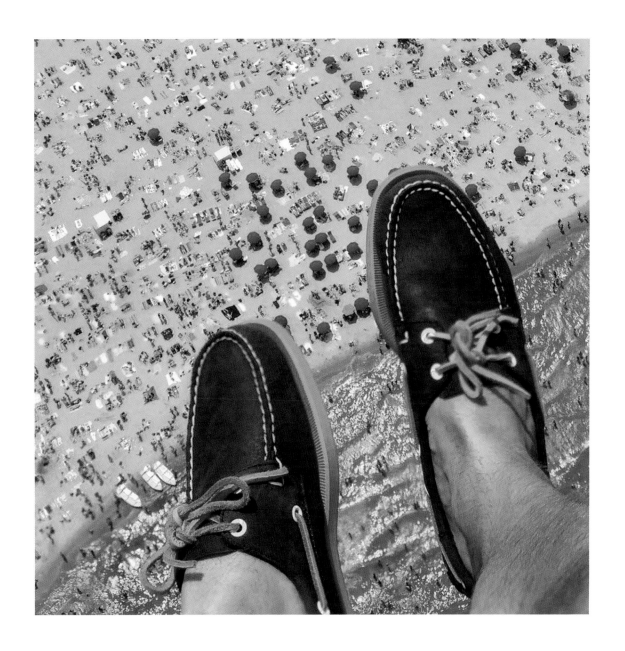

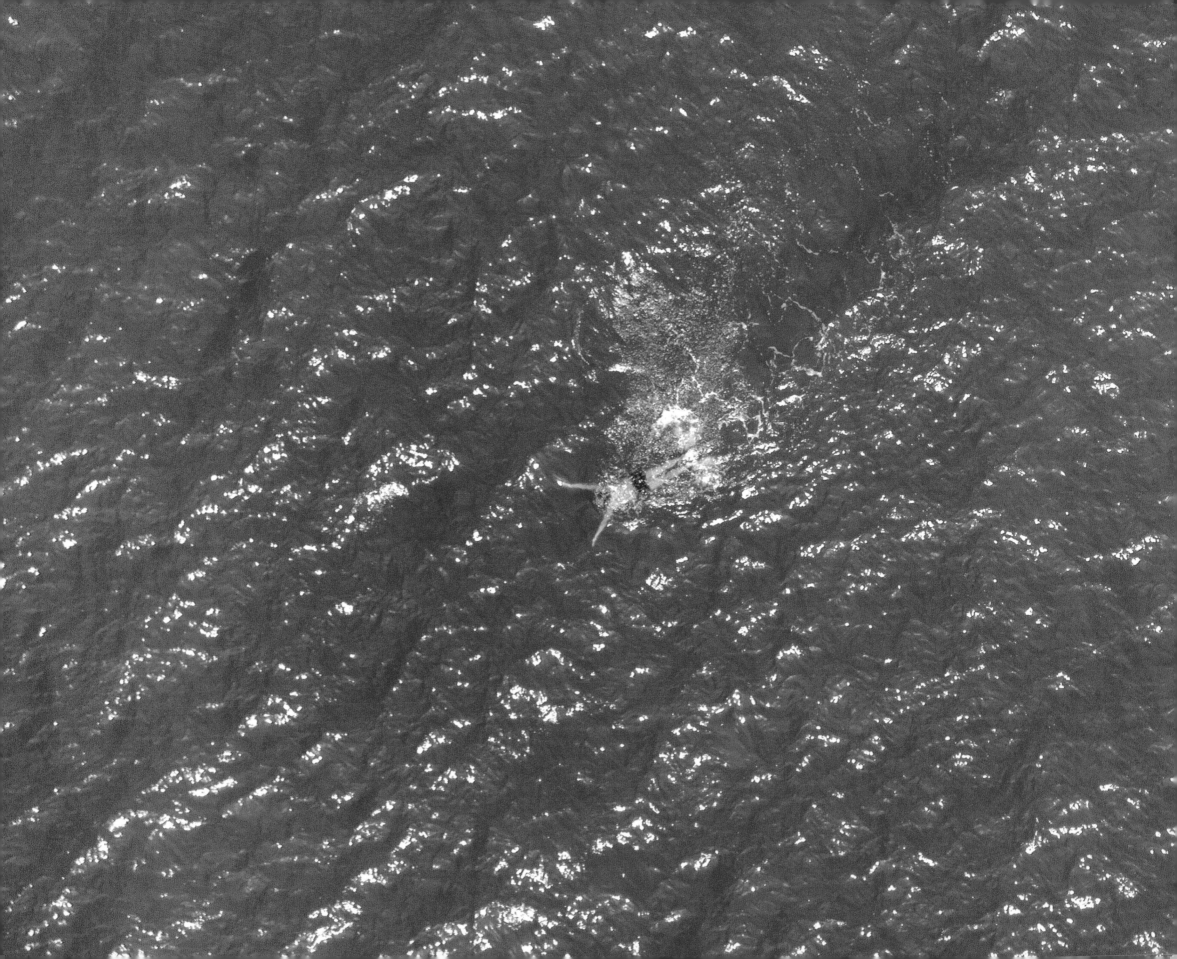

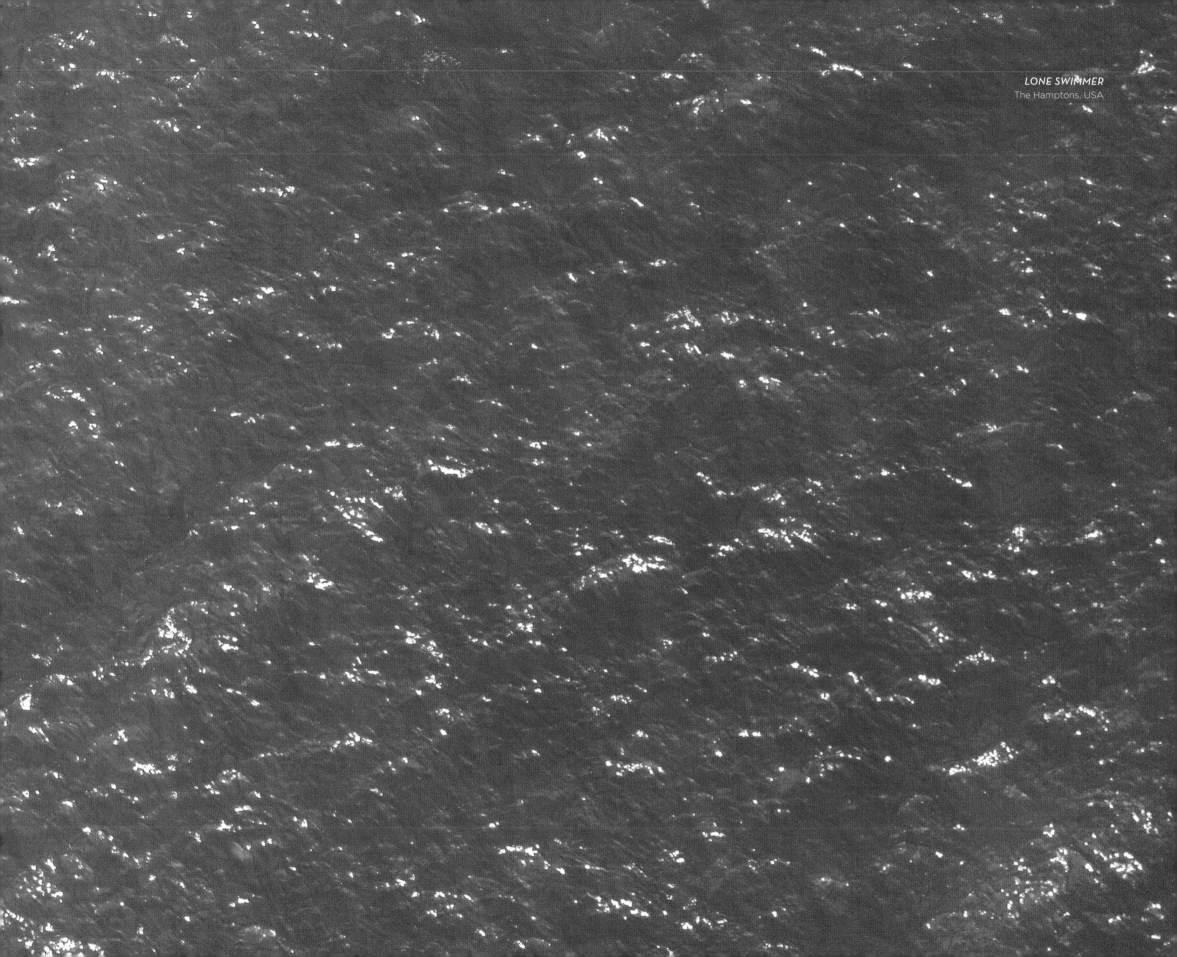

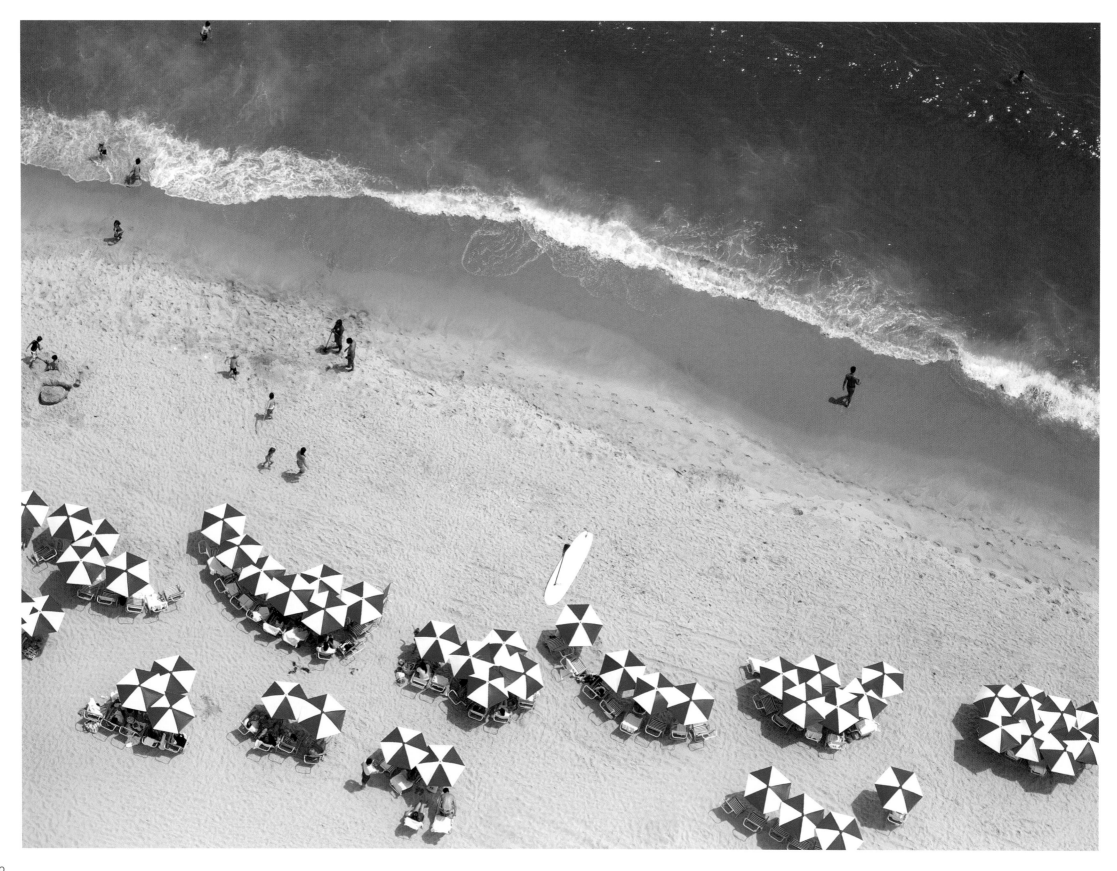

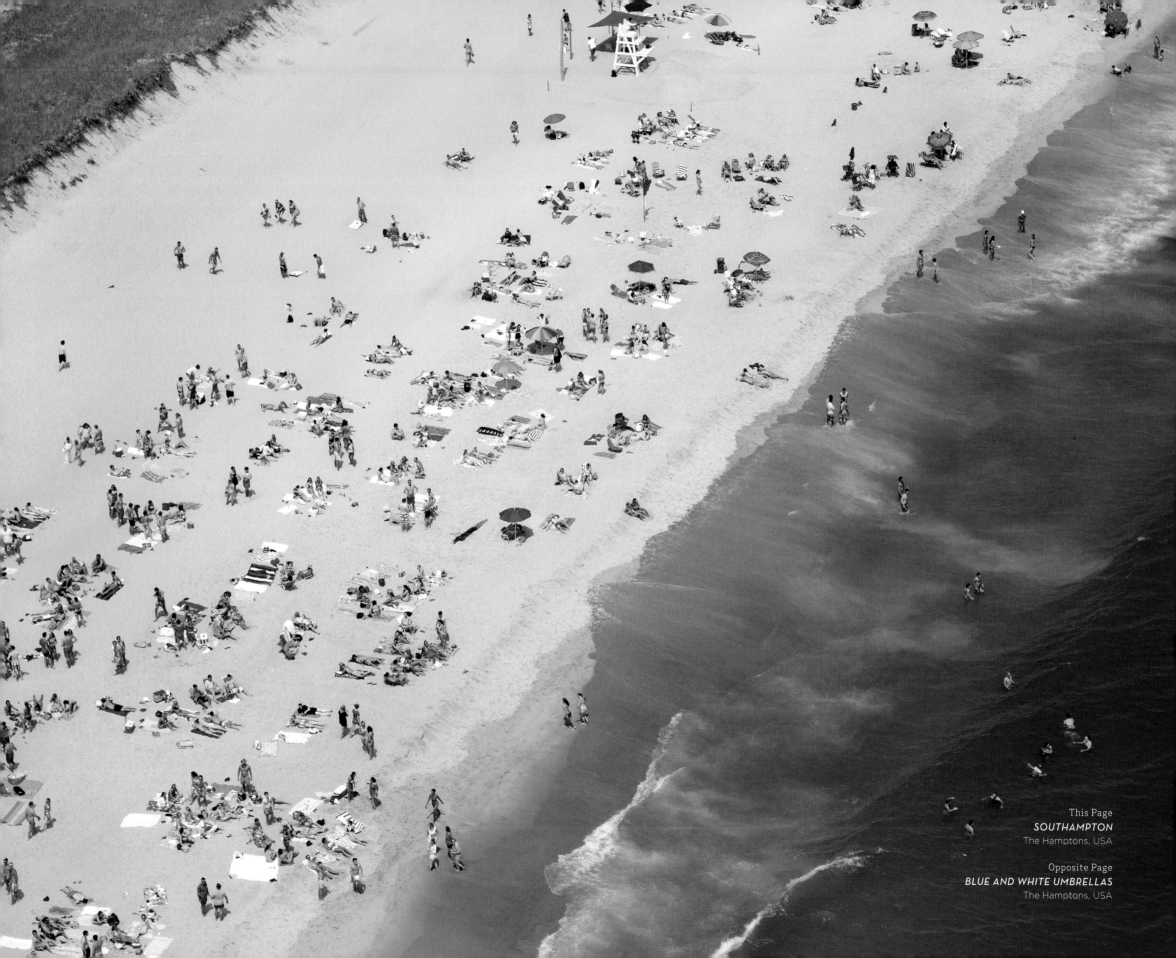

This Page
SOUTHAMPTON
The Hamptons, USA

Opposite Page
BLUE AND WHITE UMBRELLAS
The Hamptons, USA

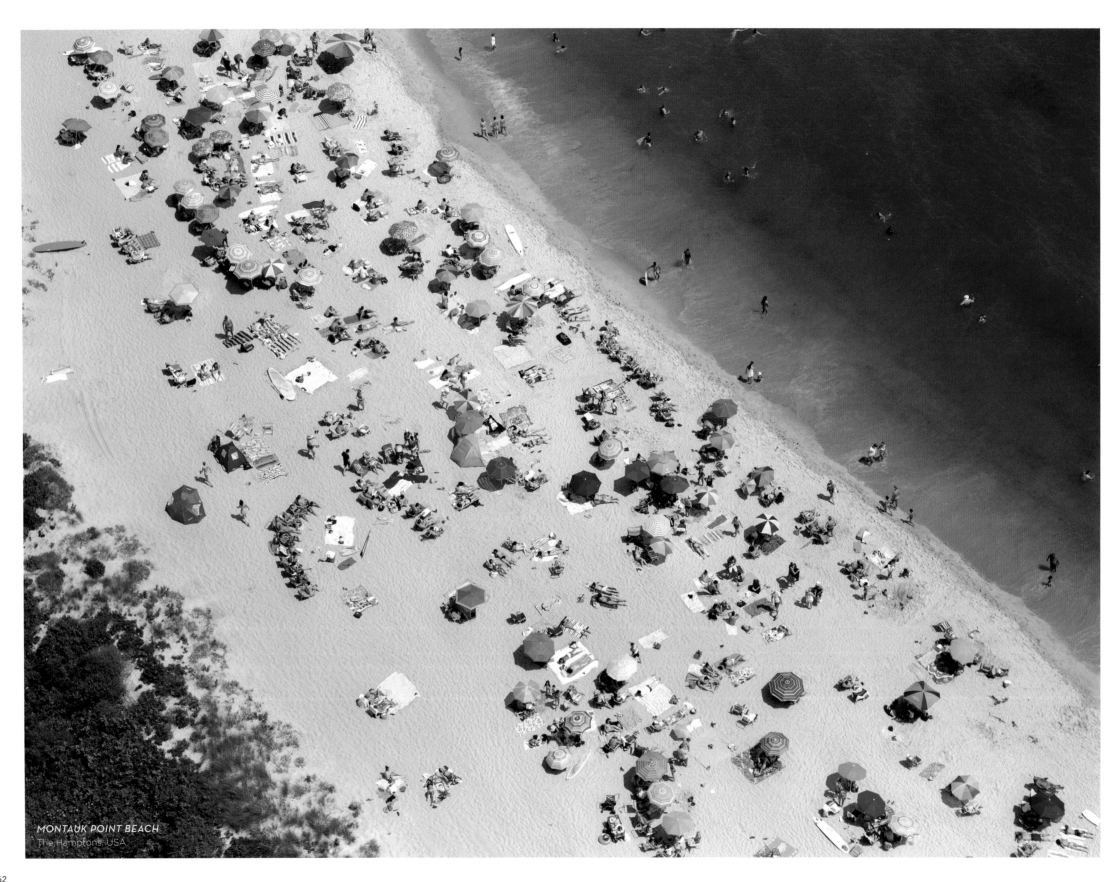

MONTAUK POINT BEACH
The Hamptons, USA

After the beach I love to take a stroll down *MAIN STREET* in Southampton.

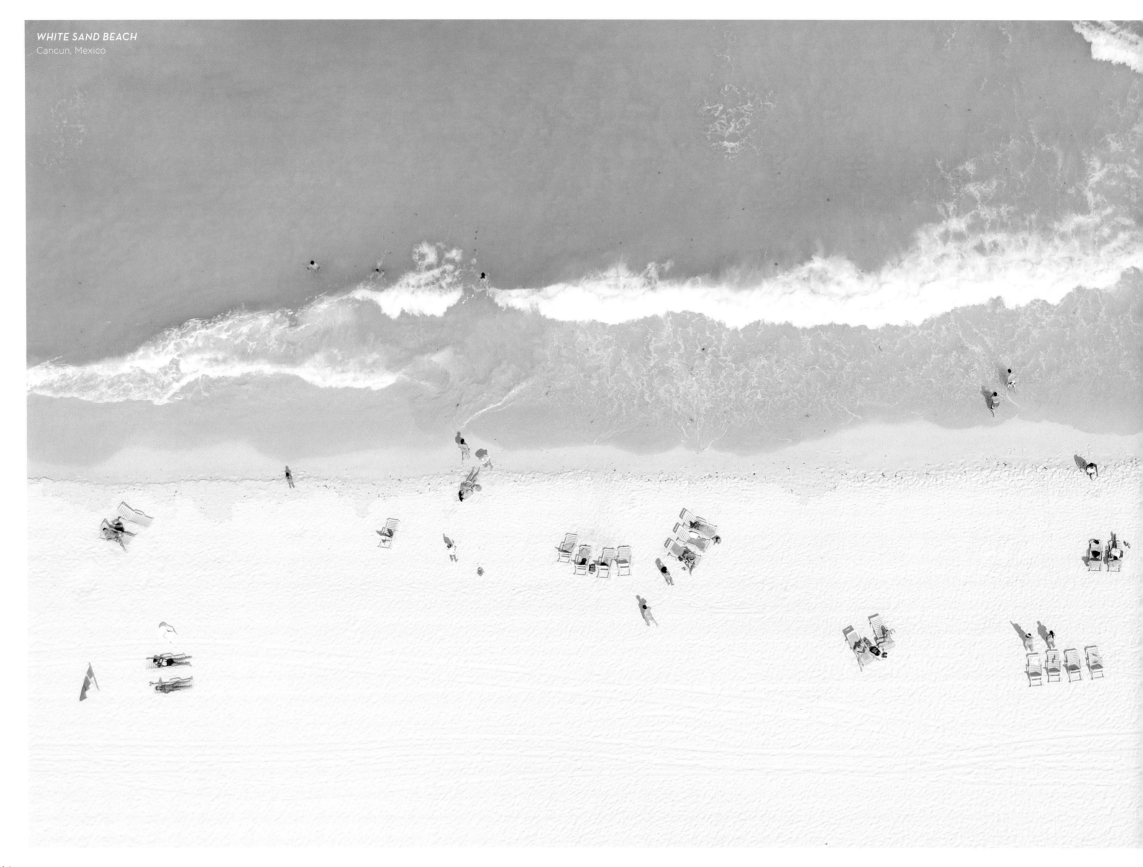

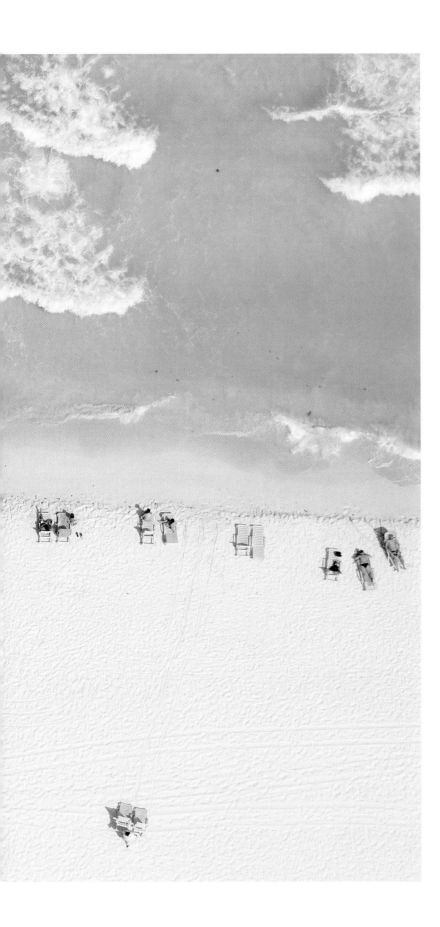

MEXICO never disappoints

with its crystal *BLUE WATER* and warm white sands...

it's a vacation DREAMLAND.

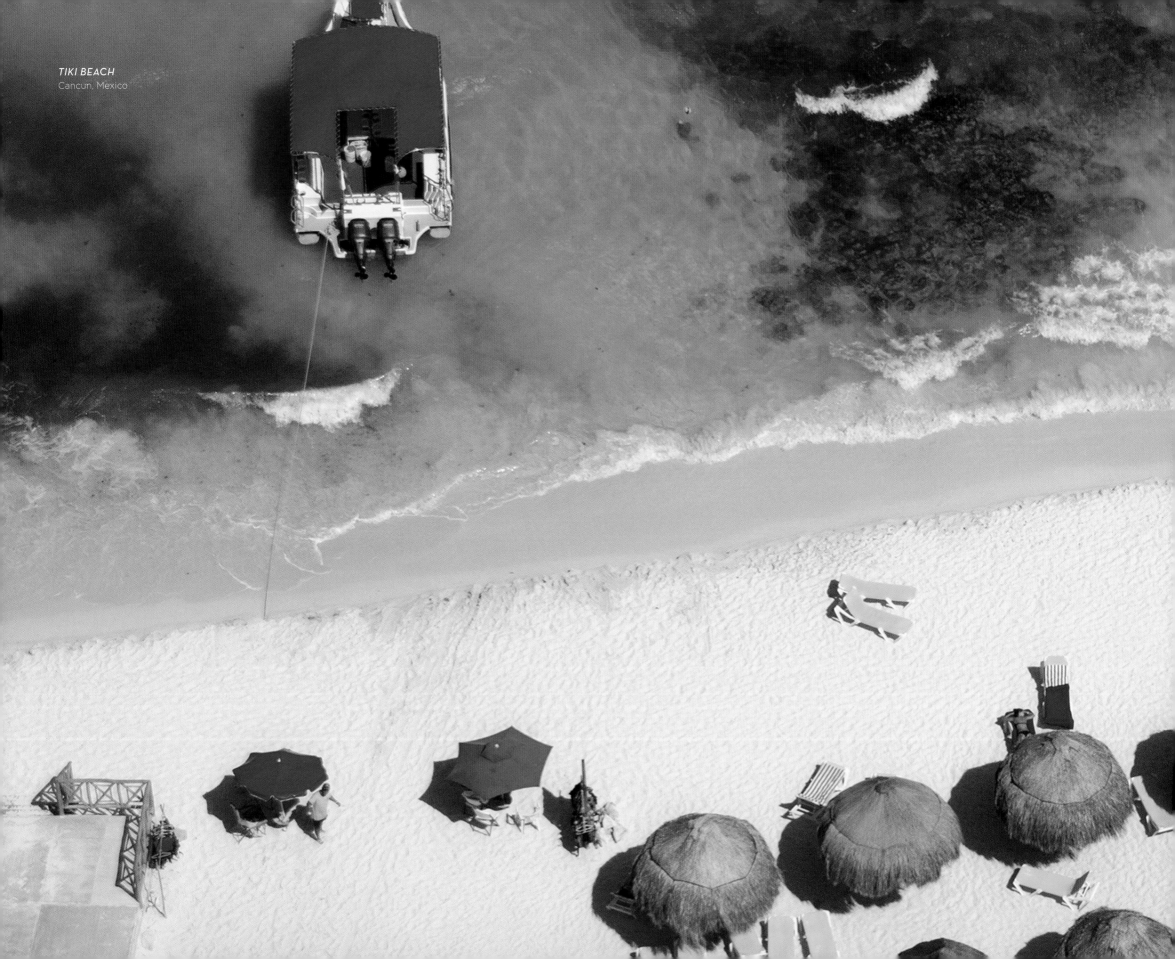

TIKI BEACH
Cancun, Mexico

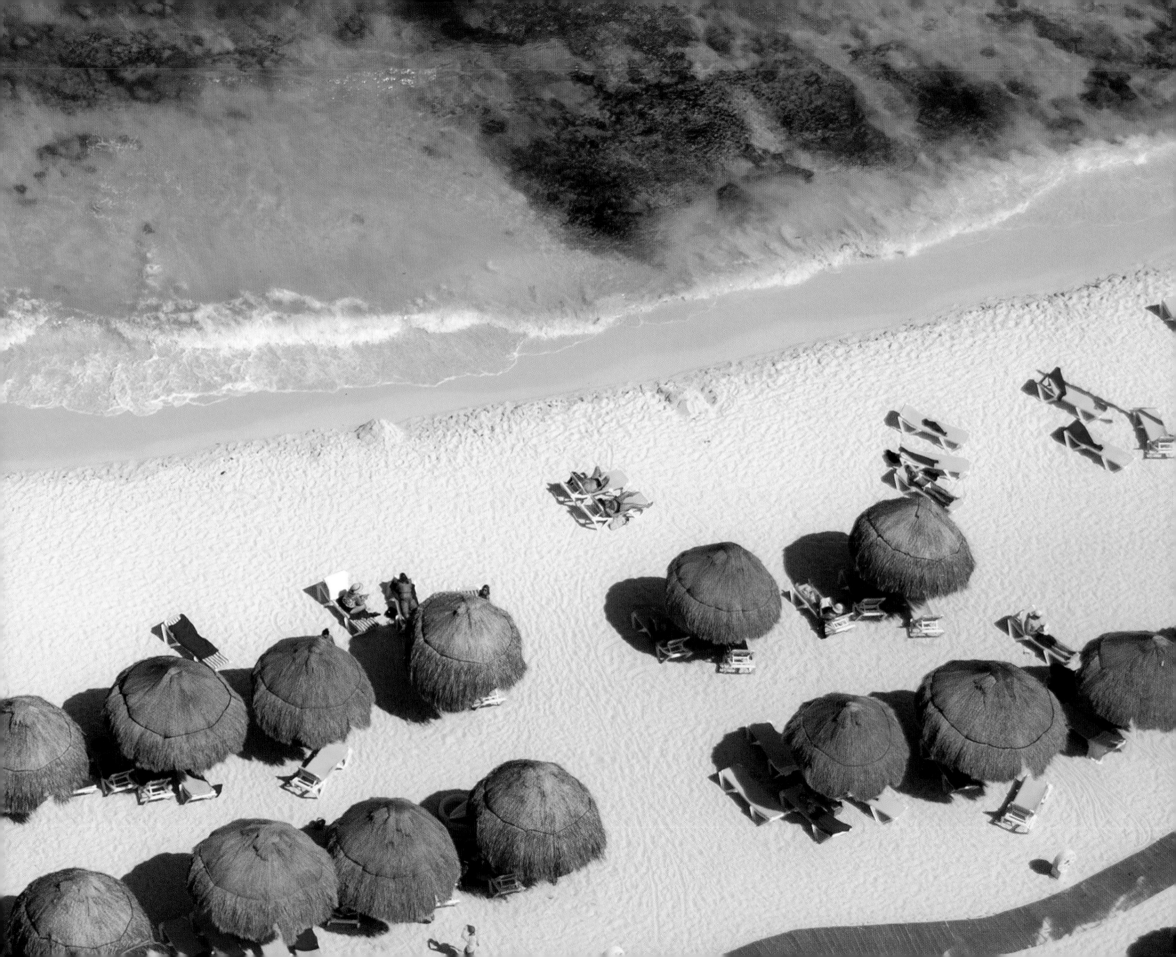

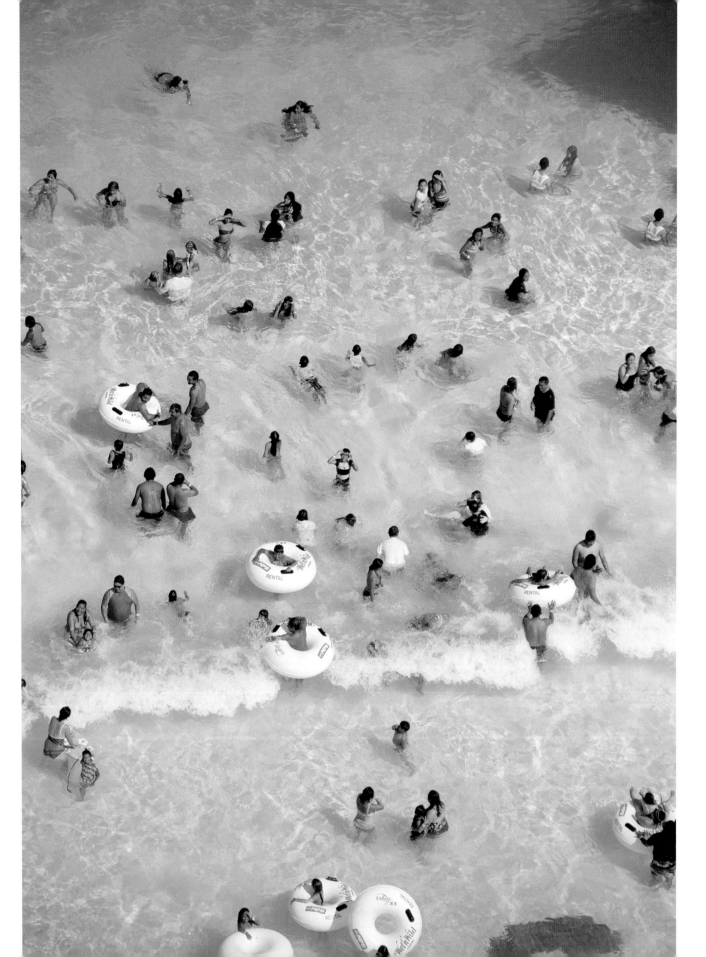
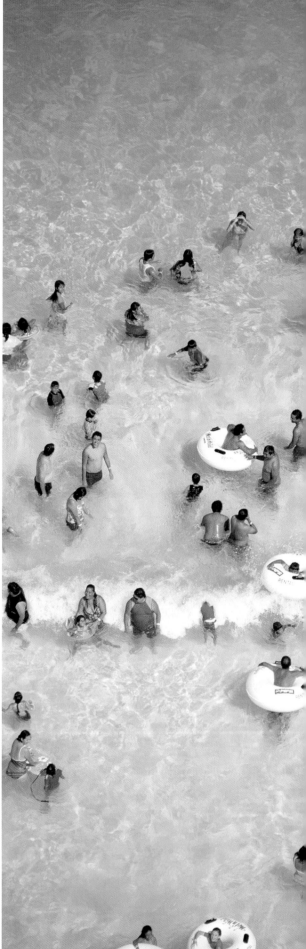

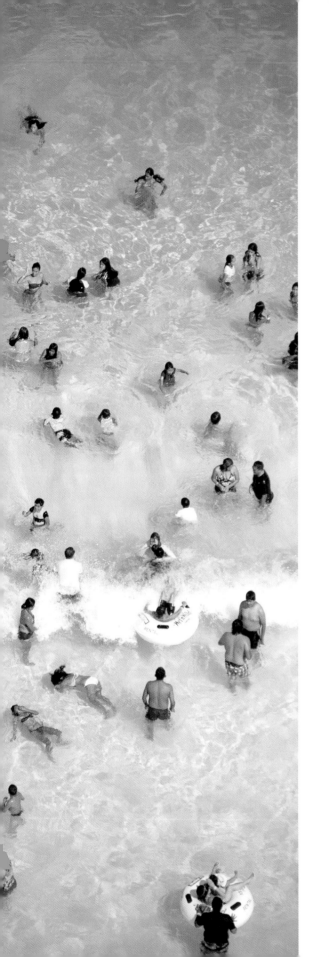
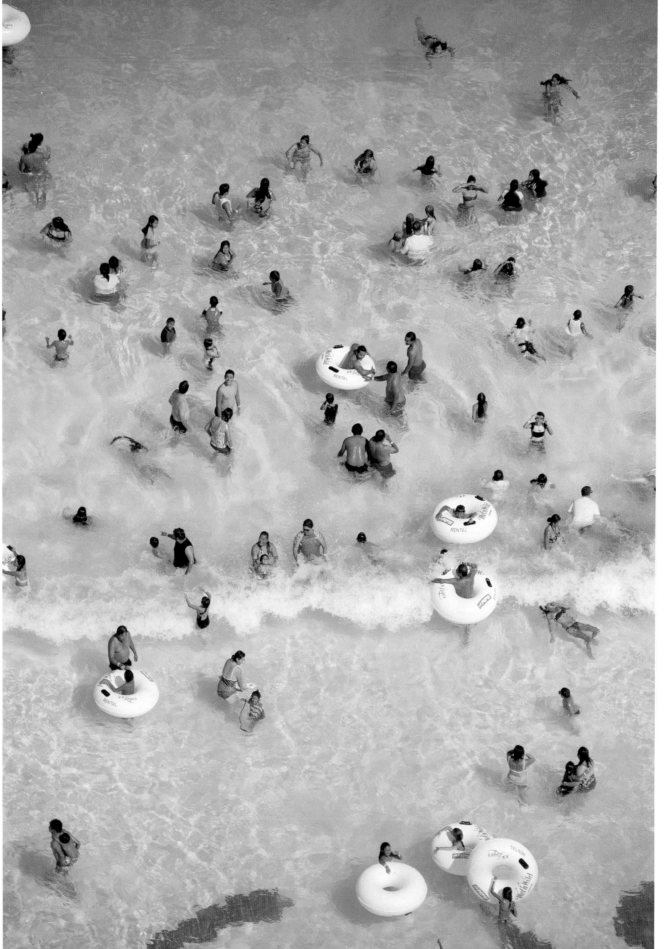

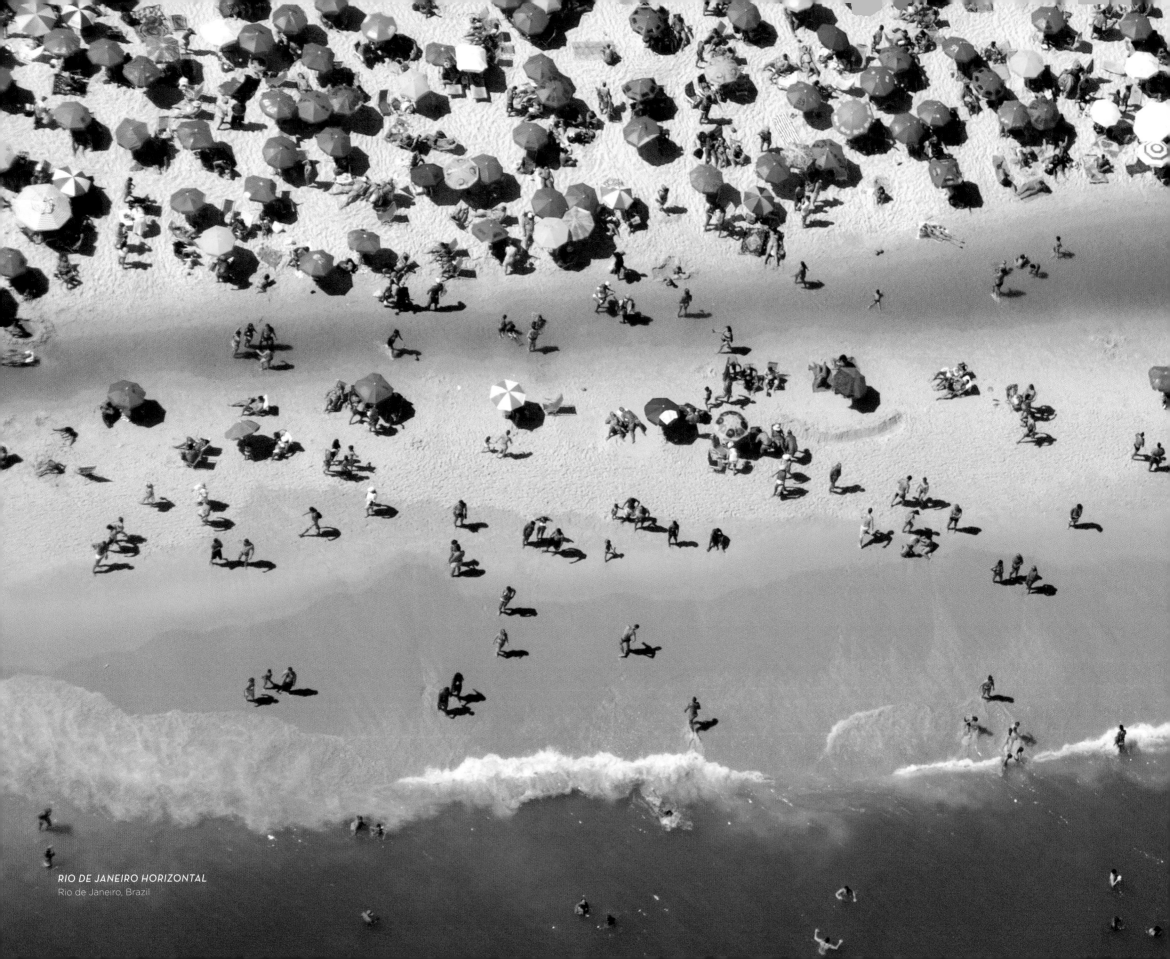

RIO DE JANEIRO HORIZONTAL
Rio de Janeiro, Brazil

SOUTH AMERICA

RIO DE JANEIRO HAS A BEACH CULTURE UNLIKE ANY CITY I HAVE EVER VISITED. LOCALS SPEND SUNRISE TO SUNSET THRIVING UNDER THE SUN. IT'S PART OF THEIR IDENTITY - *IT'S A WAY OF LIFE.*

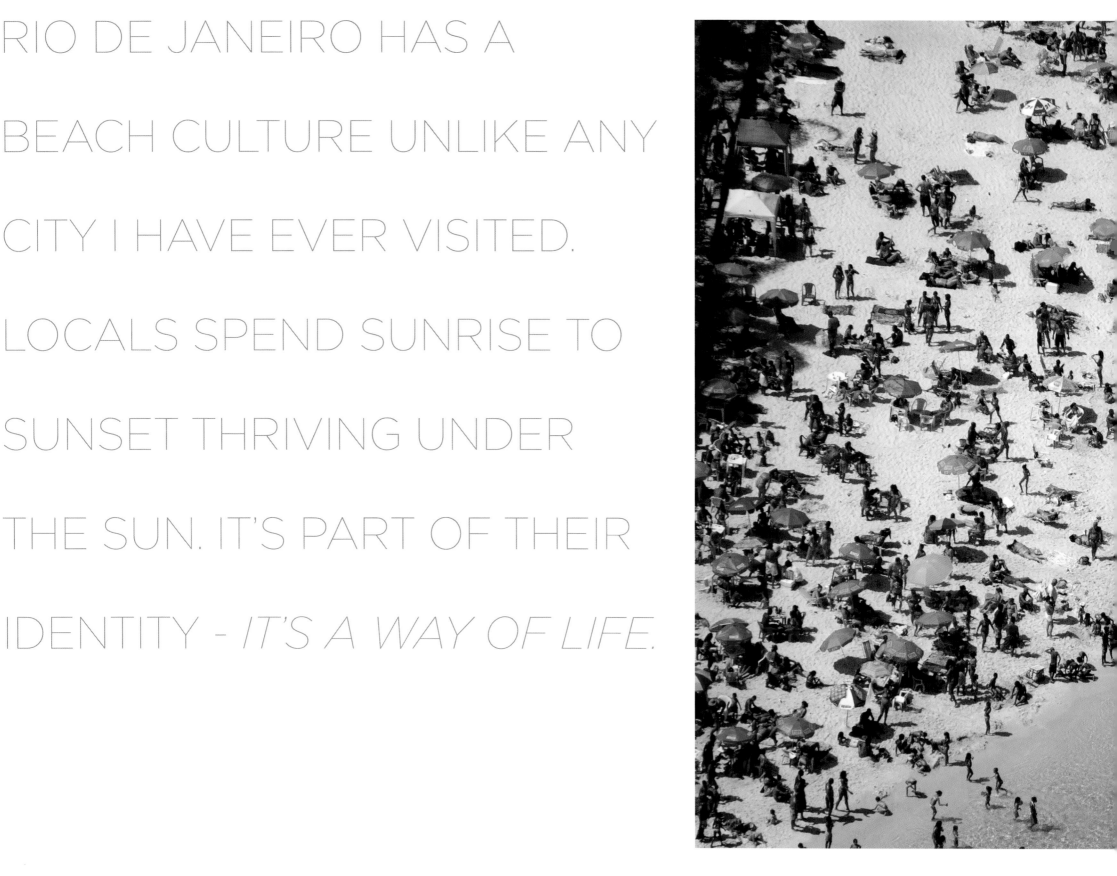

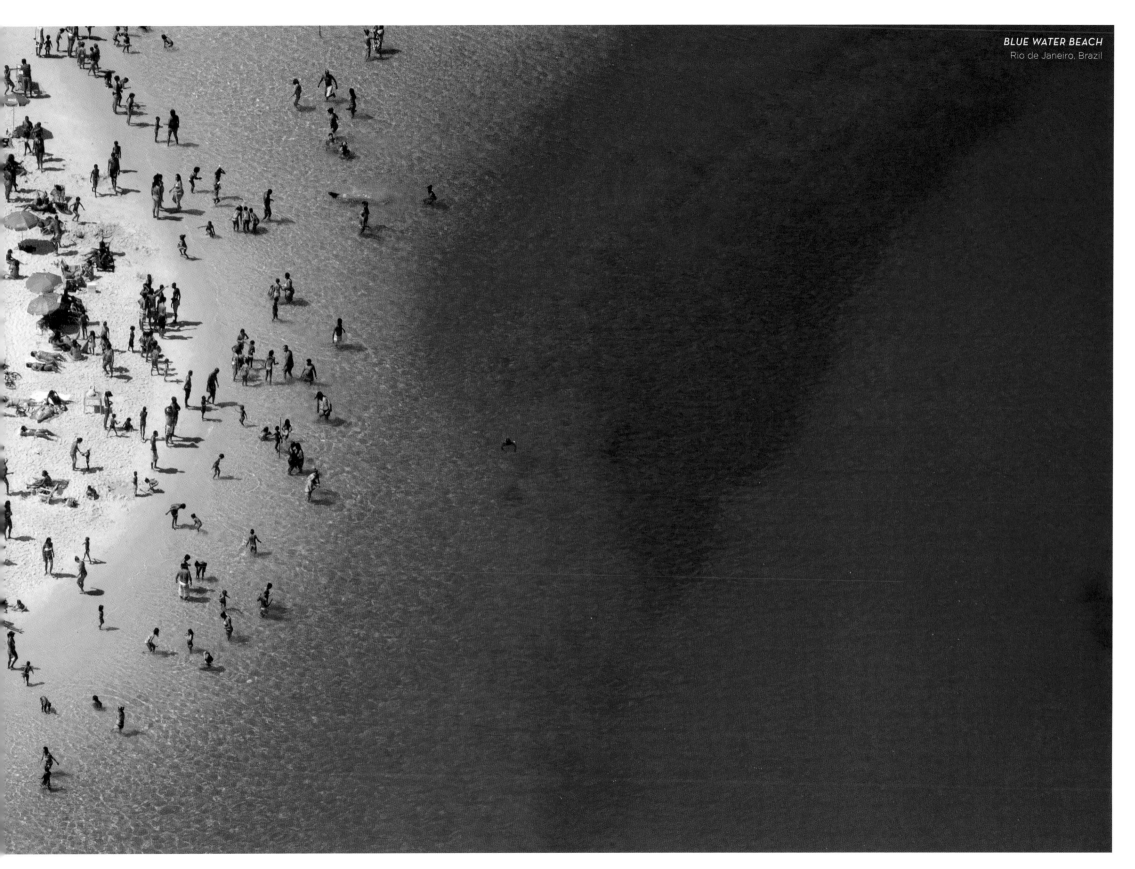

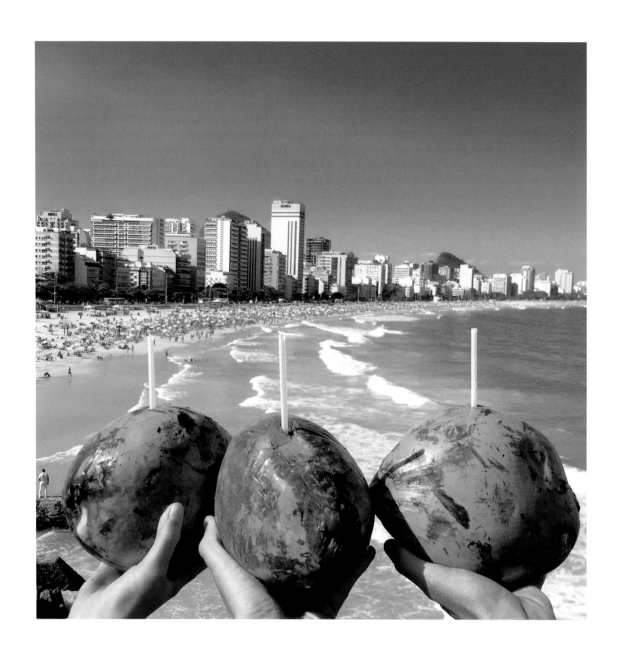

Insider tips

RIO DE JANEIRO

\\\\\\\\\\\\\\\\\\\\\\\\

WHERE TO STAY

Hotel Fasano

Hotel Fasano in Ipanema Beach
has a contemporary design feel but the real
draw is the unbelievable location, which
is a stone's throw from Ipanema Beach.
The rooftop pool and bar are also not to
be missed during your stay!

FOR CULTURE

Niterói Contemporary Art Museum

Niterói Contemporary Art Museum,
also known as the MAC, is a saucer-shaped
museum designed by Brazilian architect
Oscar Niemeyer. It sits cliffside with incredible
panoramic views of the city.

FOR A FUN NIGHT OUT

Aprazível

Perched in the trees above
Santa Teresa in Rio, Aprazível is
an ideal place to start the night
sipping caipirinhas and enjoying
the view of Guanabara Bay.

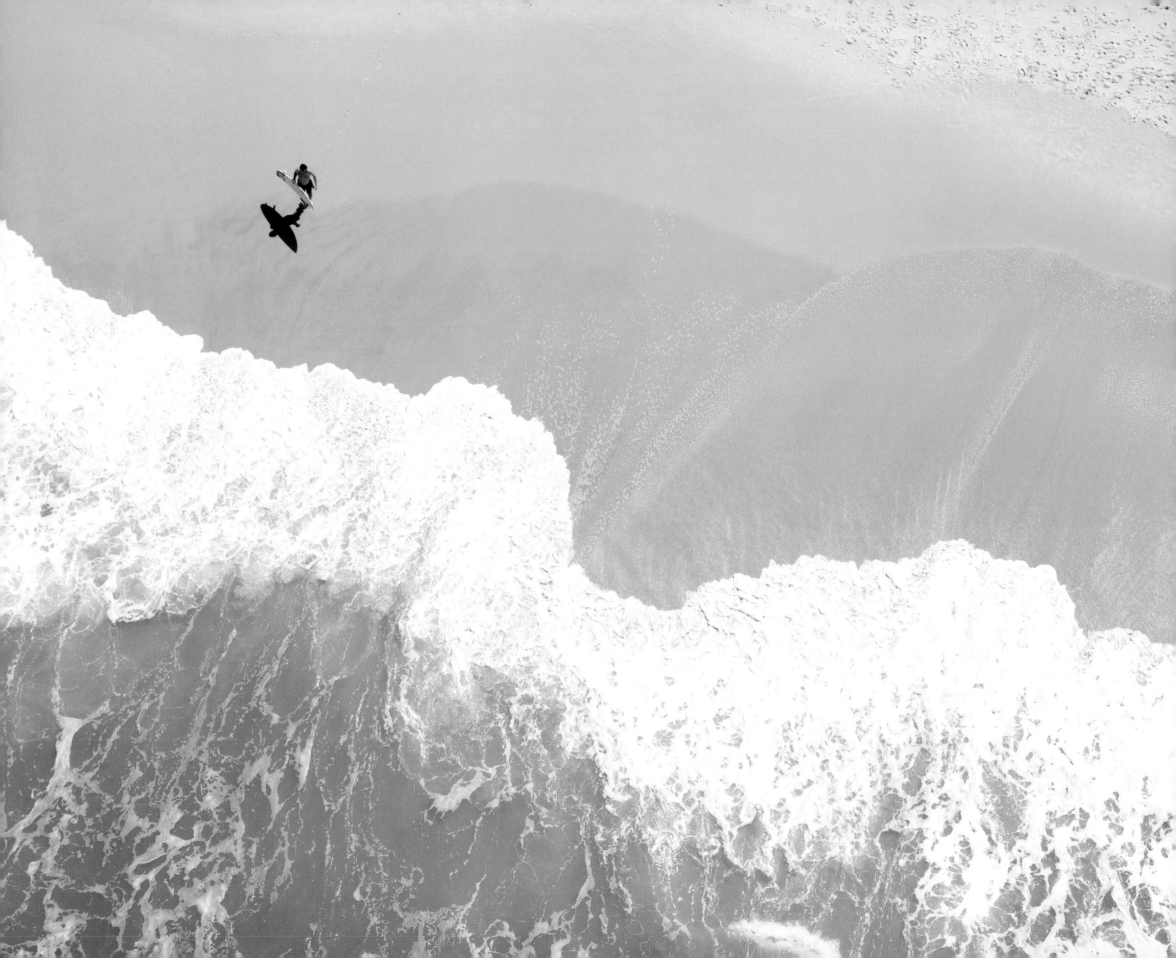

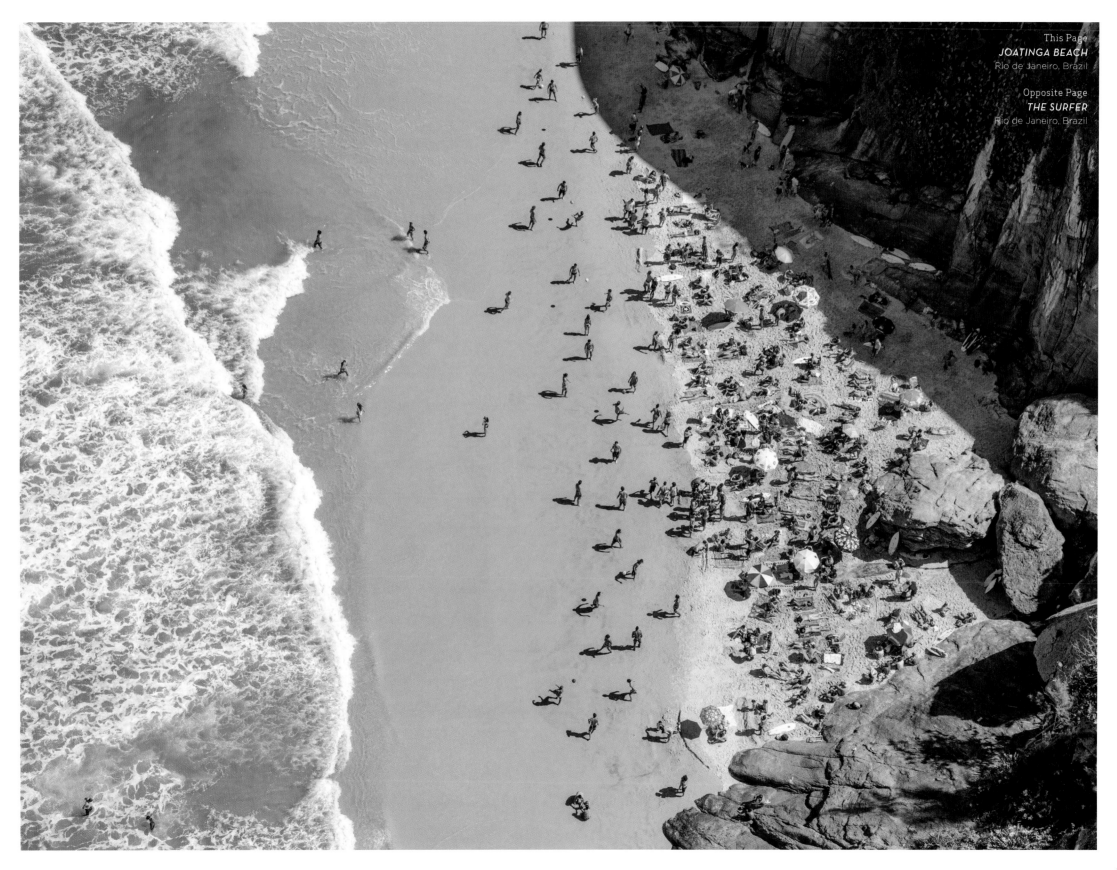

This Page
JOATINGA BEACH
Rio de Janeiro, Brazil

Opposite Page
THE SURFER
Rio de Janeiro, Brazil

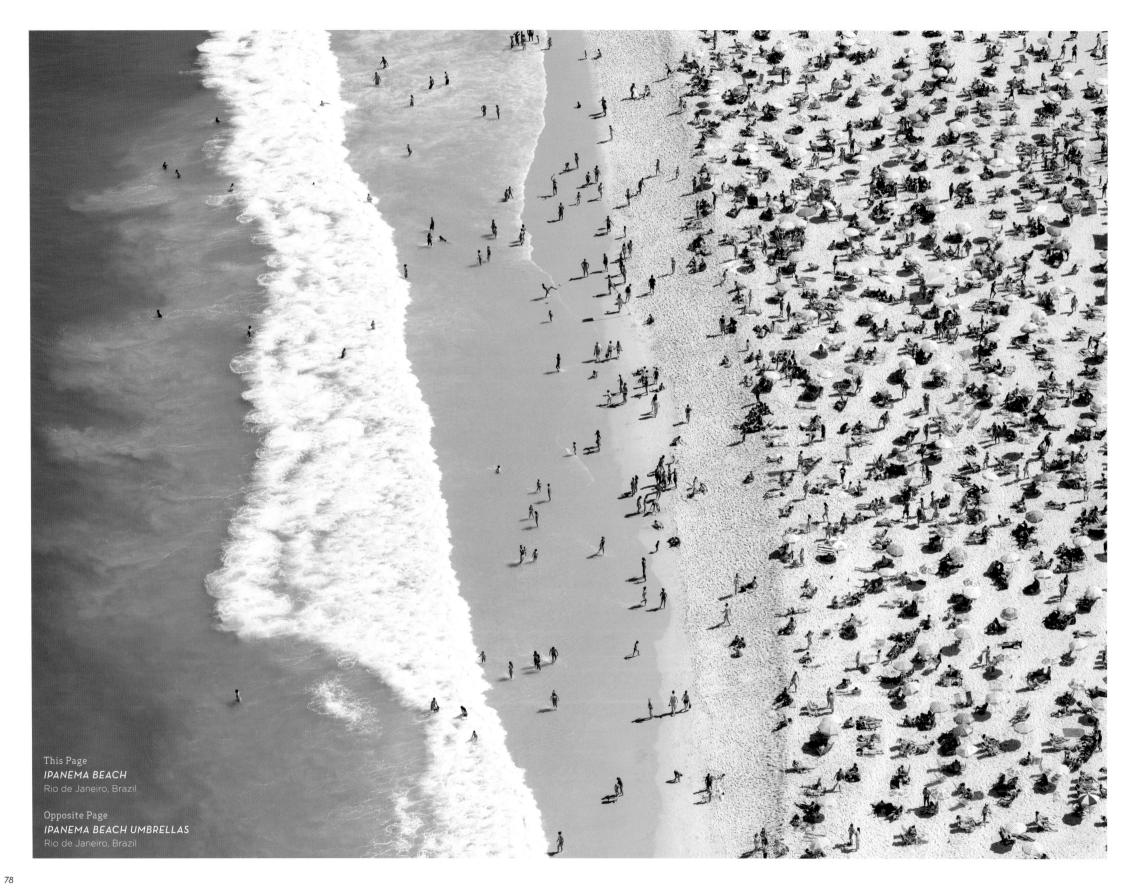

This Page
IPANEMA BEACH
Rio de Janeiro, Brazil

Opposite Page
IPANEMA BEACH UMBRELLAS
Rio de Janeiro, Brazil

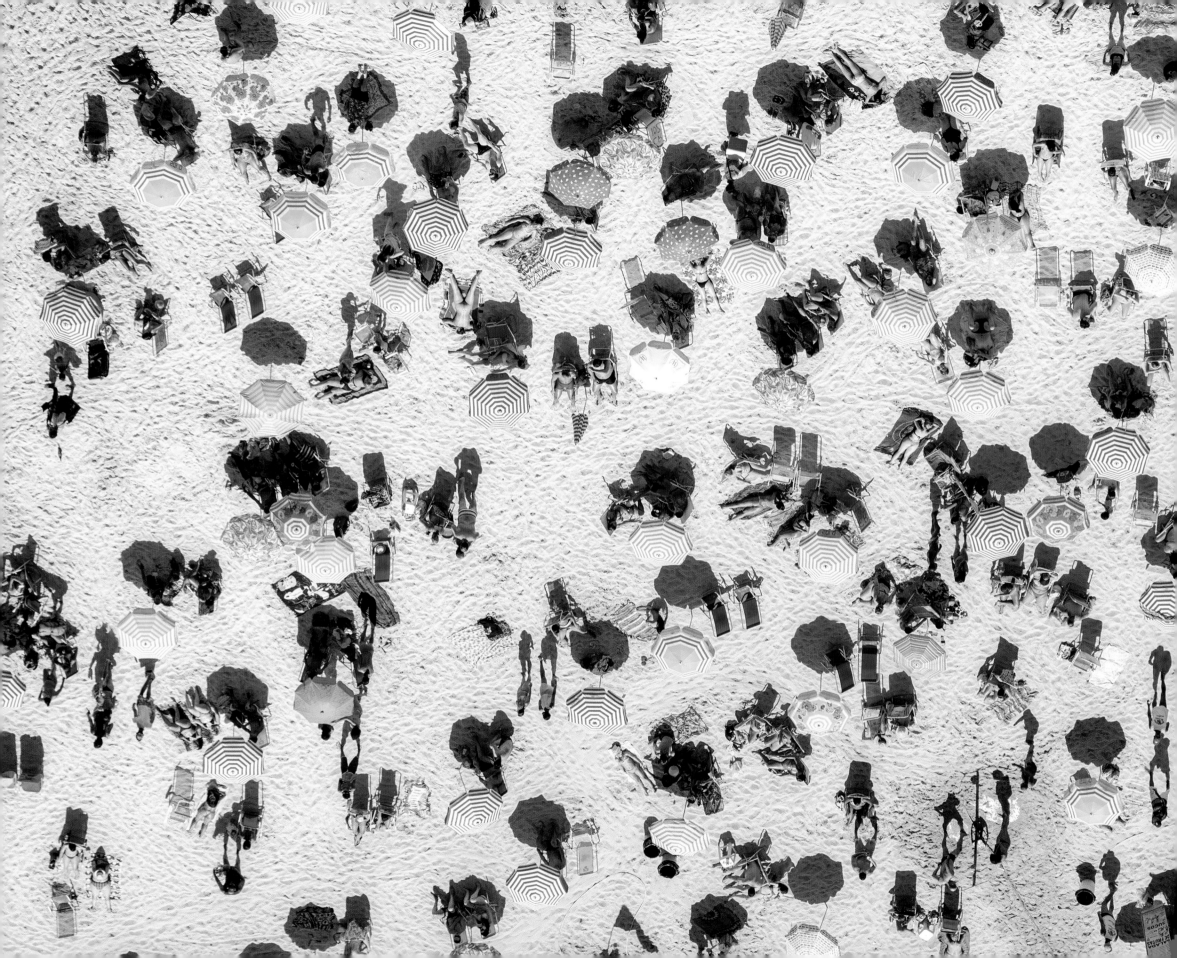

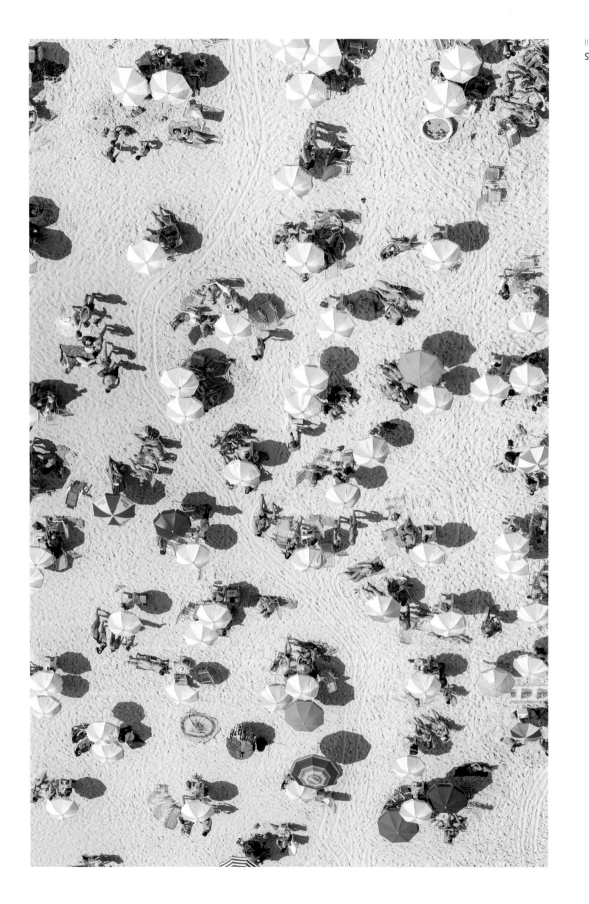

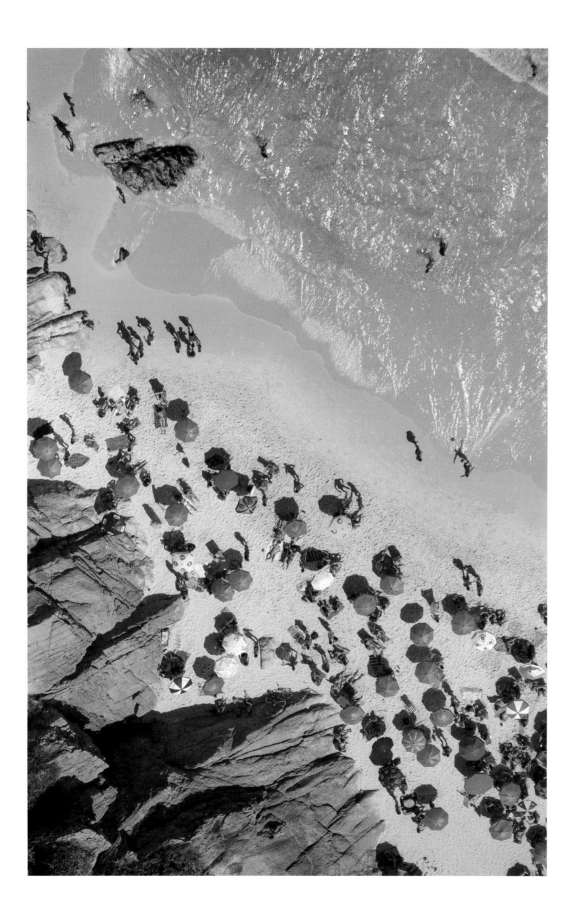

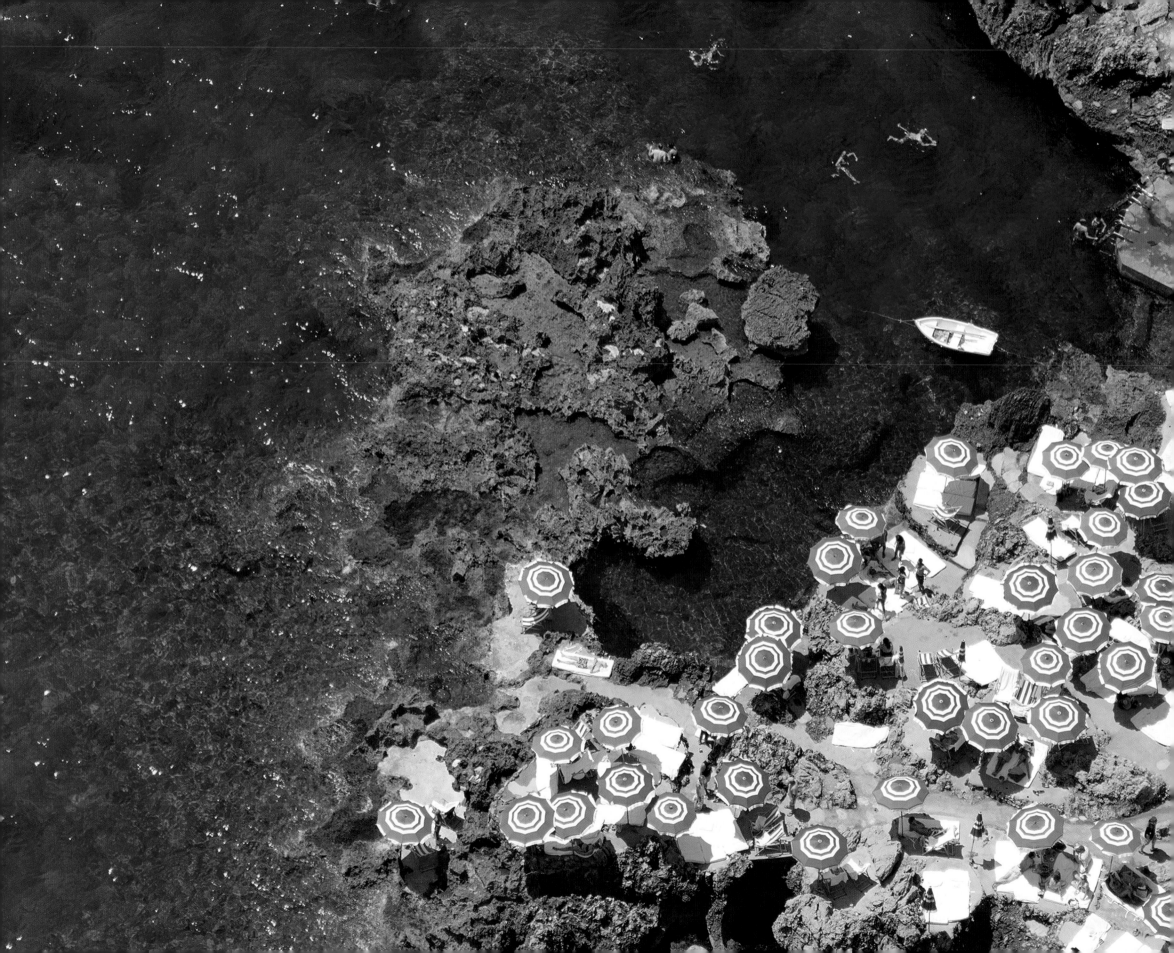

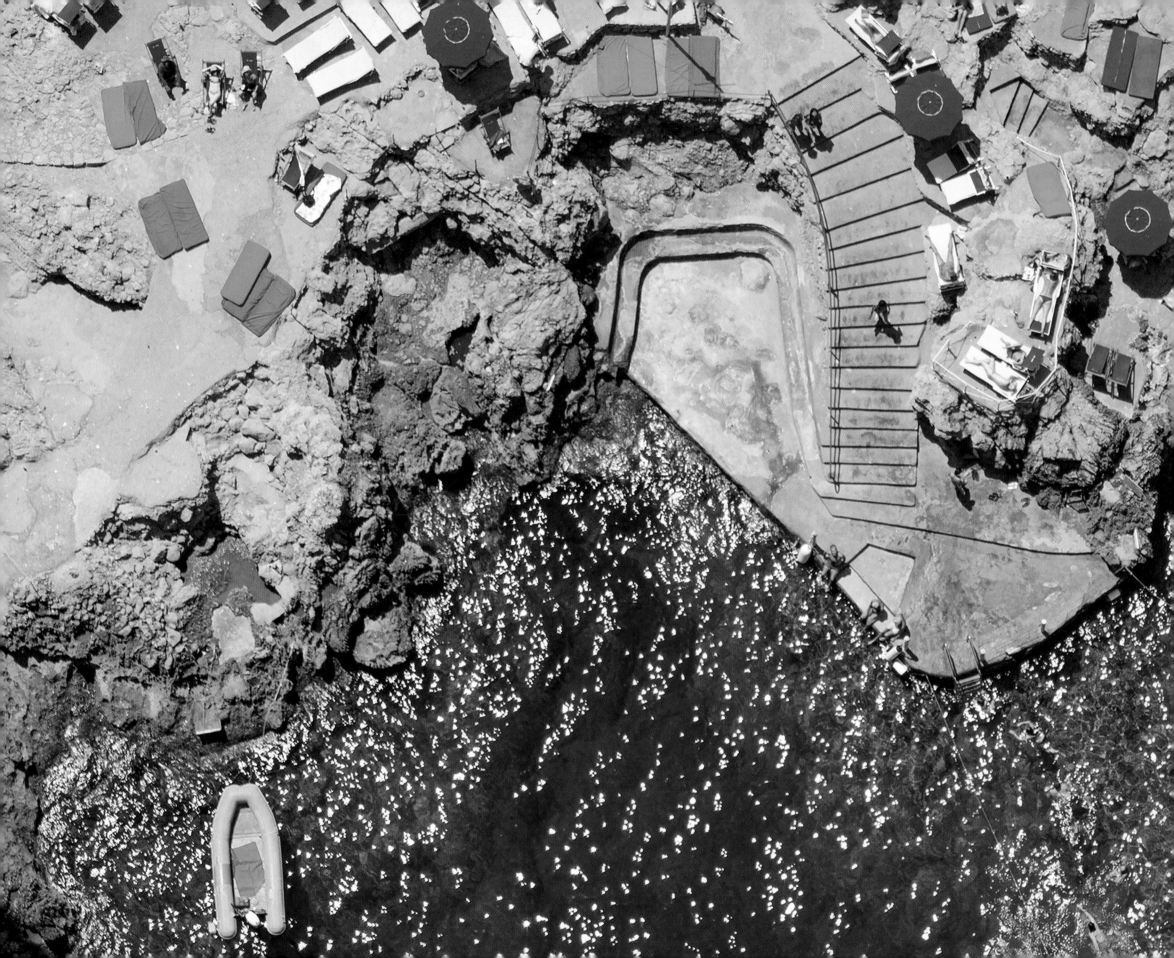

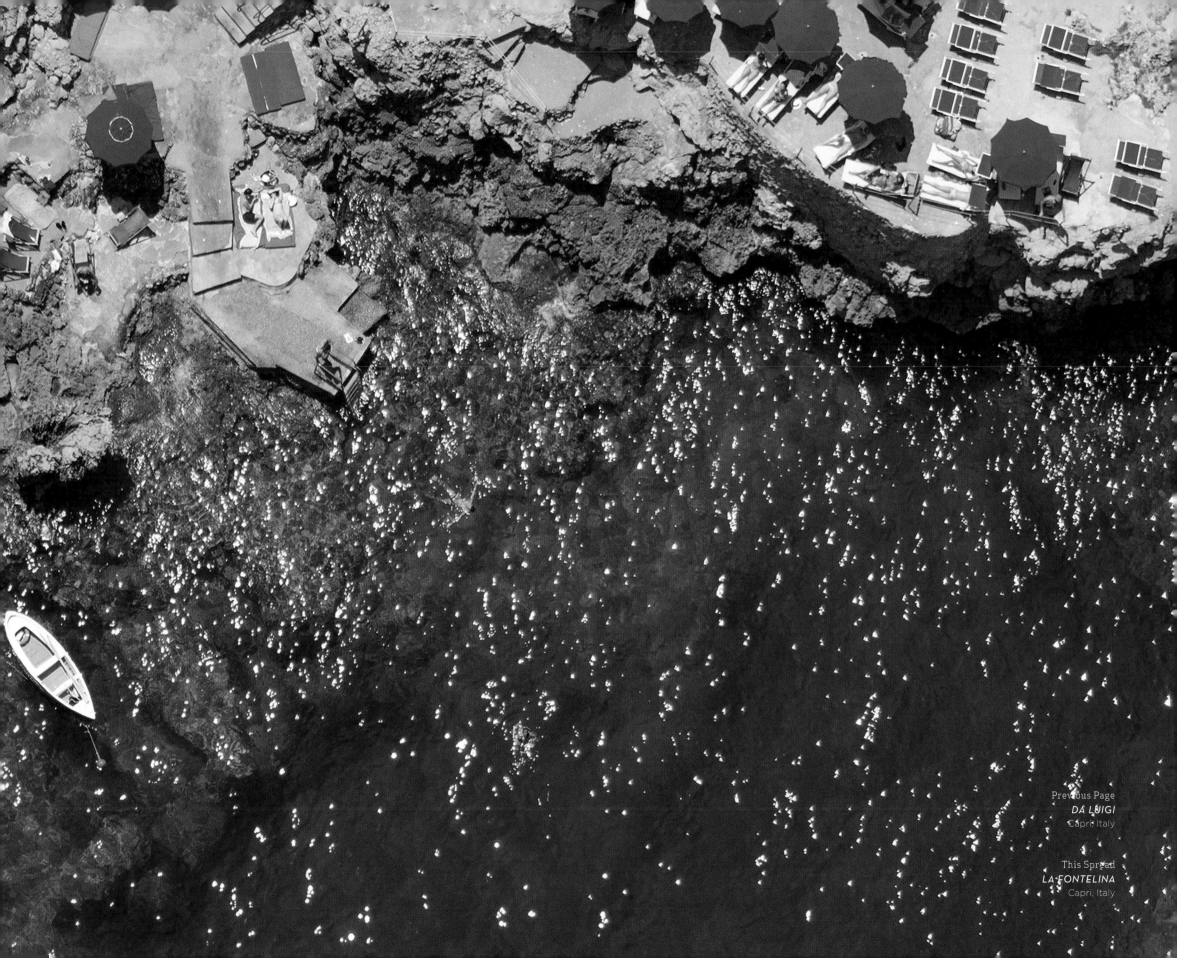

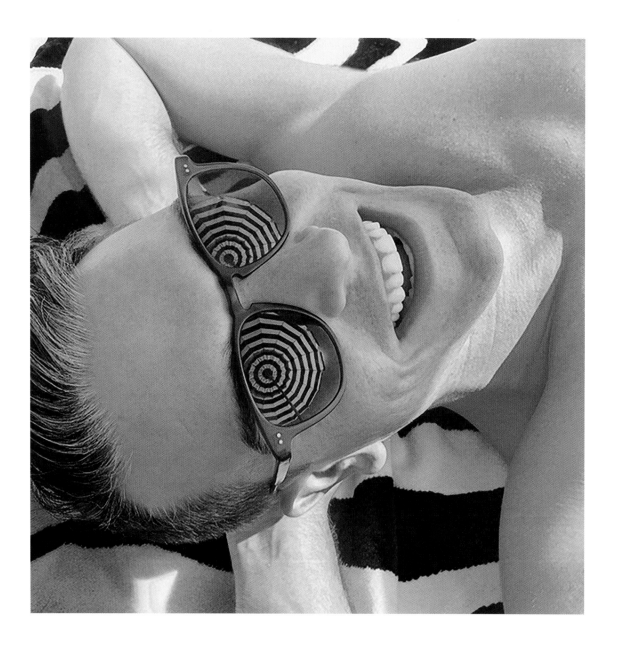

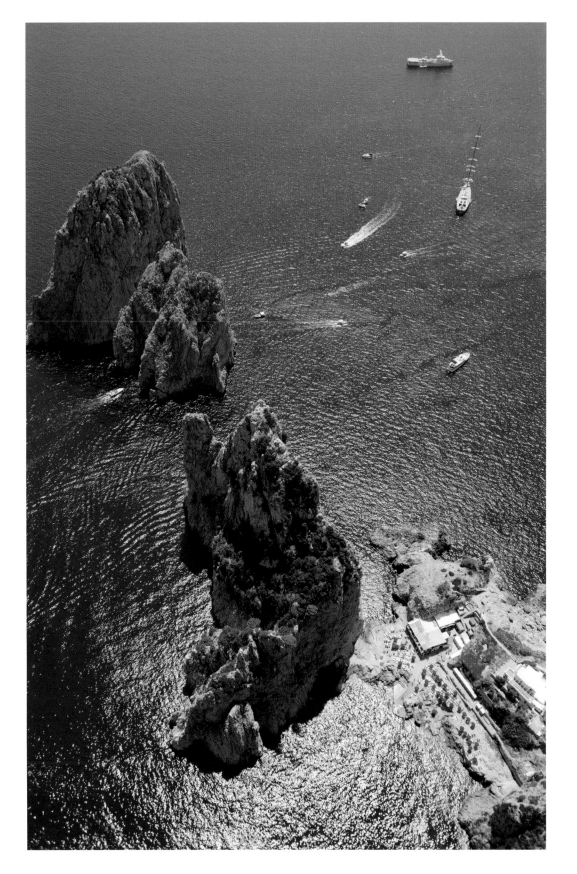

FARAGLIONI
Capri, Italy

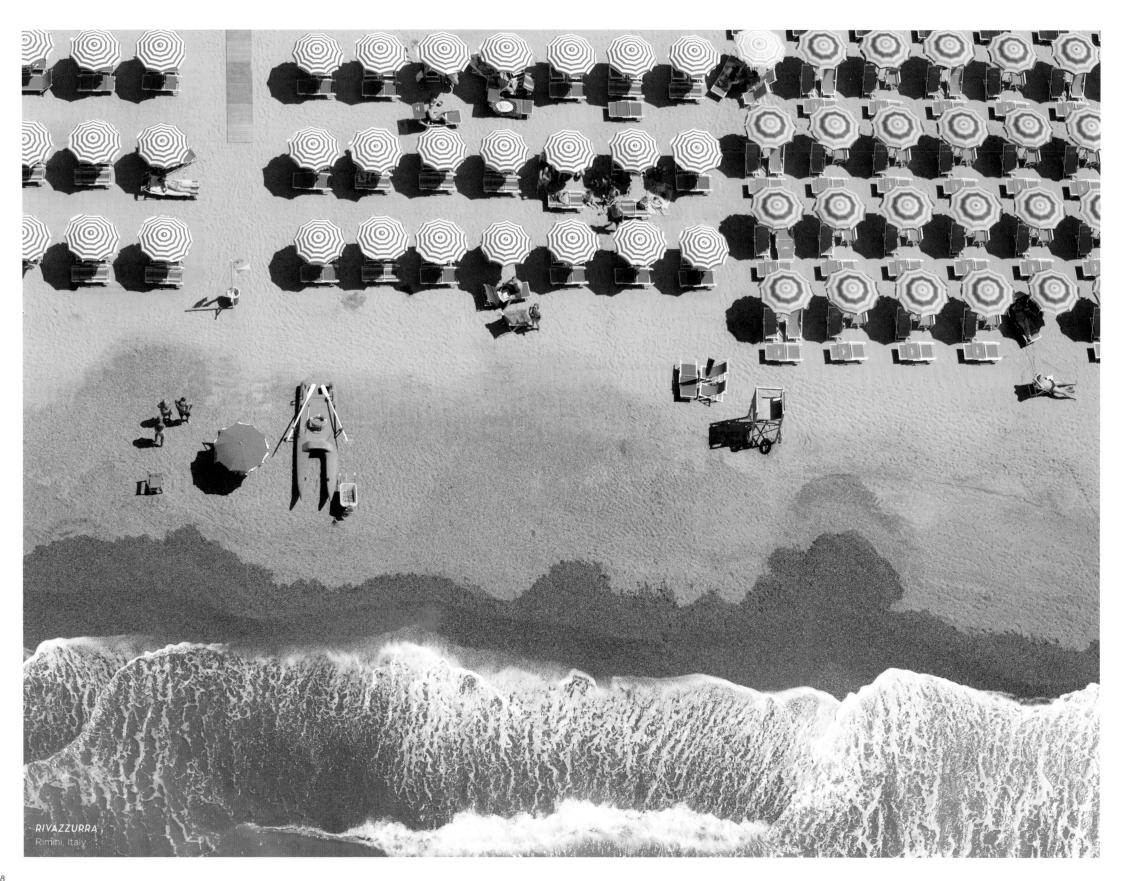

RIVAZZURRA
Rimini, Italy

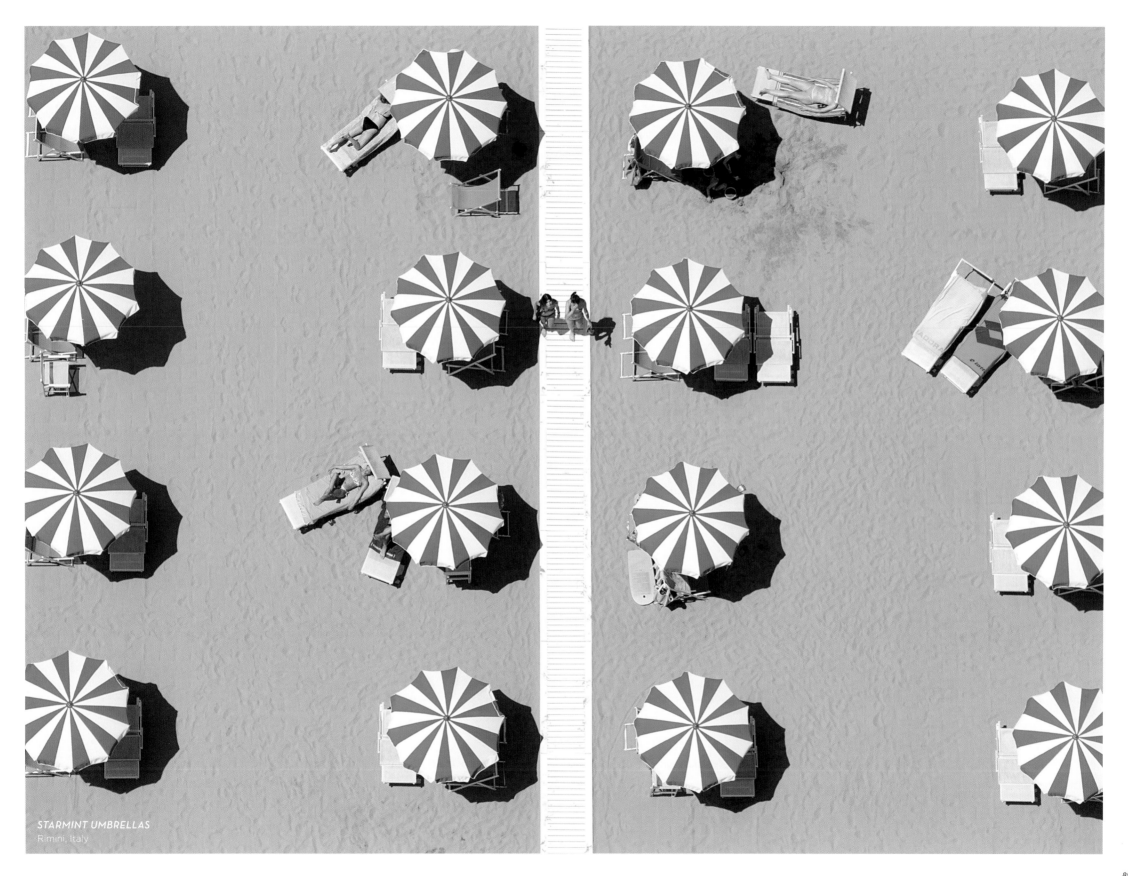

STARMINT UMBRELLAS
Rimini, Italy

WHEN I WAS FLYING ABOVE THE BEACHES OF ITALY, MY UMBRELLA-OBSESSED MIND WAS OVERSTIMULATED AND MY EYES WERE POPPING OUT OF MY HEAD AT THE INCREDIBLE PATTERNS THAT WERE FORMING BELOW. EVERY TYPE OF UMBRELLA YOU COULD IMAGINE IN EVERY SINGLE COLOR YOU COULD DREAM OF PERFECTLY LINED THE SAND FOR MILES AND MILES. I WAS IN HEAVEN.

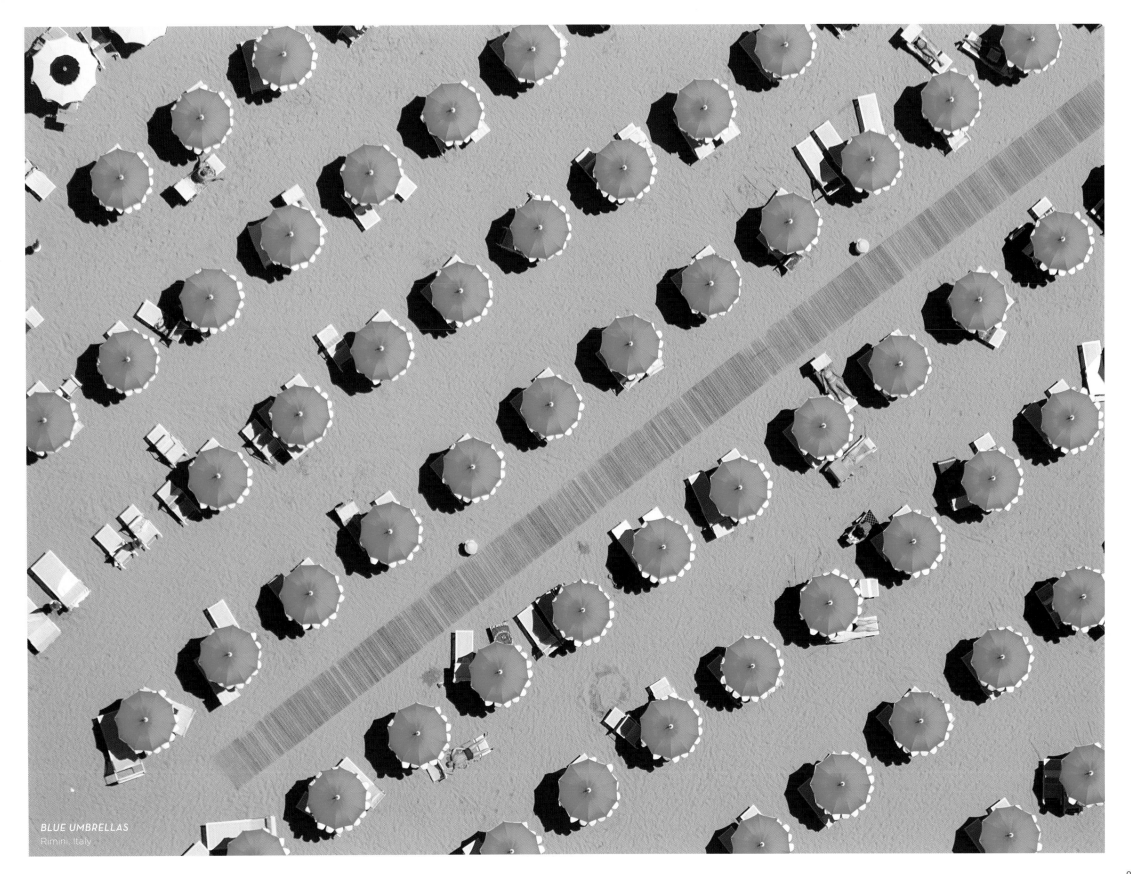

BLUE UMBRELLAS
Rimini, Italy

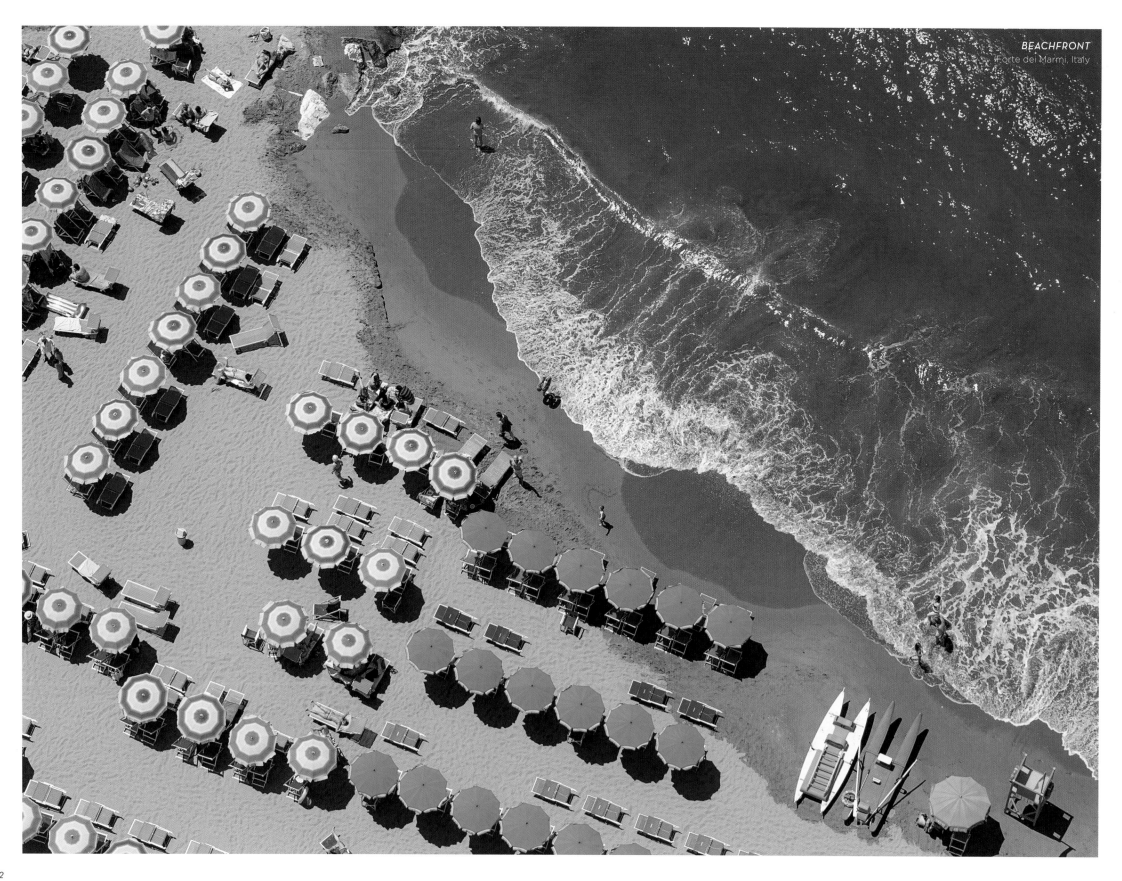

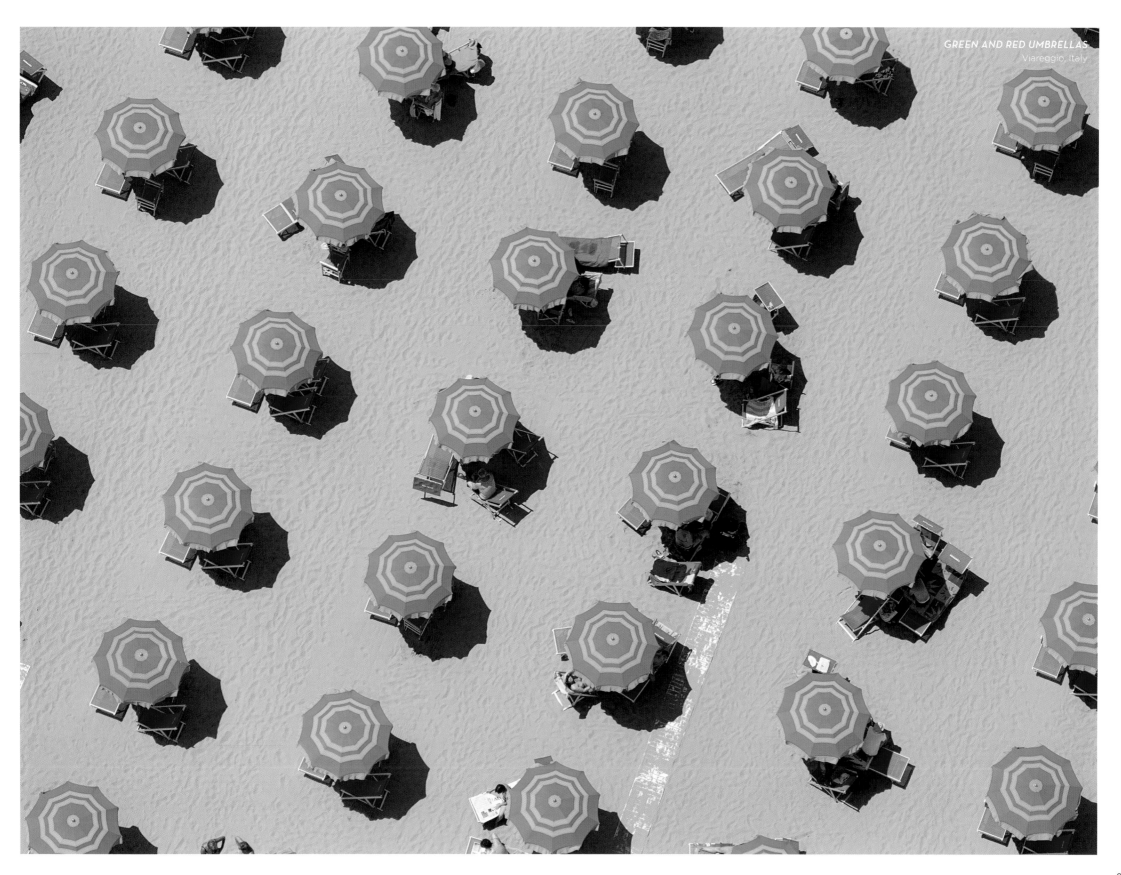

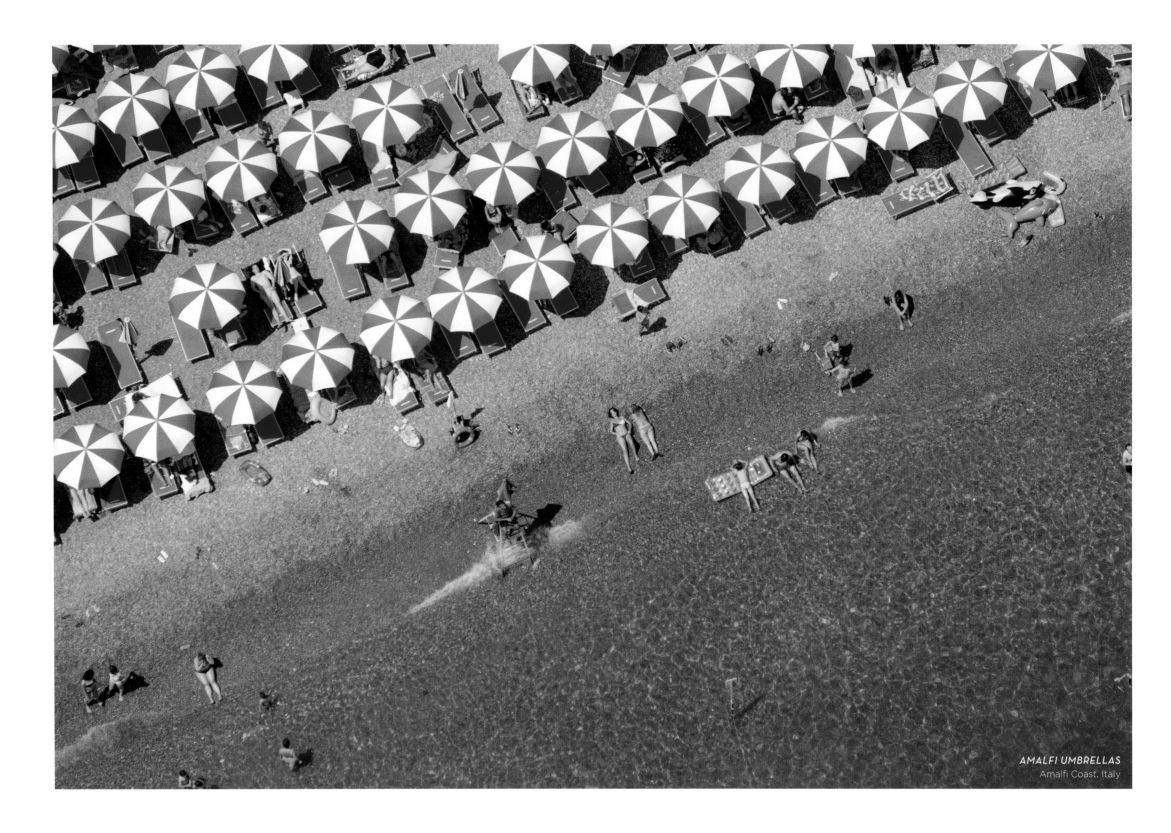

AMALFI UMBRELLAS
Amalfi Coast, Italy

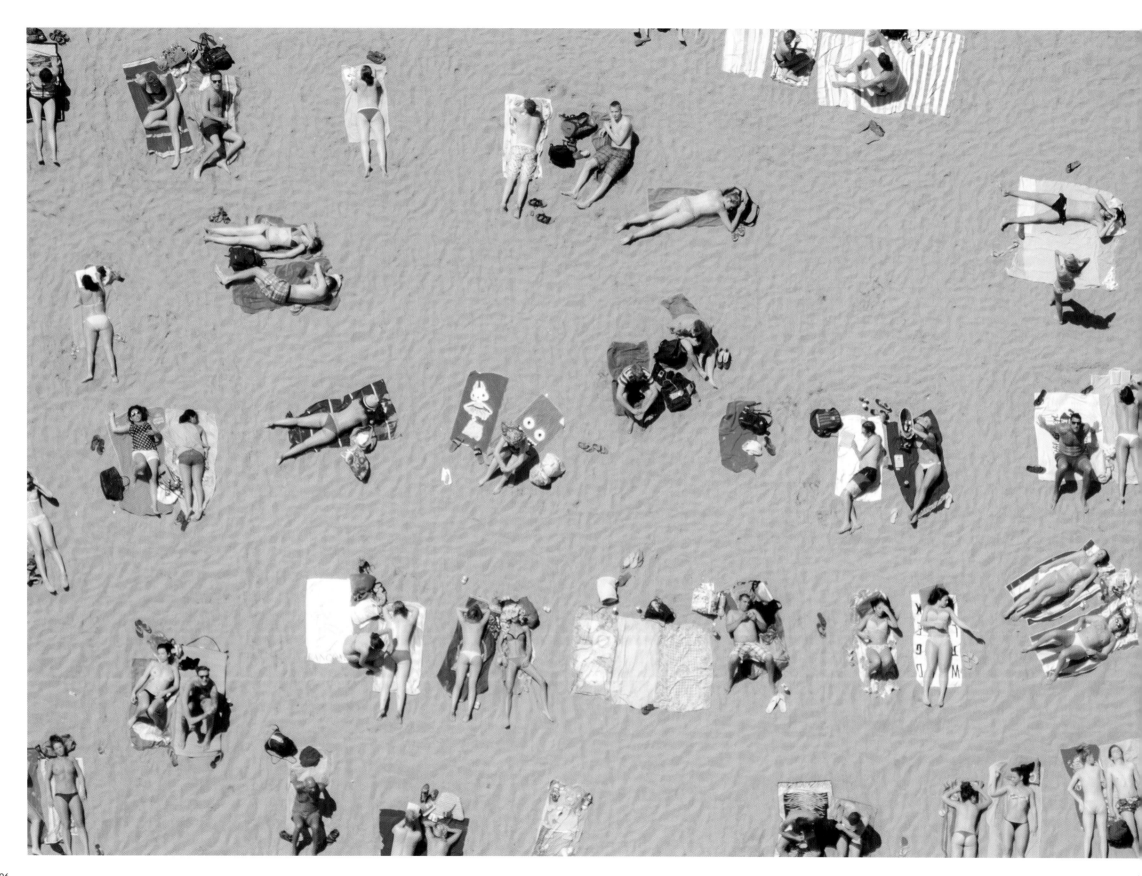

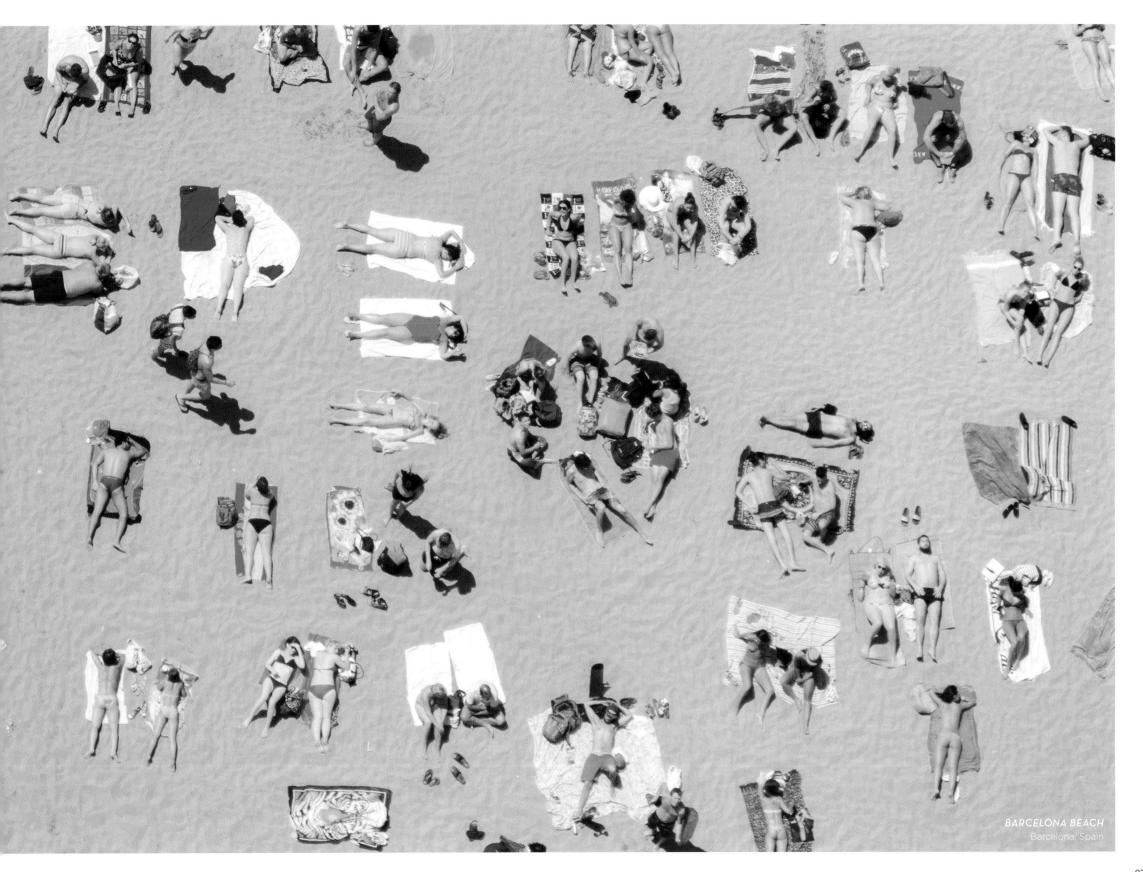

BARCELONA BEACH
Barcelona, Spain

Swirly twirly *BARCELONA* wonderland.

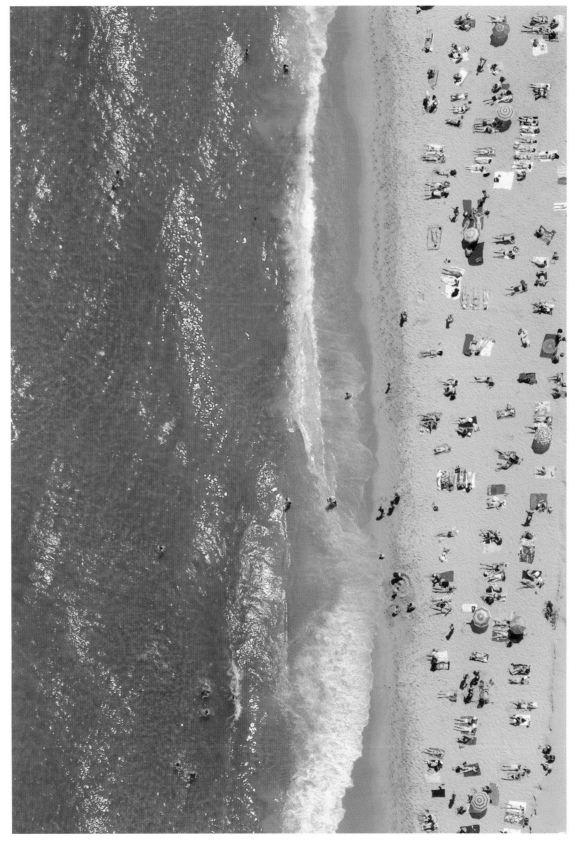

BARCELONA VERTICAL
Barcelona, Spain

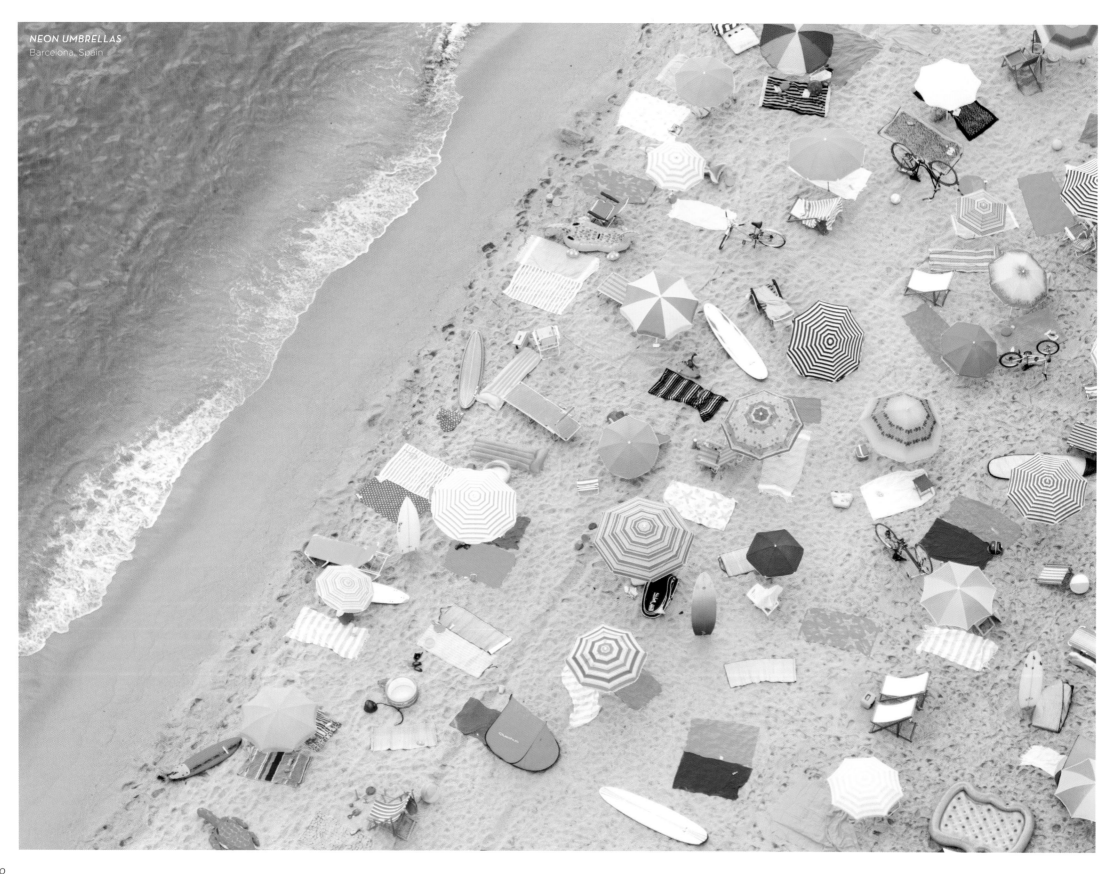

FLYING ALONG THE BEACH IN BARCELONA,

I SPOTTED AN AMAZING SPREAD OF NEON-

COLORED UMBRELLAS. AS I GOT CLOSER,

IT BECAME APPARENT THAT IT WAS AN EMPTY

FILM SET. TALK ABOUT PERFECT TIMING.

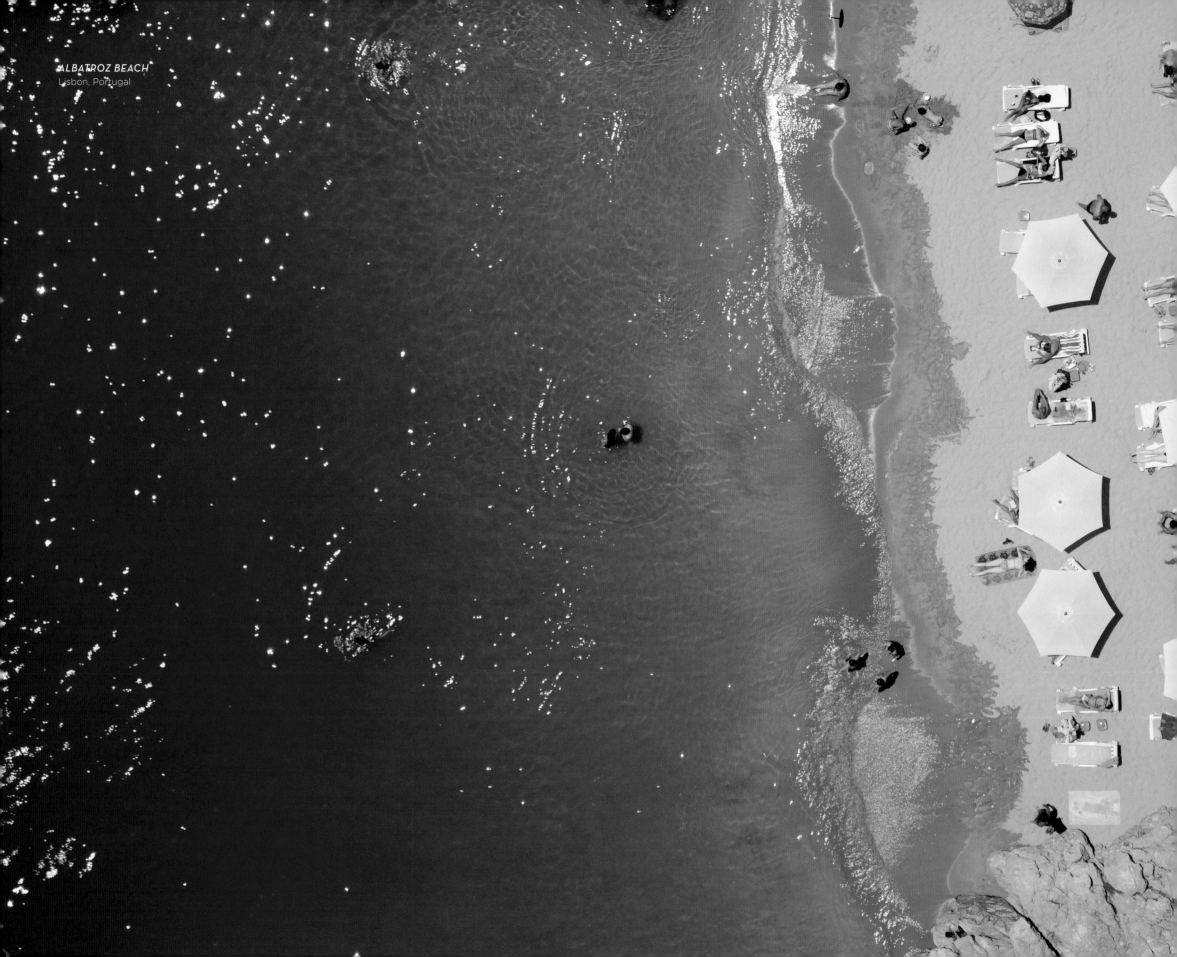

ALBATROZ BEACH
Lisbon, Portugal

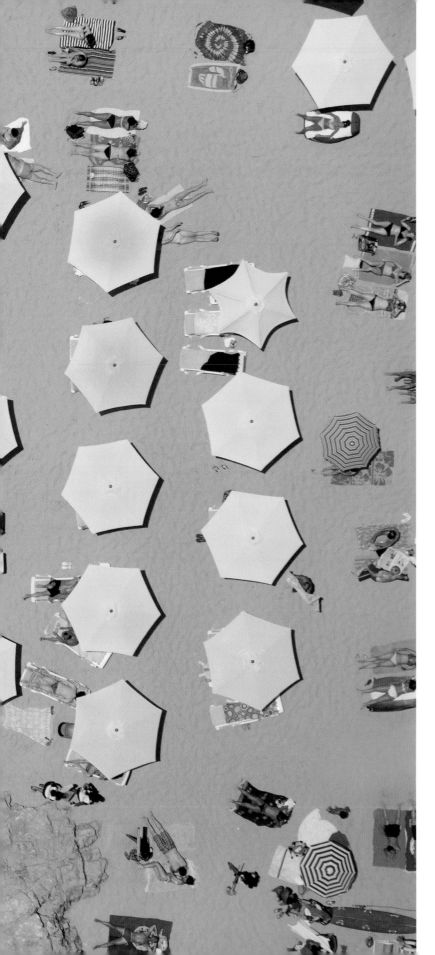

The beaches of *LISBON* stretch along different coastlines,

which range from WILL, RUGGED SURFING BEACHES to CALM, SUNBATHER-FRIENDLY locations

that are all easy to access from the city.

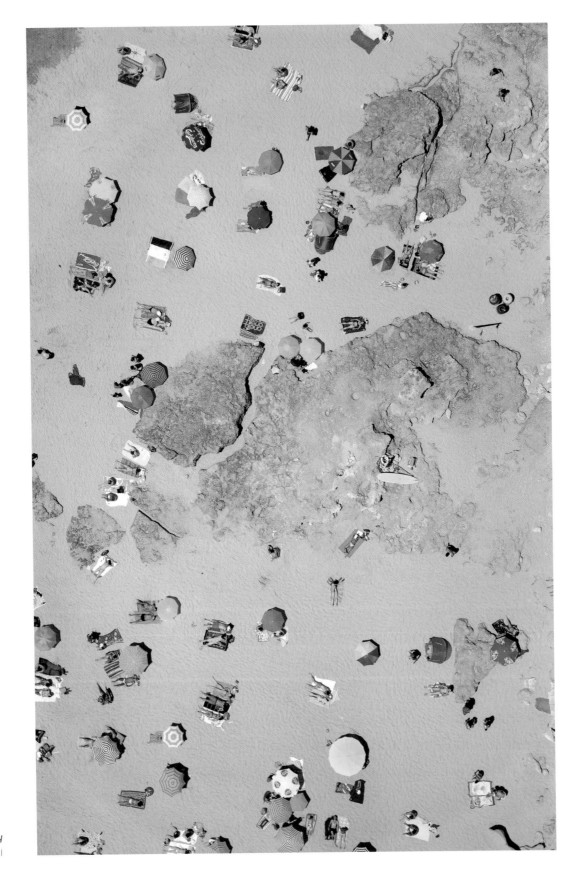

ROCKY BEACH
Lisbon, Portugal

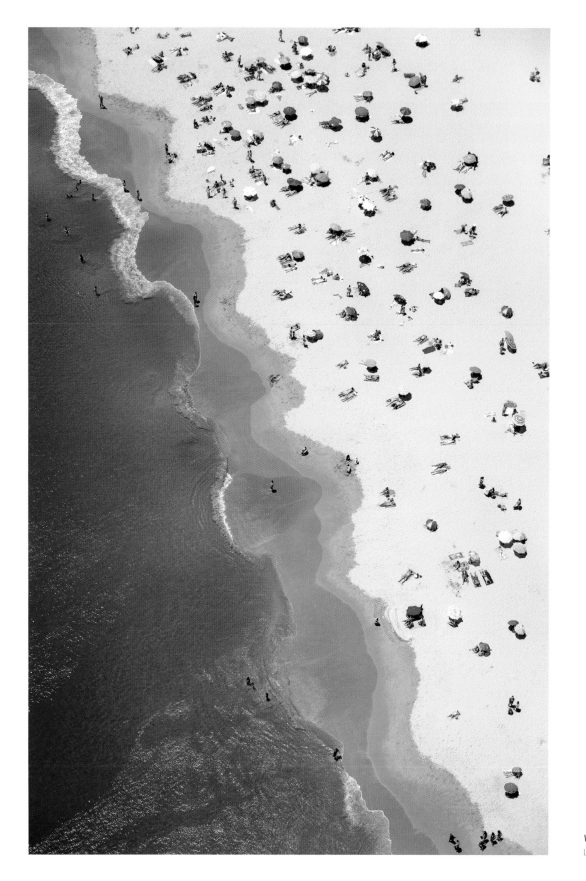

WAVY BEACH
Lisbon, Portugal

Destination favorites in

SAINT-TROPEZ

\\\\\\\\\\\\\\\\\\\\\

WHERE TO STAY

Château de la Messardière

This hotel is perched on a hillside
overlooking the beautiful bay of Saint-Tropez.
It is an escape from the hustle and bustle
of the city, yet you are only a five-minute
drive away from the center of town.

FAVORITE BEACH

Plage de Pampelonne

White sand, clear water, and
numerous beach clubs. A fun atmosphere
for walking around or laying out.

WHERE TO EAT

La Tarte Tropézienne

I dream about this bakery's namesake
Tarte Tropézienne. The decadent
brioche cake filled with velvety cream
is a Saint-Tropez staple beloved by
tourists and locals alike.

FAVORITE BEACH CLUB

Le Club 55

Try out this *trés chic* club,
which boasts beautiful people
and stunning views.

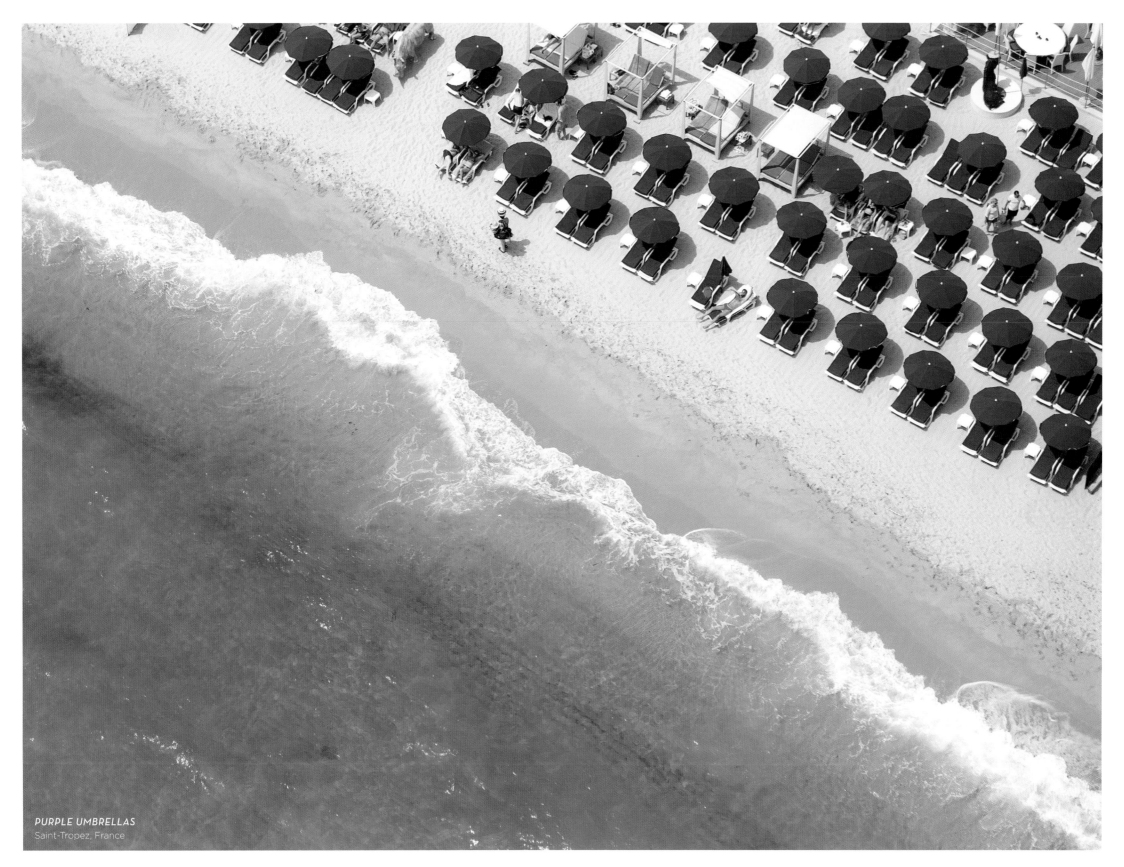

PURPLE UMBRELLAS
Saint-Tropez, France

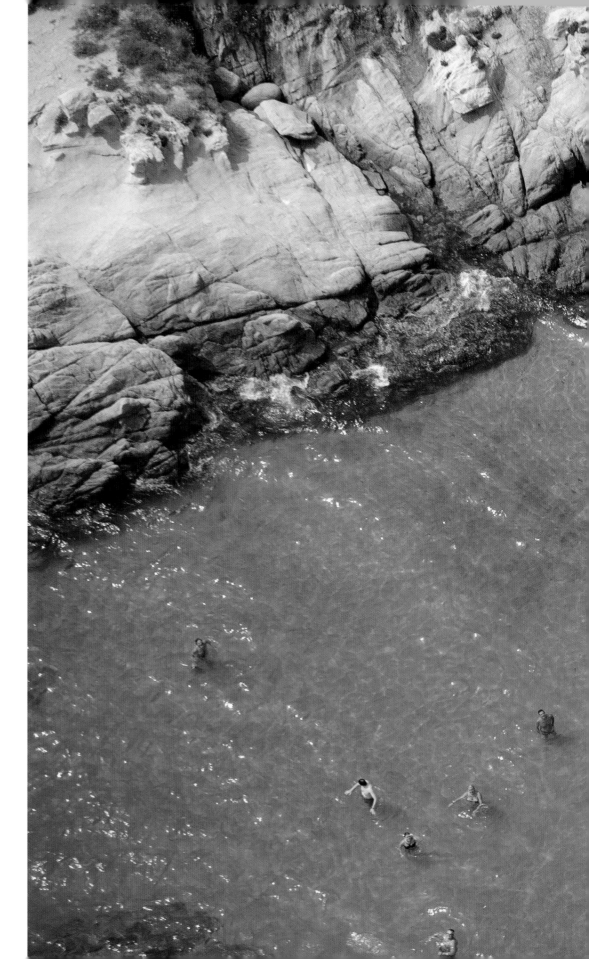

SECRET BEACH
Saint-Tropez, France

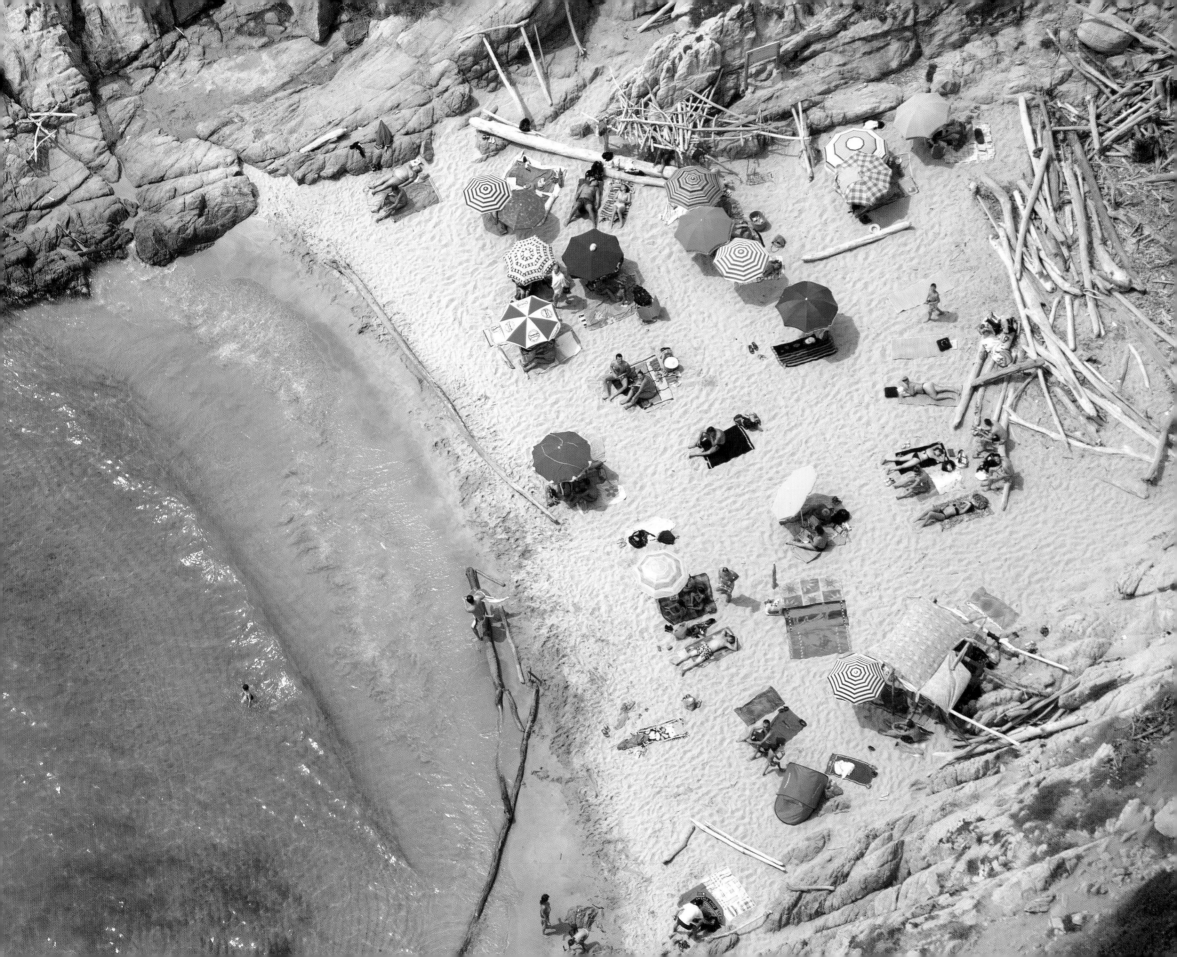

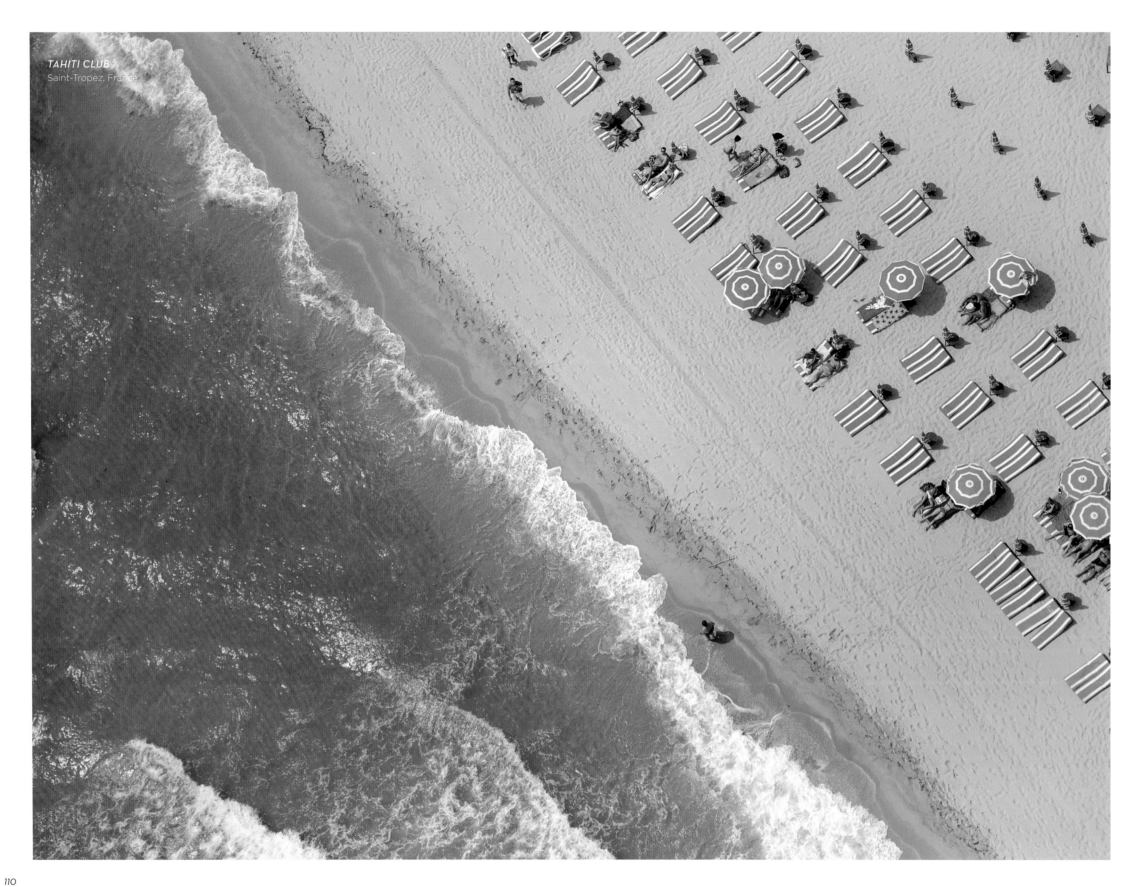

TAHITI CLUB
Saint-Tropez, France

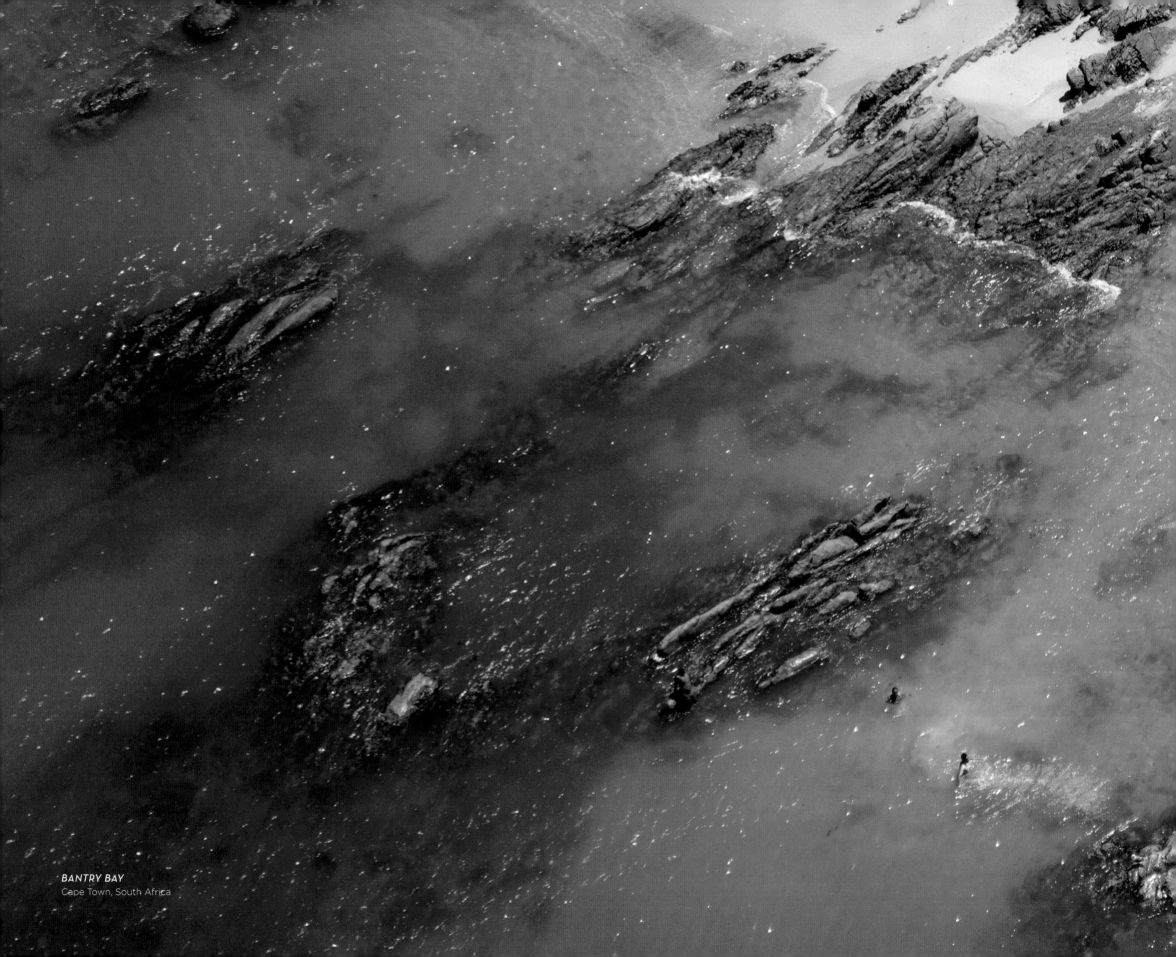

BANTRY BAY
Cape Town, South Africa

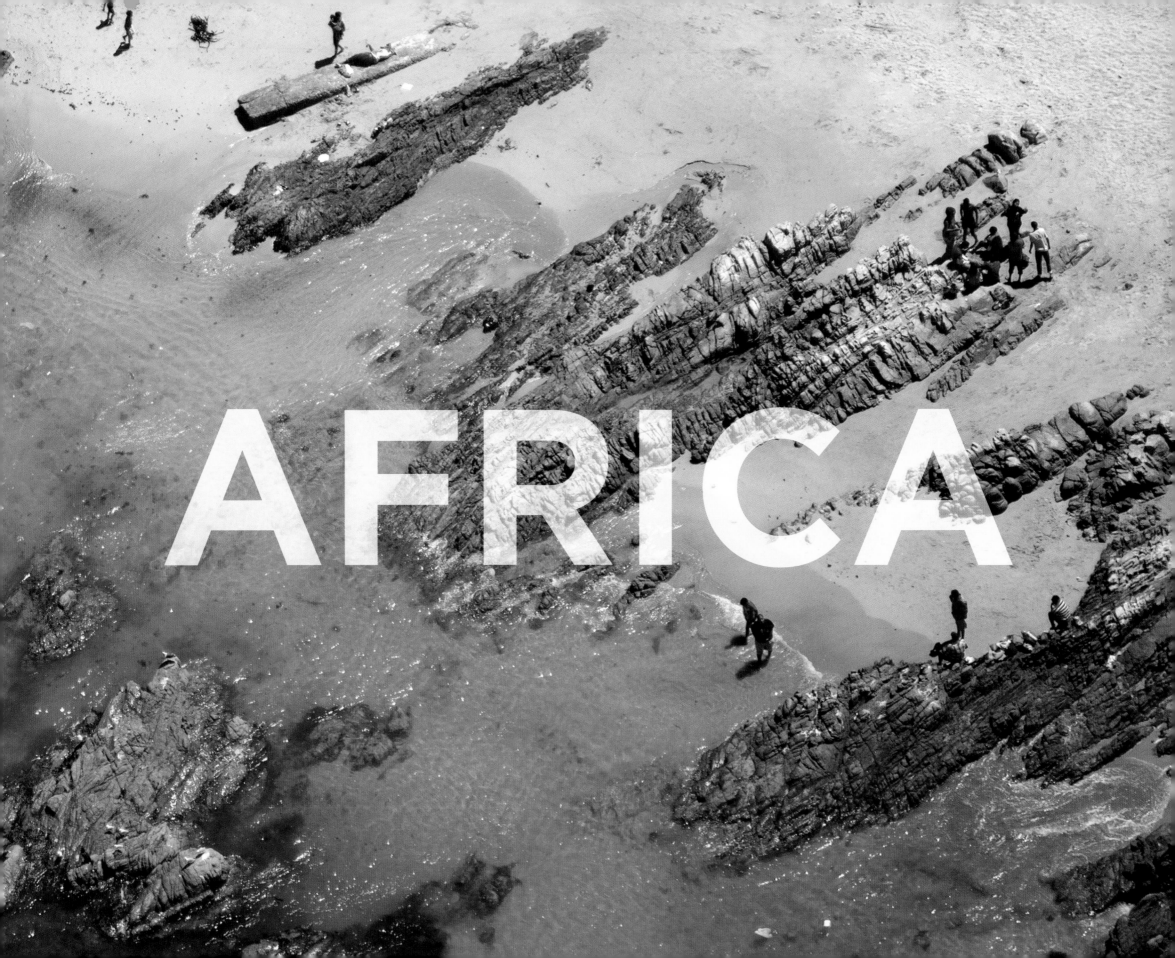

THERE ARE SO MANY SIDES OF CAPE TOWN.
IT IS EXQUISITELY STUNNING YET RUGGED.
AFTER EXPLORING MANY OF THE NATURAL
LANDSCAPES, I BEGAN TO UNDERSTAND WHY
THE LOCALS REFER TO IT AS *THE MOTHER CITY.*

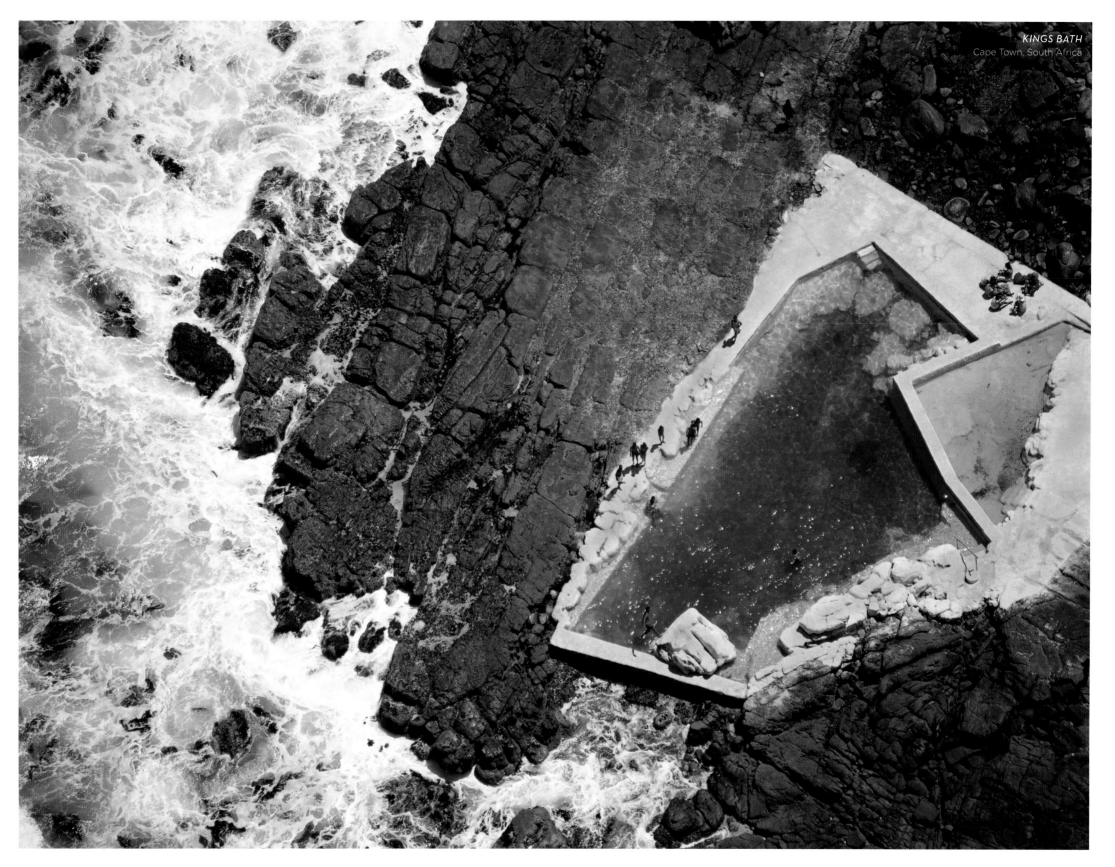

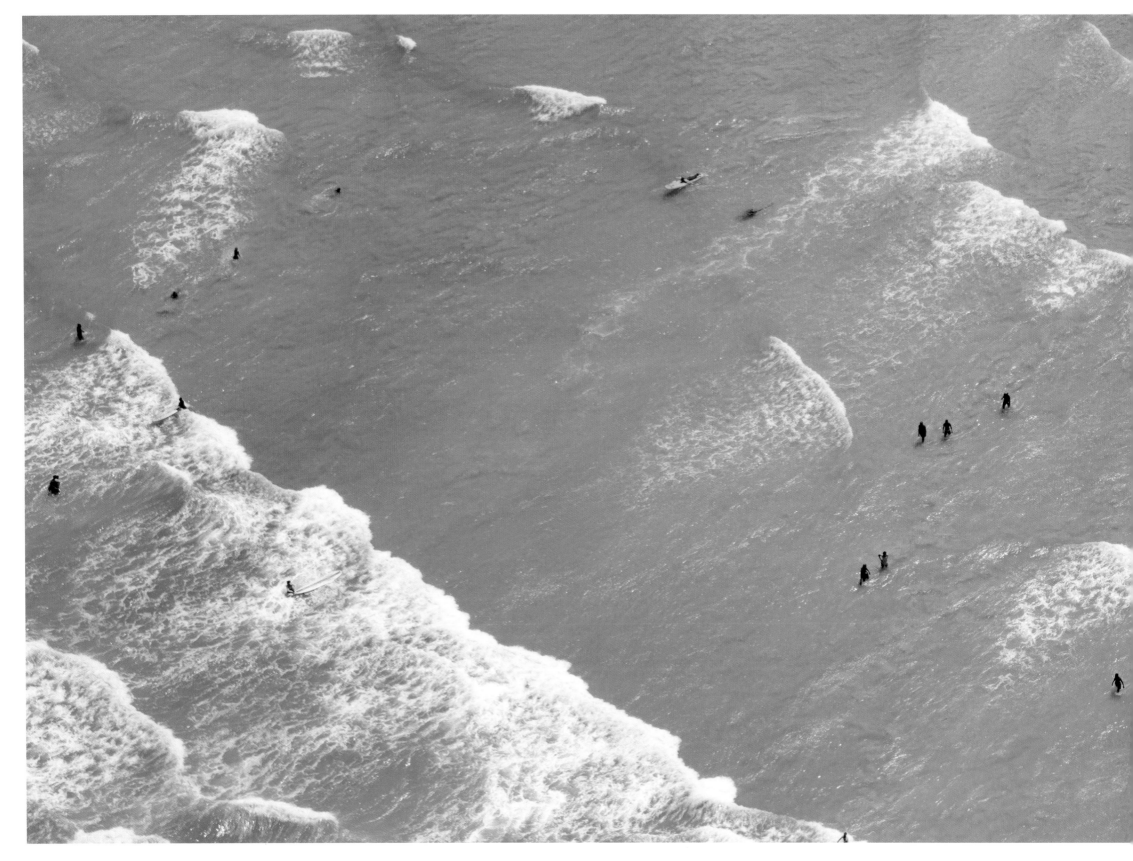

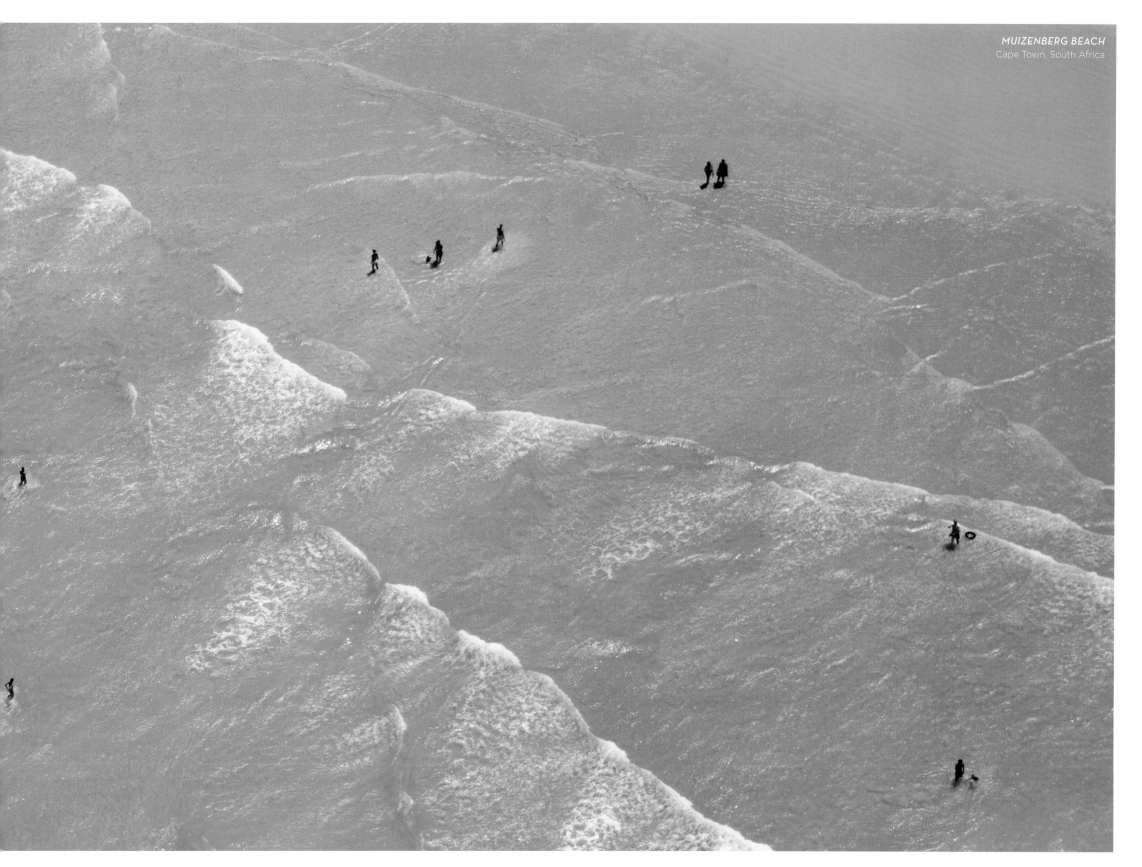

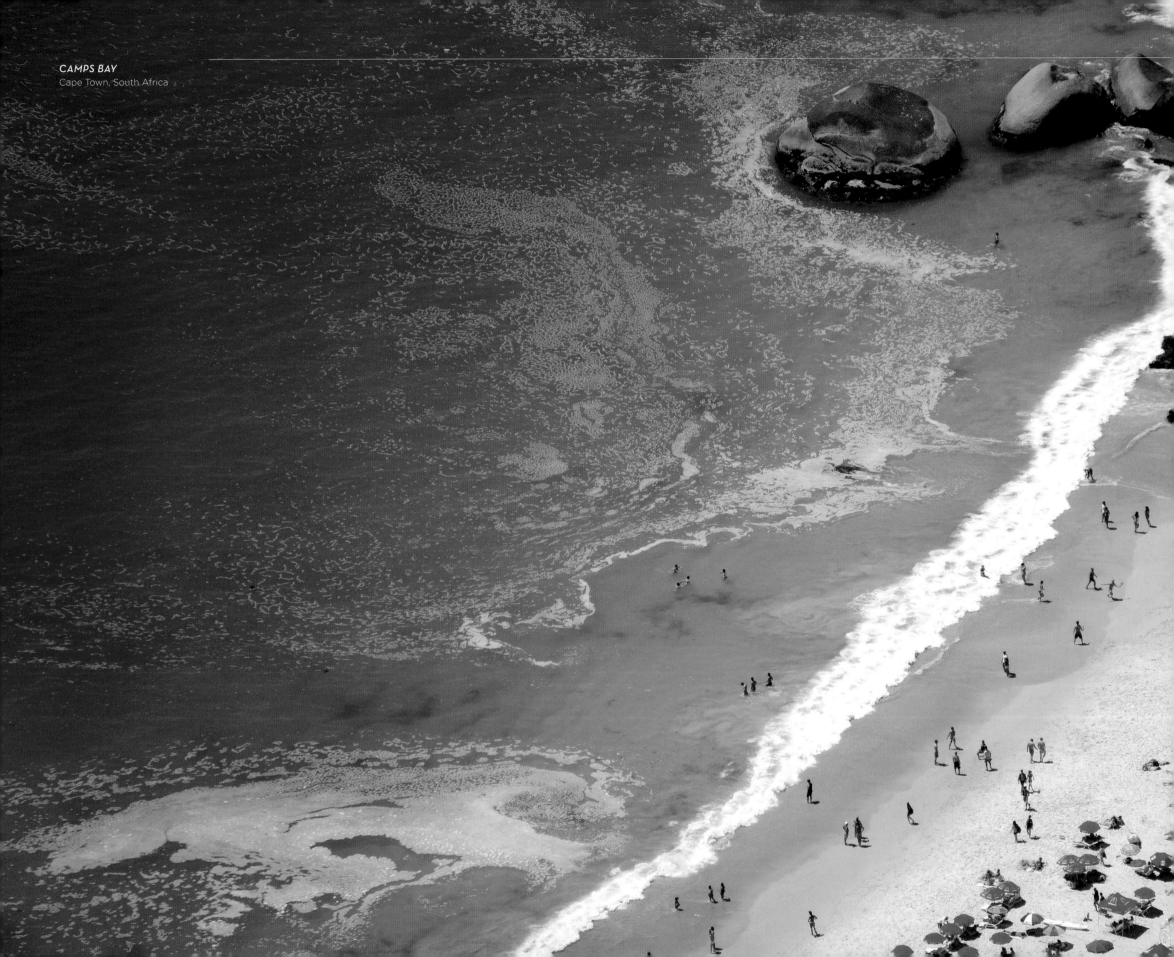

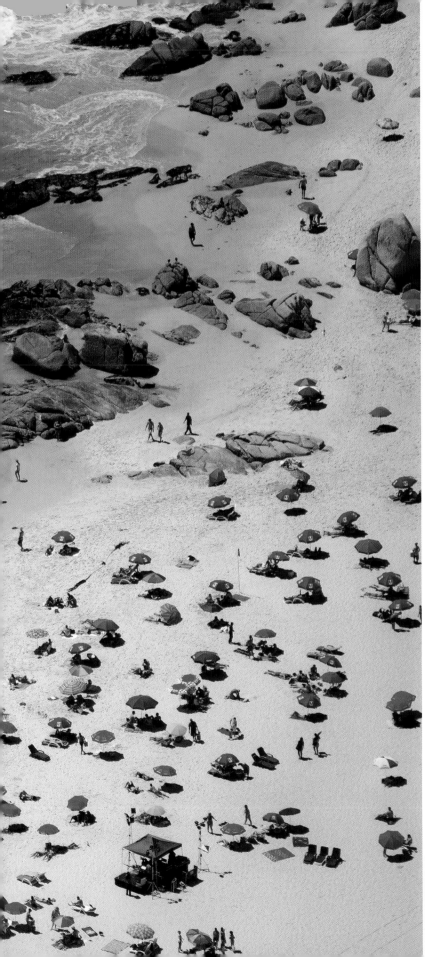

CAPE TOWN is one of my favorite places on earth

and I can't seem to spend enough time there. *BEAUTIFUL*

BEACHES, incredible wine and food, and inspiration

at every turn; what more can you ask for?

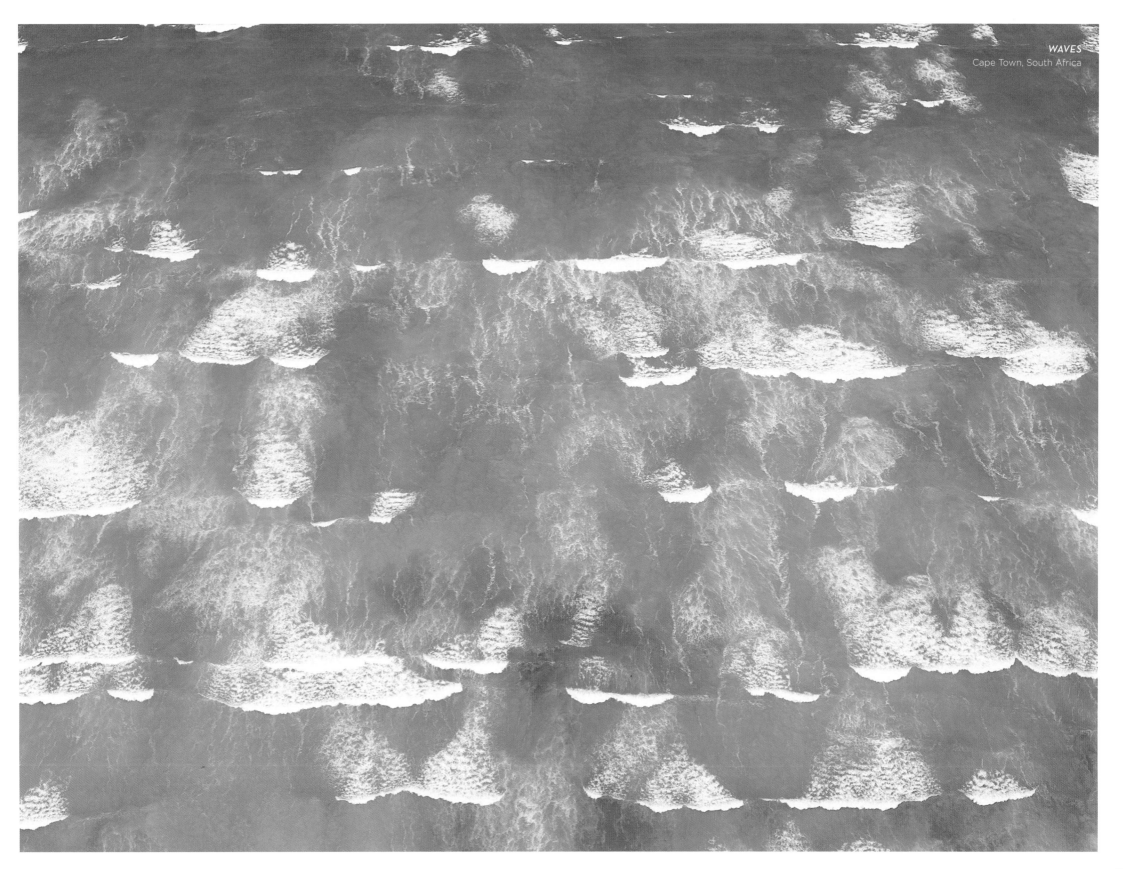

WEATHER IS A CONSTANT CONCERN FOR A PHOTOGRAPHER. HAVING FLOWN HALFWAY ACROSS THE WORLD, I FOUND IT ESPECIALLY NERVE-RACKING THE DAY OF THE SHOOT. LUCKILY, WE HAD CLEAR SKIES AND VERY LITTLE WIND. AFTERWARD, WE DROVE TO BOULDERS PENGUIN COLONY AND MADE SOME CUTE NEW FRIENDS.

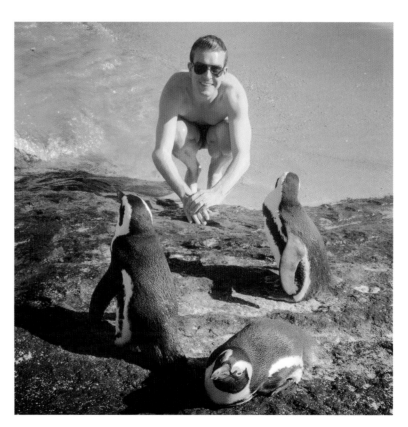

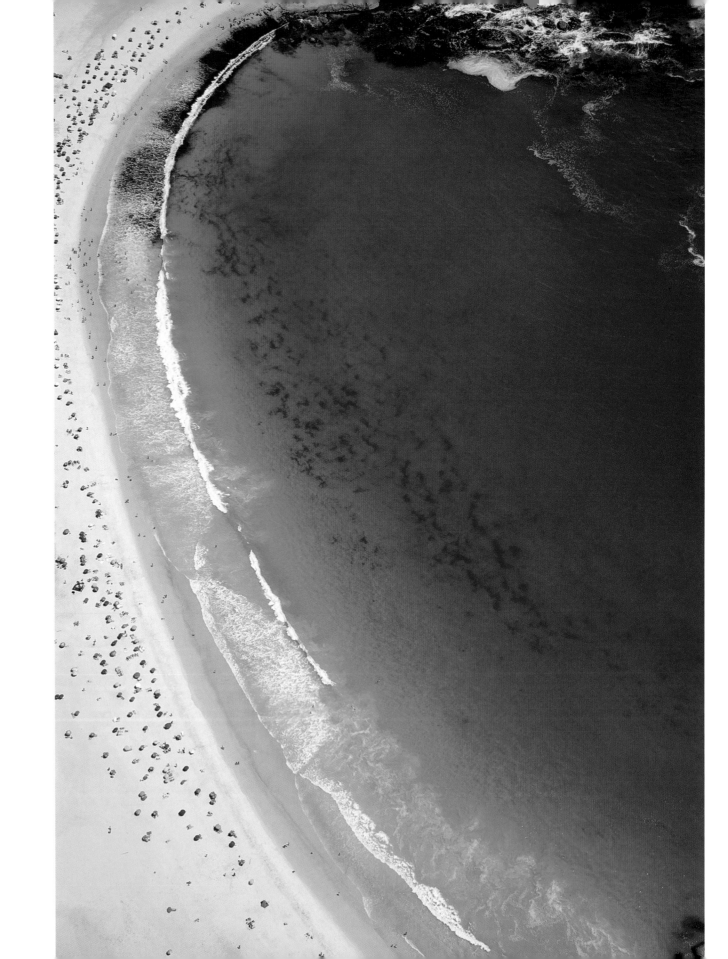

CAMPS BAY HEART DIPTYCH
Cape Town, South Africa

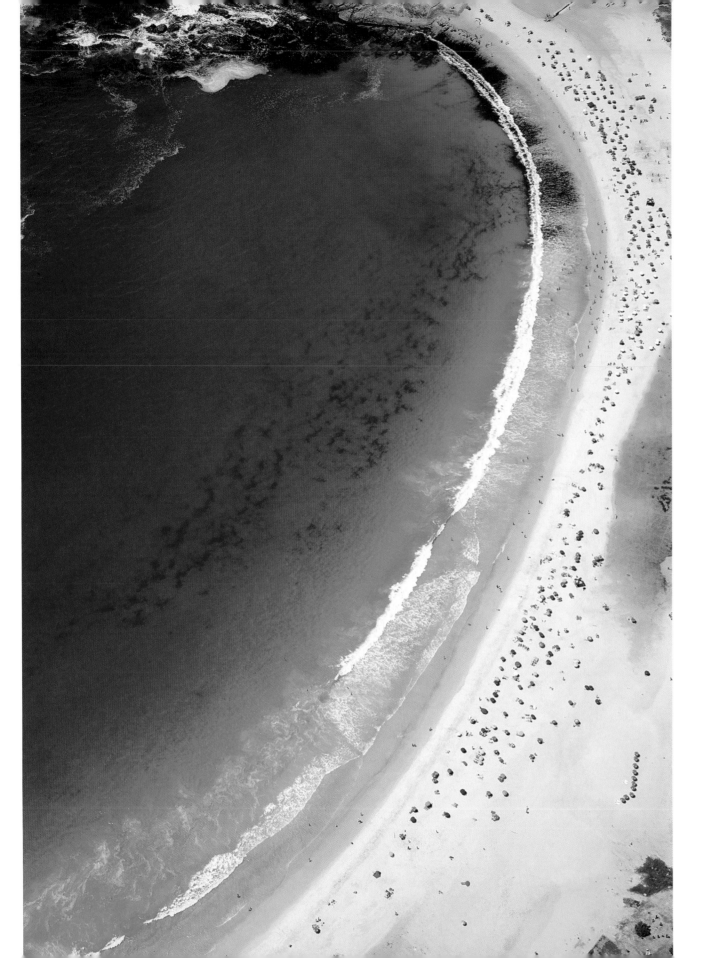

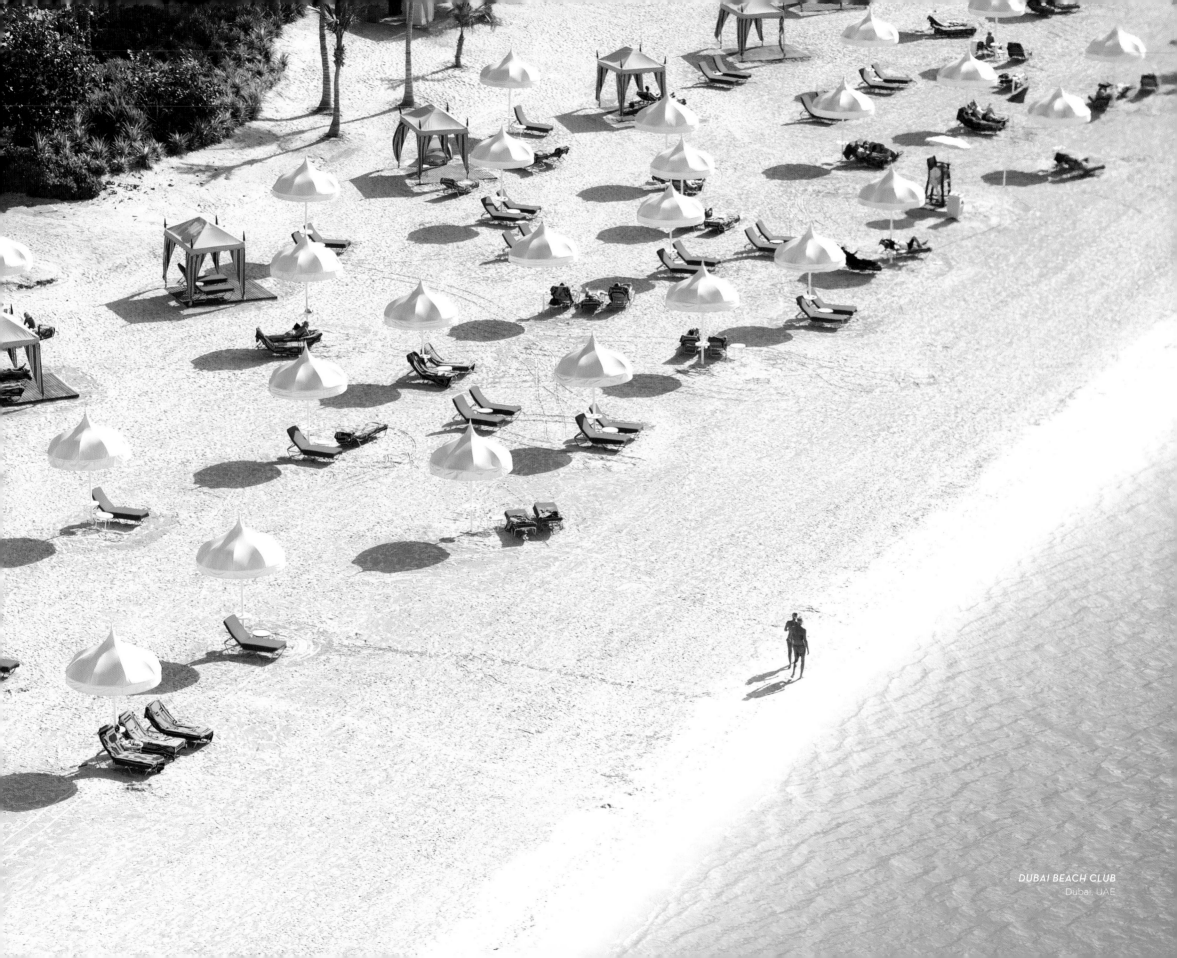

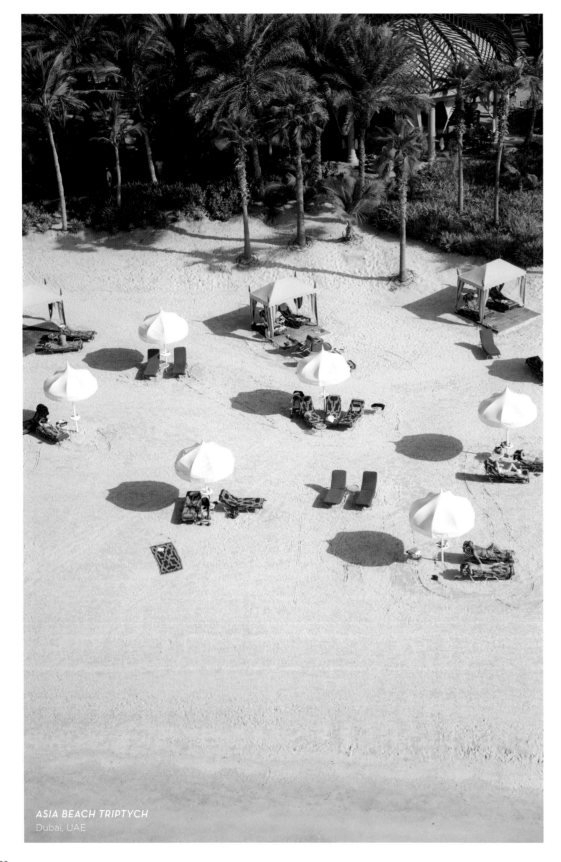

ASIA BEACH TRIPTYCH
Dubai, UAE

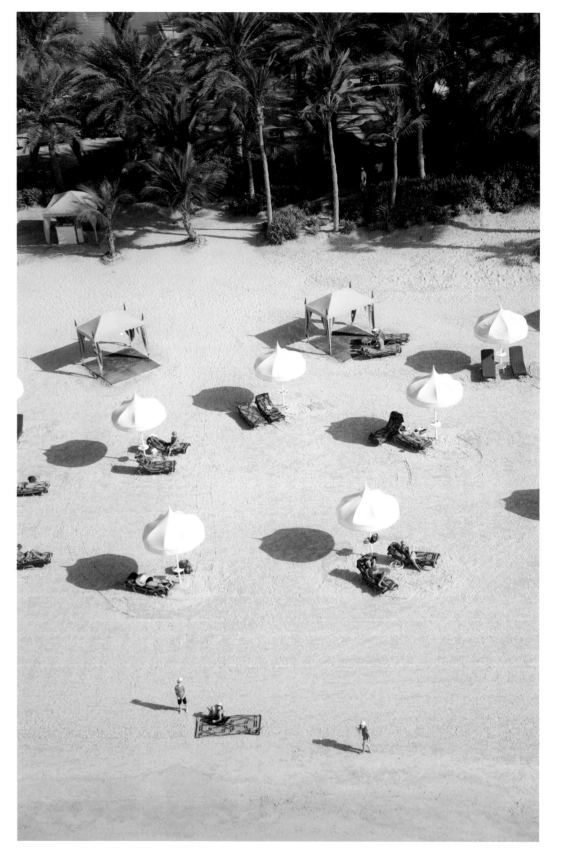

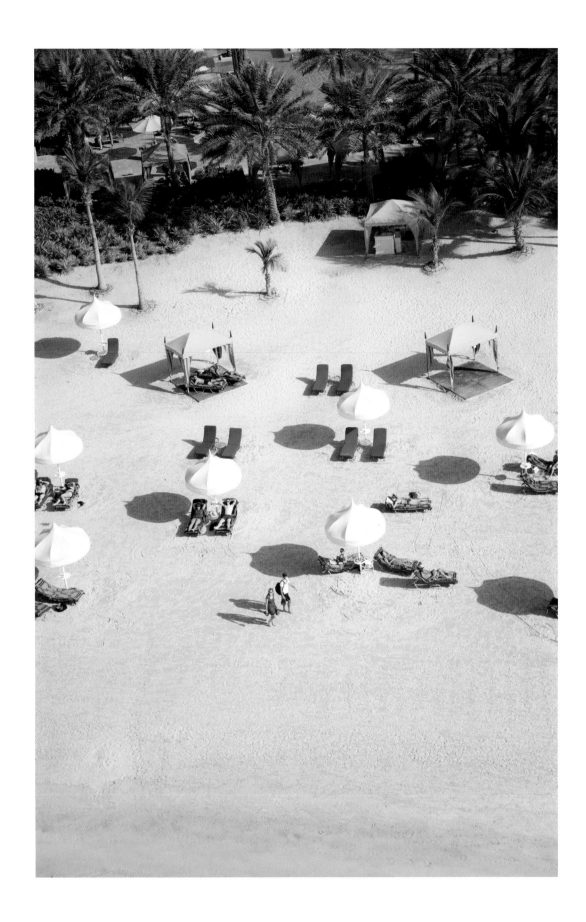

The beaches of *DUBAI* are very difficult to access by air,

so I consider myself incredibly *LUCKY*

to have had the opportunity to capture their beauty and share the experience

through my PHOTOGRAPHY.

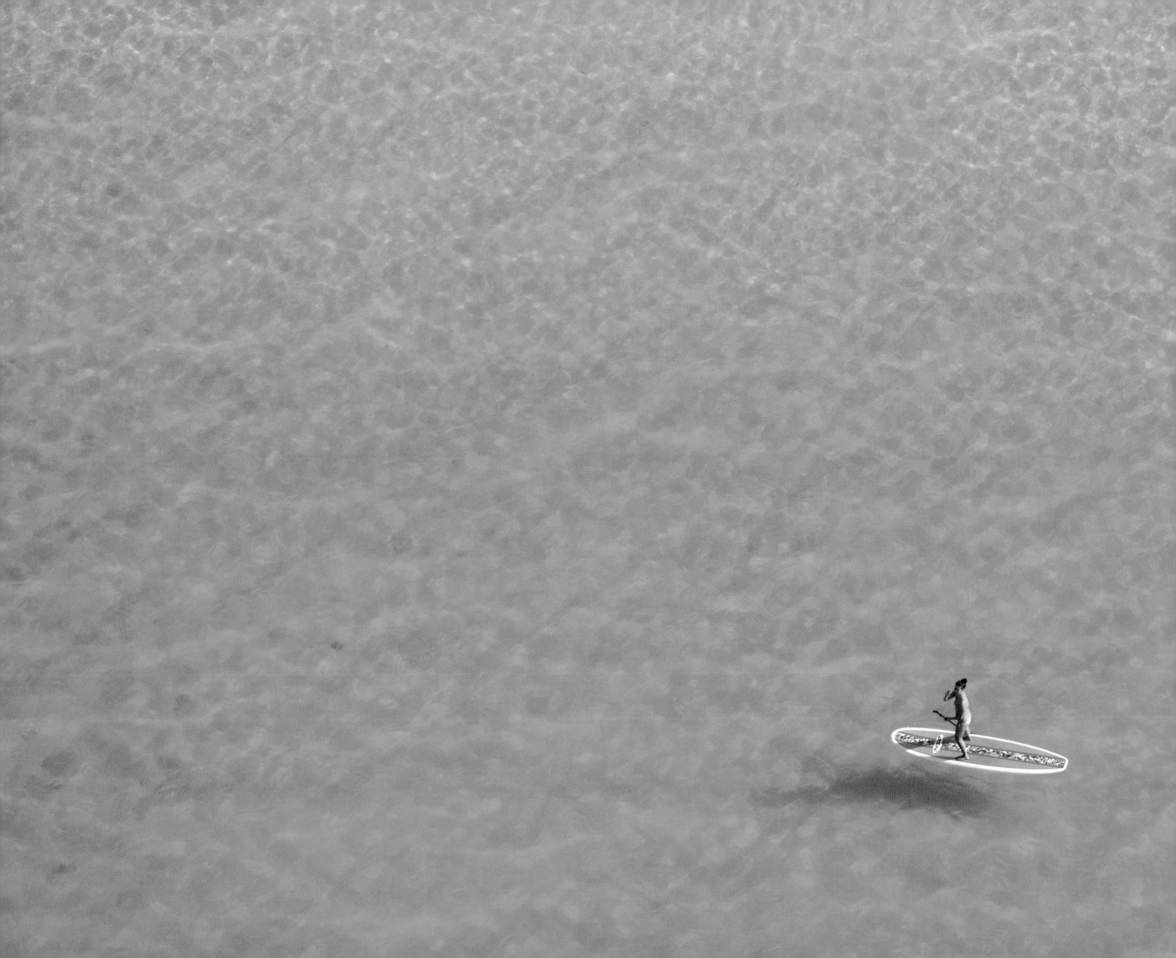

PADDLE BOARDERS
Dubai, UAE

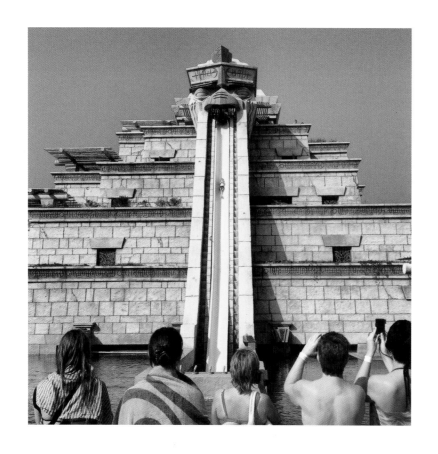
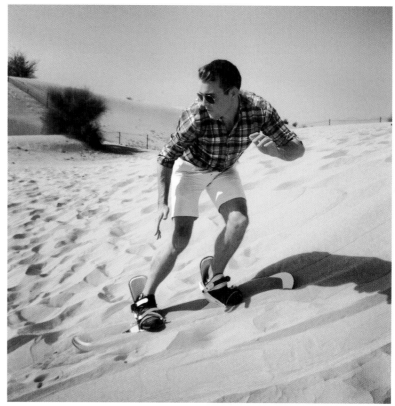
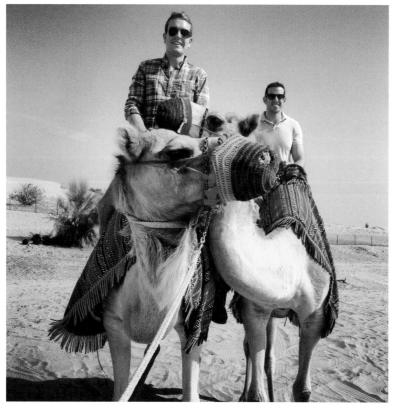
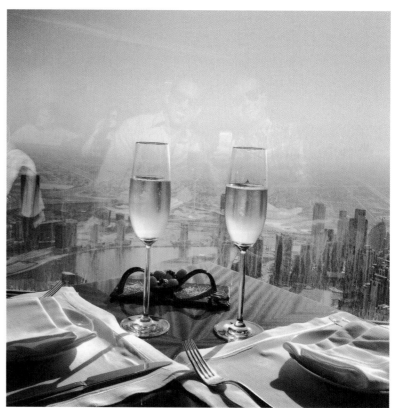

Insider tips

DUBAI

BEAT THE HEAT
Aquaventure

Be sure to check out the Atlantis hotel,
which is on the very tip of the famous
man-made Palm Jumeirah island in Dubai.
The hotel is connected to a massive water
park called Aquaventure. It'll bring out
the kid in you.

FOR AN ADVENTURE
Camelback Riding

Go on a desert safari!
Where else are you going to ride
around on camels and hop on
a board to sandsurf a few dunes?

NOT TO BE MISSED
Burj Khalifa

Having high tea at the top
of Burj Khalifa, the tallest building
in the world, is an absolute must.
From the interior design to the view to the
champagne cheers, this is an experience
not to be soon forgotten.

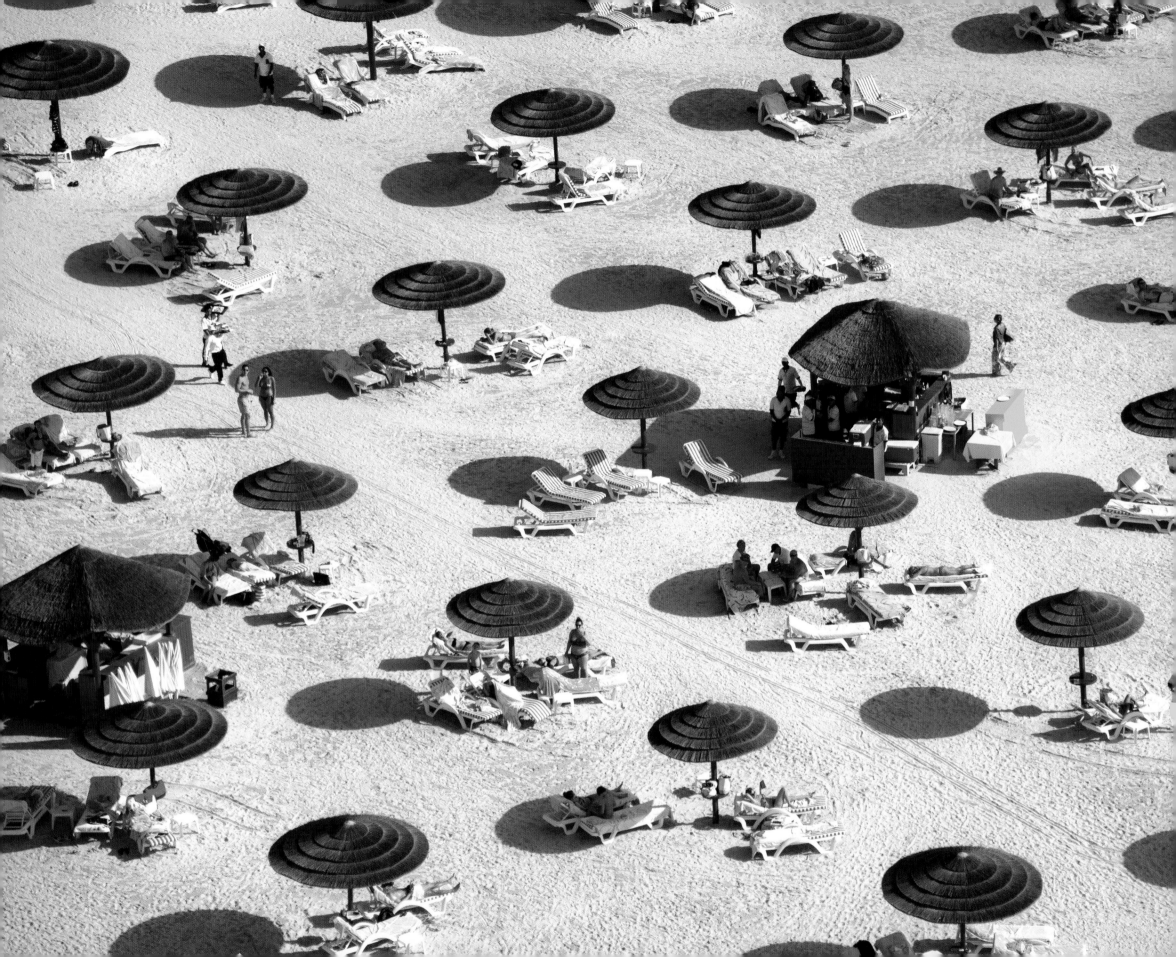

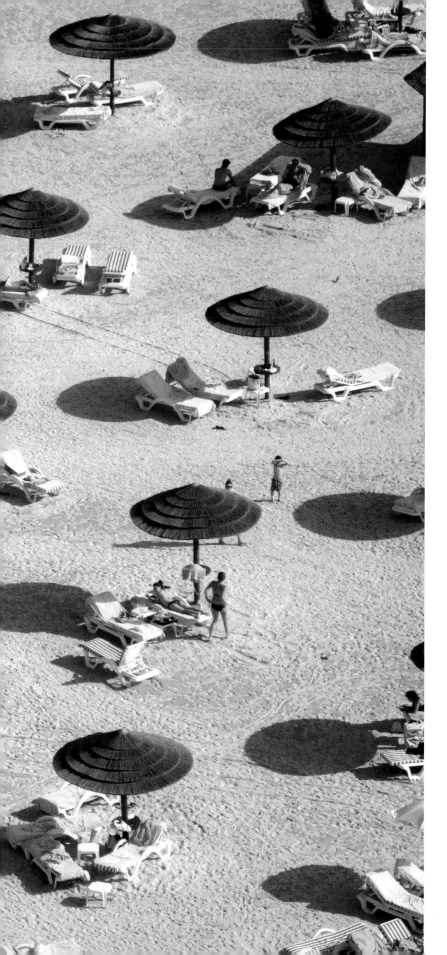

DUBAI BEACH UMBRELLAS
Dubai, UAE

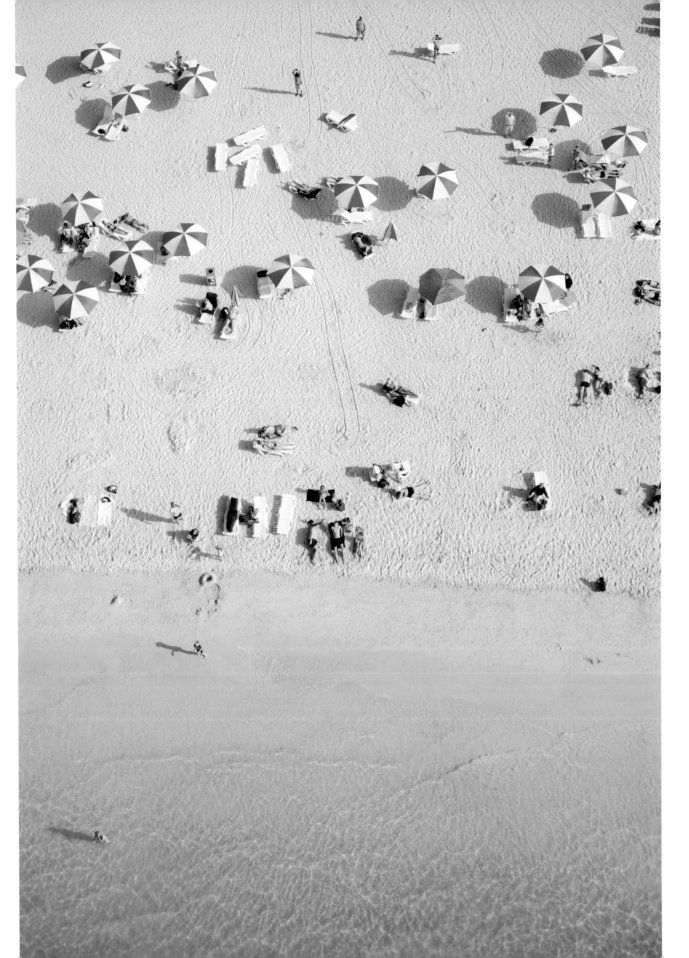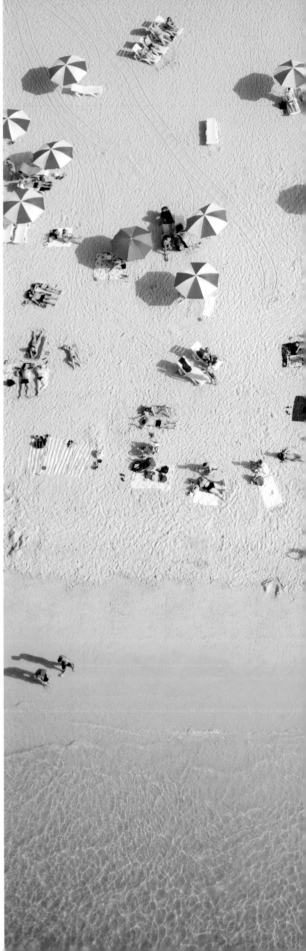

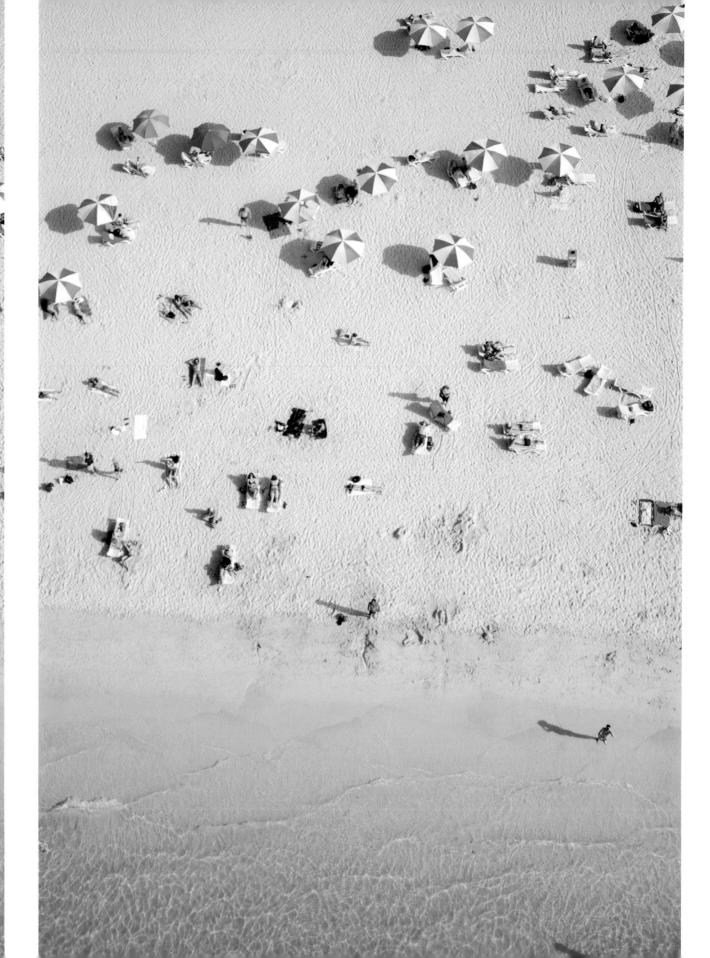

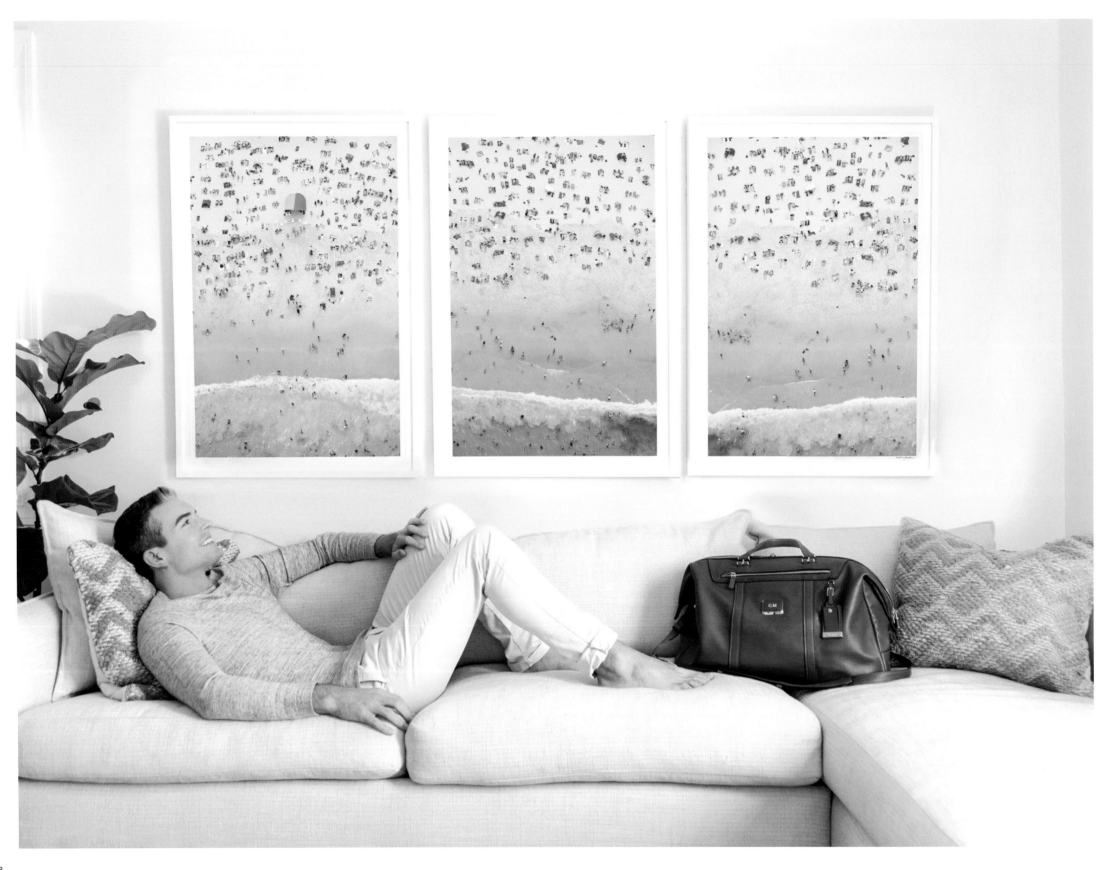

MAKE *EVERY DAY* A *GETAWAY*

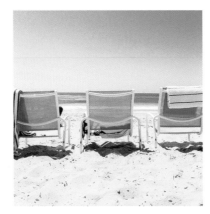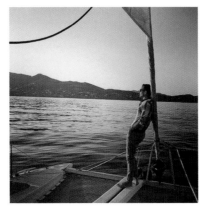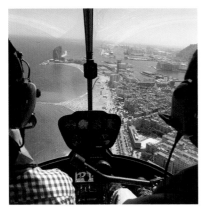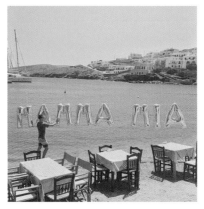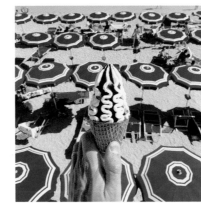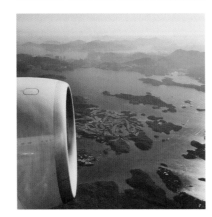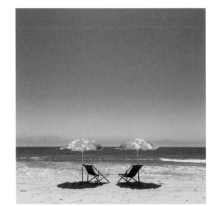

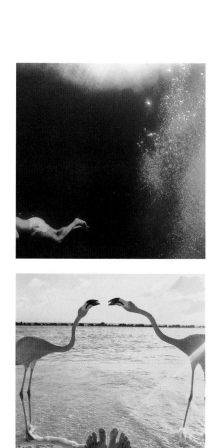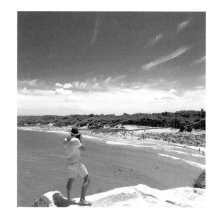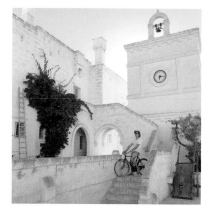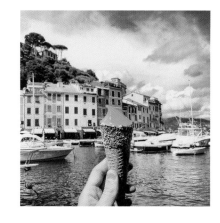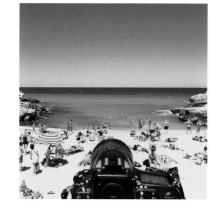

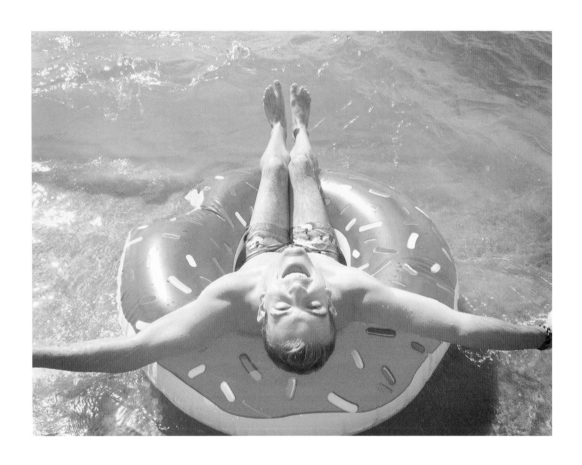

THANK YOU

\\\\\\\\\\\\\\\\\\\\\\\

There are so many people who have contributed not only to each page in this book but also to my overall career as a photographer.

TO MY HUSBAND, JEFF, for waking up at six A.M. every Sunday to help me set up my booth at the flea market. You are undoubtedly the greatest man I have ever known and I can never thank you enough for helping guide and shelter my dreams.

TO MY PARENTS AND MY SISTER, to whom this book is dedicated, for shaping me into the man I've become. I love you all to the end of time and back.

TO THE THREE INCREDIBLE WOMEN who have mentored me from adolescence to adulthood: Janis Hefly, Aline Smithson, and Susan Feldman.

TO REBECCA KAPLAN AND THE ABRAMS TEAM for helping make this dream-come-true book a reality!

TO MICHELLE KIM - thank you for designing this to perfection.

TO ASHLEE WILSON for believing in me and grabbing my hand when I needed it most.

TO MY TEAM AND STAFF: Gina Michael, Kendra Mamula, David Howard, Kristen Gray, Nick Carter, Nicholas Scarpinato, Paige Yingst, Isabella Lyle-Durham, Ashlee Wilson, Kate Leiva, Danielle Frisa, Jaden Levitt, Pina Lopez, and Bollare PR. I am honored to work with you every day. Thank you for being a part of this book, this brand, and the happiness we strive to bring to others.

ADDITIONAL THANK-YOUS to Mary Kelso, Stewart Stinson, Abby Malin, Christine Caldwell, Isabelle Blye, Skye Topic, Natalia Senise, Ali Torre, Jayme Phillips, Michael Kutach, Ryan Garvin, Tara Haaz, Stella, my friends from Castle Park, Dallas, Emerson, and Los Angeles, and my amazing extended family.

LASTLY, TO ALL THE BRAVE PILOTS WHO HAVE FLOWN ME FOR THIS PROJECT.

ABRAMS

Senior Editor
Rebecca Kaplan

Creative Director
John Gall

Design Manager
Danny Maloney

GRAY MALIN

Contributing Editor
Ashlee Wilson

Copy Editor
Paige Yingst

Photo Editor
Isabella Lyle-Durham

DESIGN

Book Designer
Michelle Kim

WWW.GRAYMALIN.COM

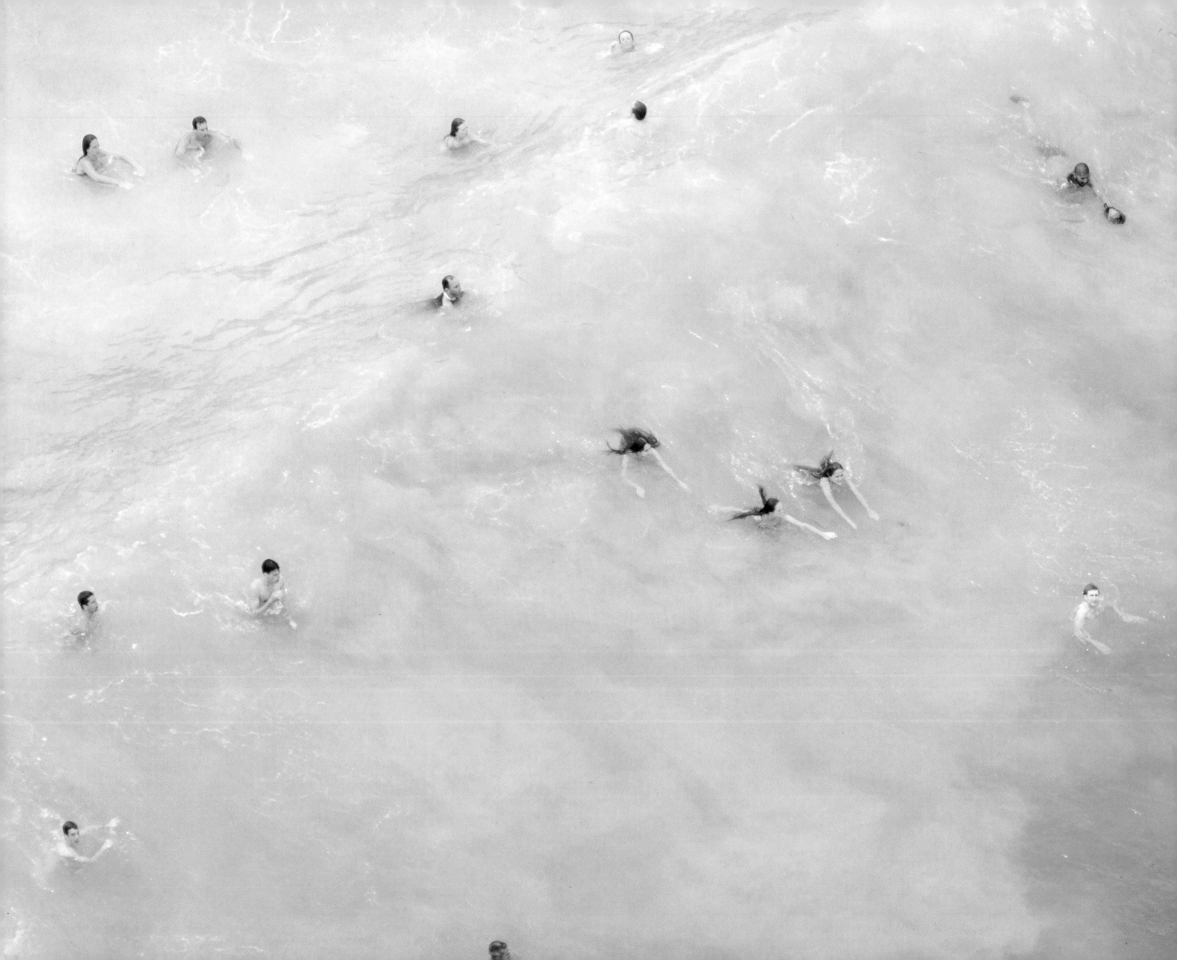